SAVAGE MESSIAH

H. S. EDE

H. S. Ede was born in 1895. He left school at 15 to become an art student. After serving in the First World War he joined the Slade School of Art until 1921, the year in which he married, and left to become a photographer's boy at the National Gallery. In 1922 he became an assistant at the Tate Gallery, which he left in 1935, when he retired to North Africa. He visited the USA on several occasions to lecture. He moved to France in 1952 and in 1956 he was awarded the Legion d'Honneur for help given to painters and sculptors. In 1957 he moved to Cambridge where he was owner/curator of Kettle's Yard, a house which he filled with many works of art, among them many by Gaudier. This house and collection he donated to Cambridge University in 1965, and lives there now as Honorary Curator.

Back cover photograph shows
Scott Antony as Henri Gaudier
in Ken Russell's Film
SAVAGE MESSIAH
A Russ-Arts Production For MGM release

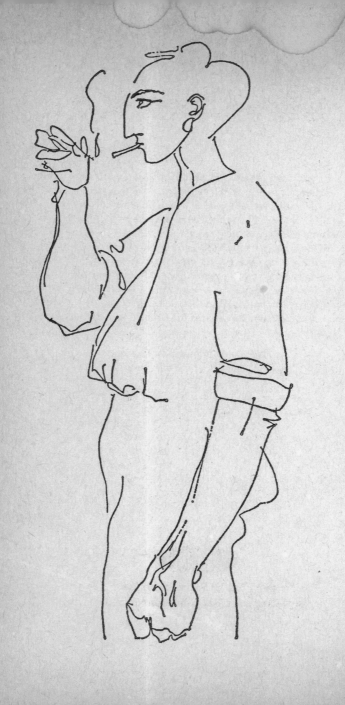

H. S. EDE

SAVAGE MESSIAH

published by Sphere Books Ltd
30/32 Gray's Inn Road, London WC1X 8JL

First published in Great Britain in April, 1931, by
William Heinemann Ltd.
New Impression May, 1931
New edition published in 1971 by
The Gordon Fraser Gallery Ltd.
Copyright © H. S. Ede 1931 and 1971
First Abacus edition, 1972

*Printed in Great Britain by Hazell Watson & Viney Ltd
Aylesbury, Bucks*

CONTENTS

PLATES

Henri Gaudier
Sophie Brzeska

The Dancer 1913. Bronze. Height 30½ in.
 The Tate Gallery, London.

Seated Woman 1914. Marble. Height 18¼ in.
 Musée National d'Art Moderne, Paris.

The Red Stone Dancer 1913. Mansfield Sandstone. Height 17 in.
 The Tate Gallery, London.

The Dog. Bronze. Length 14¾ in.
 The Tate Gallery, London.

The Duck. Bronze. Length 4¾ in.
 Kettle's Yard, Cambridge.

Head of a Girl. Pencil. 8¼ in. × 5½ in.
 Kunsthalle, Bielefeld.

Wrestlers. Pencil and brown wash. 18¾ in. × 12 in.
 Kettle's Yard, Cambridge.

Seated Woman by P. & F. Barnes, Cambridge.

Two 16 mm films are available on the work of Gaudier-Brzeska, *Henri Gaudier-Brzeska* and *The Red Stone Dancer* produced by Firebird Films and available through Contemporary Films Ltd., 55 Greek Street, London.

PREFACE

I have personally met very few of the people mentioned in this book, and any remarks about them in no way denote my own feeling, but entirely those of Henri Gaudier and Sophie Brzeska.

My authority for what I have written has mostly been a Diary kept by Miss Brzeska, whose statements I have checked both with letters from Henri Gaudier and by conversations with people who knew them both. Where it has been possible, I have used Miss Brzeska's own words, putting them between quotation marks; but usually the Diary is too diffuse, and too personal to Miss Brzeska, to allow of a direct translation.

All Henri Gaudier's letters were written in French, with the exception of two early letters to Miss Brzeska, pages 17 and 27, and the rough draft of one to Middleton Murry, page 87, and these are printed in their original language. In translating the letters I have occasionally left out passages which are mere repetitions, or of no general interest.

H. S. EDE

PREFACE TO THE 1971 EDITION

In the fifty-six years since Gaudier's death his reputation has grown from that of being simply 'an illustrious unknown' and moves towards his recognition as perhaps France's greatest sculptor.

Until a few years ago his name was known only underground, chiefly to other sculptors. Henry Moore, speaking of him as one of his formative influences says : 'He made me feel certain that in seeking to create along paths other than those of traditional sculpture, it was possible to achieve beauty, since he had succeeded.'

Today a large number of his works may be seen at The Tate Gallery in London, Kettle's Yard in Cambridge,* the Musée National d'Art Moderne in Paris and the Bielefeld Art Gallery in Germany. His reputation continues to grow.

H. S. E., 1971

* *Publisher's Note.* Kettle's Yard is neither an art gallery, nor a museum, nor even a special collection of works of art; the author describes it as 'a continuing way of life from these last 50 years'. Kettle's Yard has the semblance of a private house made beautiful by paintings, sculpture, stones, glass and space.

For thirteen years the author has encouraged people, particularly undergraduates, to visit him to enjoy works of art in a personal setting. Six years ago he gave Kettle's Yard and its collection to the University of Cambridge; Mr. Ede continues to live there and is visited by many thousands of people who come to see the collection.

THE MEETING

Sophie Suzanne Brzeska and Henri Gaudier met for the first time at the St. Geneviève Library in Paris during the early part of 1910. It was the strange meeting of two people with violent temperaments, widely different in age and experience, utterly unsuited to each other, and yet destined to live together for the next five years, and in the end to die violently as they had lived, the one on the battle-field, the other in a madhouse.

Miss Brzeska, a highly-strung Polish woman, already thirty-eight years old, was working, or fancied she was working, at German : she was interested in languages and in the literature of different countries, but owing to her hate of the Germans she had not studied their language before. She was small, flat-chested, with a pointed chin, thin lips, tilted nose, sensitive nostrils, and high cheek-bones, which rose up to meet the large eyelids sheltering strange tired eyes, eyes that often stared big and vacant, and then of a sudden melted into roguish intimacy. Her movements were rapid, abrupt, and angular; her student's paraphernalia, which she set about her on the table with neurotic precision, were extensive, and often attracted the attention of the young men who sat and worked at the same table, and to whom her eccentricities and seeming independence were the cause of much speculation : a speculation not to be wondered at, since she was a woman who was bodily ill and mentally diseased, whose life had been a succession of continual emotional crises; of terrors, intuitions of evil, forebodings of madness, outbursts of rage, meditations of suicide, and intimations of her own greatness. She was extremely poor and absolutely alone, without a friend to speak to; she had come to Paris, a few months before, with the firm intention of killing herself to escape from the fine torment of life into those vast spaces of rest and forgetfulness which she believed to be the reward of death; but life in Paris, with its keen student energy, and the thought that if she were buried her body would be eaten by worms, had weakened her resolve, and she was again making frantic efforts to conquer her depression.

Sitting by her, in the Library, was a young boy who often looked at her furtively, almost timidly. He was about eighteen, with dark, finely-chiselled features and sparkling eyes, and his attentions occupied much of Miss Brzeska's thought; he was an artist, she supposed, since he was studying anatomy; he looked poor and tired, indefinably

gentle and yet somehow alert and cruel, like a panther. This incongruity fascinated her, for it had much in common with her own swift outbursts. She wondered why he looked at her with such interest : he was so young and she—she might be his mother. Why had she never had a child, she whose experience of life was so vast? She could have protected and helped a son, studied the growth of his ideas, and found satisfaction in his turning to her for support; such were the thoughts she noted in her diary as she watched Henri Gaudier, and as she felt his young presence near her. She even wondered if he might love her; but no, that was impossible : love did not exist, she had been too often mistaken to fall a prey to that deception.

In order to break the monotony of her daily life she was prepared to do anything, even to give up her eternal search for an experience in which love and friendship would be united, and just to give herself quite wantonly, asking for nothing but to be possessed by the deep-reaching abandon of physical love. But it was quite clear to her that it must not be with Henri Gaudier. Such an action could only bring her shame and remorse; she wished to revenge herself on men, but to break into his life would be like torturing a baby. She wanted to be happy, to laugh and to be free, to forget her grinding pain. She would like to smile at Henri, to take his hand, no more. They might be companions and help each other; but then her heart cried out to her that she was old, in the autumn of her life, and that she could never play so austere a part, for she would need to be strong enough for two, since he was so young, and young people were so easily excited. Besides, she felt that he was far too good for her, she needed someone cast in a rougher mould.

She chose a Russian, a largely built, pale-faced man with small, penetrating eyes, and she threw him a significant look which he smilingly received; he seemed to set no barrier between them, and already, as she looked at him across the table, she felt herself in his arms. But Miss Brzeska's temperament was not of the kind which made her able to give herself easily; she was spirited and proud, so she drew back again into herself, and hid behind her provocative air of listless gaiety.

At the end of a couple of weeks she no longer wanted to abandon herself to this Russian : her immediate excitement was allayed, and she felt that perhaps after all she would find somewhere a real friend. She continued, however, to play with the Russian, who, after making many vain attempts to come to an understanding with her, to meet her when she came to or from the Library, would decide to give her up, but then returned to the attack only to disappear again beaten. She did not care for him, but the game amused her, though her conscientious nature began to give her serious pangs of regret; what right had she to make the poor fellow suffer? The other students at the

table followed the flirtation with great interest, and some of them gave her encouraging looks, hoping that they, too, might be drawn in, but on their own account; thinking themselves more able to gain a victory than their fellow-student.

Henri Gaudier was the most assiduous of these. He always managed to sit by her side, putting his books quite close to hers. This often upset her plans with the Russian, but she had never the heart to look at him severely. One day she asked him to show her his book of drawings, which he did with evident pleasure, trying to draw her into conversation; later he waited for her at the exit, and they walked a little way together. He evidently wanted to talk to her, and she allowed her interest to ripen for this young life, which thought only of Art and the big work it would accomplish. One night Sophie let him walk with her as far as the door of her hotel. He complained of his loneliness and of his desire to know someone who would understand him and encourage him in his ambitions. Sophie was immediately touched to the finest fibre of her nature; spontaneously she replied : 'I am too old for you really, but I will be a mother to you, if you agree.' Henri said he would be enchanted, he had wanted to know her for so long, he thought her beautiful, and she pleased him. Sophie looked at him with surprise; no one had ever felt like that about her before, and at home since her childhood she had always been spoken of as ugly. Henri explained that that was because people did not see true beauty, the beauty which lay in the heart and in the expression. What was more, he loved her concentrated energy and was intrigued by its changefulness; at times she would be completely absorbed by her work, and then she would stare at the ceiling with eyes full of tragedy.

'Sometimes you look as if all the devils in hell possessed you—for instance, when you look at the Russian.'

'Aren't you then frightened of me,' said Sophie, 'seeing how wicked I can be?'

'On the contrary, I hate those mincing beauties whose expressions never change—they are no more than mummies.'

So for a long time they walked and talked in the Rue Cujas, hours filled for them with breathless excitement; what did it matter what they said, since to be talking at all meant that they were no longer lonely, and before they separated they arranged that on the next day they would visit the Louvre together.

MISS BRZESKA

Sophie Brzeska was born in a large house in the heart of the country, not far from Cracow. Her father, a solicitor, had, according to her own report, only two interests—wasting his inheritance, and entertaining women of all stations in life, provided they were young; and so long as he was left quietly to this occupation he was a pleasant enough man to live with, but it kept him much from home.

Mrs. Brzeska, on the other hand, was always at home. She gave birth to nine children, of whom Sophie was the only girl. Her parents were constantly irritated and humiliated by this, and kept telling her that she was a useless encumbrance who would remain on their hands and give them no return.

During her early childhood she was alone with her mother, who was continually pregnant, often bearing still-born children; Sophie watched the funerals of four of these. There were young brothers growing up entirely neglected by their mother, who read and studied all day without any system, and they naturally joined in their parents' abuse of Sophie. Mr. Brzeski shut his eyes to all the disharmony of his family so long as his own pleasures, which were the cause of many objectionable scandals in the house, were not interfered with.

Sophie tried, when she was sixteen, to escape from the miseries of her home; she wished to work, and already felt a desire to write; but her parents told her that there was no money for so stupid a person, and that the only thing she could do was to find a rich man as stupid as herself, and persuade him to marry her.

The only subject of conversation on her account seemed to be of arranging such a marriage, and after several attempts, an elderly Jew was found who consented to become engaged to her, much against her wishes. She even thought of escaping from her troubles by suicide, only the fear of her mother forced her to accept the Jew's proposal. Happily the Jew expected a dowry with her, and this infuriated Mr. Brzeski, who felt that anyone of such obscure origin should think it a sufficient honour to be given his daughter; so the engagement fell through with insults on both sides.

During the next four years there were three incidents which might have led to marriage, the first two with men as little to Sophie's taste as the Jew. The third was a young man, of shockingly poor physique, but universally spoken of as a decent fellow. He had a rich mother

who wished him to make a brilliant marriage, but who for a time countenanced his attachment to Sophie. One day Mrs. Brzeska made a dreadful scene with him over a game of cards, and without consulting Sophie's feelings turned him out of the house. His own mother was in her turn furious, and made him promise never to see Sophie again; but he wrote to tell her that he would always love her, and that they must trust in the future. Then came Mr. Brzeski's bankruptcy, and a little later, his death.

Miss Brzeska, who suffered much from gastric catarrh, had saved a little money out of her dress allowance, and driven from the house by her mother's ill-treatment, went to study in Cracow. From there she moved to Paris, where she worked for a time as a nursemaid, but was made miserable by the gibes of her fellow-servants. Then she obtained a succession of posts, often only for a fortnight at a time, until her health entirely broke down. She was obliged to take a short rest, after which she found a position with a family who were going to Philadelphia. There was a little boy of ten years old and a girl of sixteen. Sophie became deeply attached to the boy, but after a few weeks he died, leaving only his sister for her to take care of. This girl kept asking for indecent stories, and because Sophie did not tell her any, she complained to her mother that Sophie was dull. The mother told Miss Brzeska that she must try to entertain her pupil better; so in fear of losing her job, and because the child was already more worldly-wise than she, Sophie invented scandals about Parisian actresses, much to the delight of her pupil. One day the mother and father overheard their talk, and Miss Brzeska was dismissed.

She now went to live in a French 'Home' in New York, kept by nuns. From that time on there came more and more detestable children and impossible parents, and each year she became more painfully nervous. Her whole aim was now to get back to her own country, particularly as she had heard from her cousins that her young man was still faithful to her. She must economize, make money; but she must make it honestly. Many a time, from fathers in whose families she worked, she might have earned in a week, had she been amiable and complying, more than she could otherwise do in four years; but she had a profound belief in the sacredness of love.

In the meantime she longed for human affection, and felt so much the need to forget herself in her love for someone else that she began to fall in love with other women. In this she met with nothing but disaster. For all her affection and her generosity she got only deception and abuse. Miss Brzeska felt at this time that she had reached the acme of suffering, that life could hold no bigger trials for her; and it was only want of money that prevented her from returning to Poland, which she now felt to be her only escape.

Little by little she saved enough for her return, and then heard

from her eldest brother that he wanted to come to New York. She was fond of him, for he was sensitive and delicate, and she pitied his being under the maternal roof. She sent him enough money for his journey, and so gave up her own chance of returning. For five months her brother could find no kind of work, and finally had to accept a post as kitchen boy in a large hotel. He began to accuse Sophie of having persuaded him to come to America, and finally he refused to see her. To add to her troubles, she was out of employment herself; so when suddenly a chance offered of getting to Paris, she accepted it with alacrity.

She had planned to stay in Paris, and make a position for herself, in preference to returning home; for she was now thirty-six years old, and feared that the man who had promised to wait for her might think her too old and too battered by the life she had been forced to lead. However, in Paris she could get no work, and thus was compelled to return to her mother's house, where another severe blow to her pride awaited her. She had an uncle, aged seventy, of whom she was tremendously fond; she had always treated him as a father, and felt him to be her one stay in life. She found that on the death of his wife he had persuaded a shameless cousin to come and live with him; and although there was no need of arguments to accomplish her seduction, he told her that Sophie, the refined and correct Sophie, had been his mistress, and that in order to avoid a scandal he had sent her to Paris. This discovery so shattered Miss Brzeska that she felt its effects for the rest of her life.

Her family ridiculed her for having only saved a thousand francs during all her years in America, and they laughed at her ideas of virtue. She then heard that her friend had become engaged to an heiress, and she wrote to him imploring him not to ruin his life, saying that she was prepared to wait for him as long as it was necessary: he replied, coldly polite, that he loved and respected his fiancée.

By such blows Sophie was turned sceptical, and believed that she no longer desired the love of men. To deaden her distress she forced herself into a life of dissipation. Her health soon broke down and she went to Baden for a cure.

It was here that she met Monsieur M., a rich manufacturer aged fifty-three, with whom she had her most serious love affair. Now was her chance to show her relations that when she chose she could make a good marriage; but again she was caught. Monsieur M. proved to be amusing, intelligent, a lover of nature and full of kindness, understanding quickly all the pent-up troubles of her heart; and before she knew where she was, she was passionately in love with him. He assured her of his love for her, and she believed him, her nature needed so intensely to believe him; but he did not ask her to marry him.

Their friendship lasted for over a year. During this time Monsieur M. encouraged her and to a great extent used her, but never gave her the complete satisfaction for which she craved. Ultimately, after a dreadful scene which nearly ended in the death of both, he told her that he had a son, and that he had promised always to remain free in case the boy's mother wished to marry him—that he adored his son, and that his one ambition was to make him a home.

Poor Sophie, she who was so famished for love, who had guarded herself so carefully until she felt that she had found someone who was worthy of her love, who wanted love to be eternal, how was she now distressed! She felt her senses leaving her, and for some time she was on the verge of madness. She wrote to Monsieur M., imploring him to kill her if she went mad; and he replied that she had upset his nerves for nothing, that she had better go to the country to cure her hysteria, and that he was quite willing to pay. After heart-rending scenes she returned in despair to her home. Her allusions to madness had decided Monsieur M. to have no more to do with her, and he left her numberless letters unanswered.

At home she would lie for hours on a sofa wondering how best she could kill herself. A fat aunt, who was there, occasionally indulged in vulgar pity. 'Poor girl—you evidently want something—it's a pity, all the same, that you did not marry that old man your mother found for you—he was certainly stupid, but he seemed to have a kind nature.' Then Sophie would stamp and shriek with rage, flinging invective and injury upon her aunt, while her mother would stand by smiling. 'You see what a toad she is—what a scorpion; didn't I tell you? But you would never believe it. You can see for yourself now.'

It was less than two months after this that Miss Brzeska saw Henri Gaudier for the first time in the St. Geneviève Library.

HENRI GAUDIER

When Henri visited the Louvre with Miss Brzeska he was very atten-
tive to her, explaining everything most vividly. He enjoyed so much
being able to enlarge on his ideas to his enthusiastic companion, for
he had never met anyone before who cared to listen to him. He was
particularly attracted by the sculpture, and endeared himself to
Sophie by taking off his hat in front of the Samothrace 'Victory'.

Henri was very poor, his clothes were torn and dirty and his shoes
full of holes, but Sophie felt proud to be with him, although usually
she would have been much put out by such things; for several years
she had not followed the fashions, but she had always been scrupu-
lously clean in herself and her linen.

Slowly but surely he entrenched himself deeply in Sophie's heart;
he gave her his diary, in which he complained of being 'without love
and without friends', and he told her that he was fully satisfied with
her motherly love.

She herself was in a seventh heaven : it was, I think, the happiest
time in her life, perhaps also in Henri's. Once or twice a week she
would go to his tiny room at 14 Rue Bernard Palissy and he would
draw her portrait while she told him her ambition to be a writer, and
read him several of the short stories she had written. Henri used to talk
to her in English, and they learnt together Shakespeare's sonnets and
discussed the literature of many nations; for Sophie was widely read,
and they were both intensely keen on searching into the manifesta-
tions of human development. Many were the delicious moments
which they passed together, he with his head on her shoulder or she
resting on his; the solace of kisses was not allowed, but their spirits
were united in a radiant joy. They had their own troubles to talk
about, and they discovered that they were both suffering from the
same ills. Miss Brzeska had been a short time before to a specialist,
thinking she had caught some disease in the hotel where she was
living, and the doctor had told her that her state was one of nervous
prostration due to lack of food and over-anxiety. Henri was in just
the same position : his weakness was extreme, his hands were always
moist, his cheeks hollow. For some time he would not confess to being
short of money, and when he did, it was with the greatest difficulty
that Sophie persuaded him to accept a few francs. Often she would
buy food and come to share it with him in his room. Once when she
had to keep to her bed, he bought her a fine rose. 'But I won't leave

it,' he wrote,* 'lest the old mufflers at your hotel give a false meaning, and profane the idea I have and which you share. Anyhow, I shall not have bought it for nothing, and I enclose some of the petals— you won't get this letter before to-morrow, which is a great pity. I am sure you would have much more pleasure in reading it to-night. Good-night, with love. Syn.'

In a letter to Dr. Uhlemayr, with whom Gaudier had lived at Nuremberg during part of the previous year, he tells of his meeting with Sophie Brzeska :

<div align="right">

Paris
18*th June* 1910

</div>

I have such a lot of things to tell you, but things quite different from those I have already talked about—I refer to the effect of love on one's working power. Would you believe it, I am in Love ! I see that you already picture me with some *backfisch* strolling in the 'Boul Mich', or whispering sweet nothings in secluded corners around the Panthéon. You are wrong; the woman I love is thirty years old †— you smile—I love her with a purely ideal love, it is flow of sensation which you must feel, since words are too coarse a medium to convey it. She is Polish—Brzeska is her name. I met her in the library where I go to work each evening. I've done several sketches of her, and thus we got to know each other. She is a poet, and her ideas on the family, society, and Western civilization are the same as ours; she has an entirely independent nature, is an anarchist—simply and naturally, has a beauty *à la Baudelaire*—and might have stepped out of *Fleurs du Mal.* She is lithe and simple, with a feline carriage and enigmatic face, the fine character of which reflects her most intimate thoughts —planes combining in the most surprising manner, impressions of age and of youth in alarming contrast. In a word, we are both as mad as hatters. Would you believe it, last Sunday we talked from eight in the morning until three in the afternoon without noticing how the time had passed. I told her of my ideas about Art for Art's sake, and she explained hers on the basis of a society founded on motherhood undertaken freely and with open eyes. We parted about four o'clock, and I came home and at once set to work. I was so thrilled that I did a great bust that evening to give her next morning, as she had asked me for a bit of sculpture. Since then I have been like a man bewitched, and I would work like a machine, only that I have forced myself, with some success, to be reasonable. All the same, I am happy, and I only hope that the fever of work which possesses me won't as suddenly leave me. I am also very pleased to know this Pole, particularly because she is a Slav and I know nothing about

* This letter is written in English.
† Miss Brzeska was thirty-nine.

Slavs. She is going to teach me her language so that I may steep myself in the Slavonic spirit. I hope that I shall profit as much by it as I have by meeting with German culture, and that it may open for me the great gateway of the East. You mustn't be annoyed with me for telling you all this, since it is only natural that men and women should love each other, and that the nearness of one should cause happiness in the other.

I don't know what my fellow-countrymen must think of me, for in the Latin Quarter I know only Russians and Germans—there is one who looks very like you and another who takes opium, he's a very interesting subject; he wished to hypnotize me the other day, but couldn't.

I begin to understand the Greek and pagan antiquity, which I now prefer to the Gothic. For a long time I have been obsessed by Ruskin and the English; now I have finished with them, as with Christian philosophy, that hysterical egoism which contemplates the material sufferings of a material body and says : 'I have no wish to be crucified. I thank you, Christ, for having suffered in my stead, to save me from Hell where my body would have burned eternally.' This now seems to me only a repugnant sadism, and I much prefer the pantheistic idea. What pleases me most of all is the Buddhist philosophy, with its 'Nirvana' as the highest form of thought. . . .

Henri had arrived in Paris from Germany in October 1909; he was eighteen years old, and became an enthusiastic admirer of Puvis de chavannes, Rodin, and Whistler's 'Portrait of his Mother'.

Through the help of Monsieur Simonet, a professor at the Sorbonne, he obtained the work of translating books and letters in a bookshop;* this occupied the whole of his day, while his evenings were spent in studying anatomy and his Sundays in drawing. His letters to Dr. Uhlemayr, written during these first few months of his stay in Paris before he met Miss Brzeska, show clearly the nature of his life and interests, and parts of them are worth quoting :

Paris
October 1909

(To Dr. Uhlemayr)

Now that I have definitely begun to live I find myself more and more convinced that civilization with its trappings and artificialities is not so good as nature. By nature I mean a natural culture—the kind you and I used to discuss in the forest of St. Gebald. But that was no more than a dream, and the present reality seems the sadder for it. Ten hours of each day I have to do translations and letters in a bookshop, which you will agree is a pretty poor lookout; the rest of the time I work for my own pleasure—I am trying to perfect my drawing, and

* Mr. Ezra Pound says this was the Librairie Collins. *Gaudier-Brzeska*, by Ezra Pound, p. 43.

hope to succeed. I've made immense strides since I was with you, but how small they seem beside those I must still make! Every evening*
I work in the St. Geneviève Library—crowds of foreign students fill the place, and at the table where I usually sit they are all Slavs and Germans. . . .

Paris, 14 Rue Bernard Palissy
1st January 1910

(To Dr. Uhlemayr)
We shall never see a greater sculptor than Rodin, who exhausted himself in efforts to outvie Phidias, and did outvie him in his *Penseur*, which reaches heights he can never surpass. Rodin is for France what Michelangelo was for Florence, he will have imitators but never rivals. . . . It is fatal, for these men by their monstrous personality bleed a nation to death and leave others only the alternatives of imitation or veneration.

Paris
5th March 1910

(To Dr. Uhlemayr)
I have been, during this last week, the stage of a great battle. One of my friends has a little house and garden in the country, and I often go there for Sunday. Last Sunday I dug in the garden all day long, and a happier man than I could not have been found. My friend, who had to go to town on some business, left me alone in his house. I started to dream and to think, and so the battle began, and these are the opposing forces. On one side happiness and nature, represented by the simple life of the fields, and on the other the sadness and artificiality of business and town life. The pleasure of the fields is clouded by bad weather, by danger to the harvest; but, in spite of this, happiness remains, no less truly. The misery of the office, though tempered by art, is the enemy of pleasure. The two main things : nature, a super-human and beautiful creation, and the town, human and ugly—these will always keep their peculiar characteristics.

The exigencies of life compel man to obtain money. A commercial life provides this, but I cannot face it, and since art doesn't bring money, I am inclined to abandon this life of a middleman robber which repels me, and will do all that I can to learn some handicraft which will dispose of the idea that to produce nothing during the day is to waste my time.

But I have decided nothing, the town and the fields sit opposite each other—and if I have a trade, I shall still need art. Only a country life can give me pleasure, and I have begun to feel that farming

* His evenings in the St. Geneviève Library were mostly occupied in studying anatomy.

is one of the most lovely of the fine arts. But since I am an anarchist in my soul and a friend of great solitude, if I wish to have done with it once for all—I should go to Canada, there they will give me land and I shall be free and happy.

If this were all, life would be easy, but my principles are to a certain extent in opposition. I am the friend of the producer, of the worker; I support him against his masters. Would it not be a horrid cowardice, a profound egoism, to go to the colonies instead of fighting at the side of my fellows? Land—Canada, these are my personal happiness. In trade, suffering, art, the town, the battle, I seek a collective happiness. I uphold the creative spirit of mankind, maintain it and make it triumph over the middle-class man who seems to deny its existence. If I abandon the workman, I take sides with the fat-bellied, flabby-faced plutocrats—a hideous idea. All the same, it is rather beauty than a selfish satisfaction which attracts me to nature—and there I come round again, and can arrive at no decision. One thing I can absolutely decide, it is the only thing I can cut off at once, namely, to give up business for some craft. I am going to learn the technique of sculpture in wood for cabinet-making. I shall give next month to this, and it is with this I hope to earn my daily bread, and not by fleecing the masses. When I face the beauty of nature, I am no longer sensitive to art, but in the town I appreciate its myriad benefits—the more I go into the woods and the fields the more distrustful I become of art and wish all civilization to the devil; the more I wander about amidst filth and sweat the better I understand art and love it; the desire for it becomes my crying need. . . .

<div align="right">

Paris
24th May 1910
</div>

(To Dr. Uhlemayr)

I have taken a great decision—I am not going to do any more colour work, but shall restrict myself entirely to the plastic. I have never been able to see colour detached from form, and this year, after doing a few studies in painting I noticed that the drawing and the modelling were all I had been concerned with. I have put by the brushes and tubes and have snatched the chisel and the boaster—two simple instruments which so admirably second the most wonderful of modelling tools, the human thumb. This and clay is all that I now need, with charcoal or red chalk and paper. Painting is too complicated with its oils and its pigments, and is too easily destroyed. What is more, I love the sense of creation, the ample voluptuousness of kneading the material and bringing forth life, a joy which I never found in painting; for, as you have seen, I don't know how to manipulate colour, and as I've always said, I'm not a painter, but a sculptor. It may surprise you that I can be content with confining myself to this

one branch of art, leaving all others untouched. Yet sculpture is the art of expressing the reality of ideas in the most palpable form. It makes plain, even to the eyes of fools, the power of the human mind to conceive ideas, and demonstrates in cold lucidity all that is fervent, ideal and everlasting in the soul of man.

You will have noticed that civilizations begin with sculpture and end with it. Painting, music, letters, are later refinements. . . . For my part I see quite clearly that I don't wish to wield the brush any longer, it's too monotonous and one cannot feel the material near enough, paint sticks well to the hairs of the brush and sings on the canvas, one appreciates its fertile texture; but the sensuous enjoyment is far greater with the clay slipping through your hands; when you feel how plastic it is, how thick, how well bound together, and when you see it constantly bringing forth.

I am now right in the midst of Bohemia, a queer mystic group, but happy enough; there are days when you have nothing to eat, but life is so full of the unexpected that I love it as much as I used to detest the stupid and regular life of trade. . . .

Henri's boyhood had been lived at St. Jean de Braye, near Orleans, where he was born on October 4th, 1891. His father was a carpenter, a clever workman interested in what he was doing, and it was from him that Henri first learnt his love of materials. There was a family tradition that one of his ancestors had worked on the cathedral at Chartres, and Henri was very proud of this legend.* He was a very sensitive child, delicate and frail-looking, but beneath all this lay a deep assurance and strength of will.

His father used always to encourage him to defend hotly what seemed to him to be right until the contrary was irrefutably proved; and as he grew in intelligence his disputes with his father became more and more intense. Already at the age of fourteen he had become the master in argument, and when he was older he would often tell how his father *a essayé de me battre, mais je lui ai donné de tels coups de pieds, qu'il n'a pu réussir.*†

At six years old he began trying to draw the things which interested him, and it is curious that already these should have been insects and the lovely patterns of which they are composed. He used to tear up all his drawings, and when his father protested he would

* Once in 1913 when he was to visit Miss Brzeska in the country, and was to pass as her brother, she asked him not to mention his Chartres ancestor, as she was considered by her landlady to be of gentle birth.

† This is a Beauceron proverb, not to be taken literally : but Gaudier sometimes amused himself by using it for his story, and watching the effect on his audience, who were generally horrified : and so the legend arose that his nature was so violent that he used to kick his father.

say: 'I have done them, and that is sufficient; if I keep them I should be tempted to do them again, and that would be worthless.' This was his attitude all through his life; he always counted on fresh inspiration, and never surrounded himself with the past as a support to the present.

At his school in St. Jean de Braye he did very well, and at the age of twelve he went to Orleans, where he won at fifteen a scholarship which took him to London for two months. This visit, in 1906, was his first experience of travelling; it gave him a decided pull over his school companions, and at the beginning of 1908 he won a second scholarship, this time of 3000 francs, to be spent on studying business methods abroad. His parents were very anxious that he should take to business. Some friends of theirs at St. Jean de Braye had a son who was already launched in Paris, and it was hoped that Henri might be able to join him; but Henri could never bring himself to show any zeal for a financial life, though for the next two years he still fluttered around the idea.

He went from Orleans to University College, Bristol, where he lived with Mr. Smith, one of the professors; and from this time on he was engrossed by his desire to draw. Already he felt that an artistic future lay before him, and he signed and dated all his drawings with meticulous care. His first sketch-book begins with a page of heraldic design, circling the name of Henri Gaudier; he saw his name repeated through the ages, it stood for the glory and honour which would be his; and this feeling was with him still in 1914, when he dreamt he had a studio with his name written up in letters of gold over the door. His continued interest in animals and flowers shows itself in this sketch-book, which he took with him on a holiday in Devon and Somerset, but of his swift certainty of line there was as yet no trace whatever. He holds his pencil with a bourgeois closeness, and it is astonishing how commonplace several of his drawings are. Two illustrations for *Omar Khayyám*, done about this time, are almost shocking in their lack of taste, and yet even in these there is no disguising his ability to convey with his pen a visual impression. He had become a square-shouldered young man, with short hair parted in the middle, and wore an upright collar, a small made-up bow tie, and clothes suited to a man of thirty.

By August of 1908 he was back in Bristol, and had begun a series of highly-finished architectural drawings; and in these, particularly in the signing of his name, the easy flow of his pen first shows itself. After a short visit to London in September he concentrated on copying the antiques in the Bristol Museum.

Towards the end of 1908 he was placed in the firm of Fifoot, Ching & Co., coal contractors in Cardiff, where he lived at No. 29 Claude Road. Mr. Ching writes of him in 1928: 'He was one of several

students who came to us, and while he excellently fulfilled the duties allotted to him, one could easily notice that his mind was not altogether in his work. Art undoubtedly occupied the greater part of it, and in his spare moments he was everlastingly, pencil or pen in hand, sketching some little incident that appealed to him. During his lunch hours he periodically walked across to the docks, and brought back with him a small sketch of, perhaps, the bow of a boat, or the elevation of a crane or tip, all of which showed genius. I encouraged him in this work because I felt that commerce was not his forte, and that he would be bound to leave it at the first possible chance. . . . In character he was somewhat Bohemian, and just a little casual, which was natural, but he was the kind of boy that one would have expected, if necessary, to have lived in a garret while he got on with his life's work as he felt it to be, and therefore you can imagine how disappointed I was when I heard nothing more of him (until you wrote) after he left our employ.'

Not only did he sketch at the docks, but he made the most elaborately finished drawings of birds, which he studied in the museum, or in Victoria Park, Canton.

On the 15th of April 1909, he left England for Nuremberg via Holland, where he went to stay with Dr. Uhlemayr; in his first letter to his mother and father he speaks of his arrival.

> 9 *Schlüsselfelderstrasse, Nürnberg*
> 20*th April* 1909

Dear Parents,

Here I am at last, after three days of continuous travelling, and not a bit tired. Dr. Uhlemayr and his wife are very nice people, and are a pleasant change after Cardiff. I sent cards to Henriette and to Renée* from Brussels, Cologne, and Frankfort, I wonder if they got them. Nuremberg seems to me to be a very lovely town, but I like England better than Germany, and if ever the English go to war with the Germans, I shall be on their side and will be delighted every time these 'pointed helmets' get the worst of it. Everything seems to be moving that way, and only last month, when Mr. Haldane said that the country was in danger, in less than fifteen days they had more volunteers than they wanted. All the same, perhaps I'm not very just towards the Germans, although they do deserve a big defeating to the tune of 'Rule Britannia, Britannia rules the waves'.

Dr. Uhlemayr speaks French very well, which is a great comfort, for I can speak hardly any German yet; but soon I will.

> H. Gaudier.

Dr. Uhlemayr and his family were among Gaudier's first sitters,

* Henri's sisters.

23

and he did several sketches of the Doctor with his violin, and one of the violin alone, which is curiously sensitive, and very reminiscent of Dürer; and it is characteristic of Henri's mind that the titles of all his sketches done at this time are in German script, a small instance of his thoroughness in acquiring knowledge : he always liked to know about everything, and by the time he was twenty-one was extremely well informed. He would instantly pretend to full acquaintance with things quite new to him, and it was this kind of 'boastfulness', as Miss Brzeska used afterwards to call it, which in 1911 prompted his reply to Epstein. He was introduced to him at an exhibition, and Epstein asked him if he cut direct in stone. Gaudier, who had never yet worked in stone, replied, 'Most certainly'; upon which Epstein said that he would visit him on the following Sunday. Gaudier rushed off, got three small blocks of stone, worked furiously all night, and had three original works lying casually in his studio by the time Epstein arrived.

Gaudier's sketches in Nuremberg and its environs are still of an architectural nature, but not so minutely expressed as those he did in Bristol—there is in them an obvious desire to be painting.

One day a Zeppelin came over Nuremberg, and Henri describes it to his father in a letter :

> *9–3 Schlüsselfelderstrasse, Nürnberg*
> *31st May* 1909

Dear Father,

Herr Doctor, Herr Gaudier, Der Graf Zeppelin mit seinem Luftschiff! Thus we were interrupted yesterday, bang in the middle of our lunch, by Marie. In the twinkling of an eye we snatched up the glasses, which mercifully were near at hand, and with one leap we were out on the balcony. There the most wonderful spectacle awaited us.

This balloon, floating in space, like the frieze and metopes of the Parthenon, defies exact reproduction or description. Picture an enormous long polygonal-shaped mass of a startling whiteness sailing two thousand feet above us. The propellers, murmuring like innumerable bees, made the canvas shiver along its rigid structure. The aerostat tacked about against the north wind, but unlike sea ships, which tack on a horizontal plane, it tilted itself upwards. It was all so full of life, vibrating with so joyous a sound and so harmoniously lovely in its setting that one could scarcely believe it a man-invented thing, but thought it some strange animal come from the higher regions of the air, prompted to look at us by contempt or curiosity. With the help of glasses I counted fifteen people in the front gondola and five in the back one; the last, mechanics no doubt. It had come from Friedrichshaven to the Alps, and so had done two

hundred and twenty-five kilometres when we saw it here, and it went like the wind—only a few seconds and it was gone. We put on our shoes and rushed downstairs, where we joined a great throng of people, half-dressed, who also hoped to see the Zeppelin a little longer. At last we caught it again just in time to see it sail over the mountains, a truly lovely sight. Its white, which had been so alive and gay, had changed to a mist, blue and airy, on which the elegant forms of its framework were delicately shadowed, the colour of light blue violets, so simple that it was one with the mountains over which it hung—and then it vanished in the air.

A memory remained, already faded; was it towards Bayreuth and Bamberg that it was going, on its course towards the north? I don't know yet, but, with Dr. Uhlemayr, we hope it will come back. It was so beautiful; not pretty, but beautiful, agreeing with the laws of Greek art and with nature, and what fun if only it would take us for a trip!

The children, Gunther and Walter, were delighted, and Walter, the younger one, aged five, hasn't ceased to look for it. After it had gone, he came to find me on the verandah, and said so sweetly, 'Mr. Gaudierlé, you must fly to catch the Zeppelin, to ask it to come back —I want to see it again.' 'But Walterlé, I can't, I haven't any wings.' —'Ach! You are a naughty Mr. Gaudier!'

We walked yesterday through the woods, which remind me very much of the forests around Orleans, to a fortified church at Gratshof, where a venerable *pasteur* was preaching. His hair and his long beard were pure white, his face beautiful and austere, and so religious a calm enfolded the peasants who were met there that it would have made a wonderful subject for a painting.

My German is getting on quite well, and I am very friendly with the people of the house. I frequently discuss art and civilization with the Doctor; *Kultur* they call it here. He is a good and simple man, son of a mountain peasant; was born in 1871, while his father was at the war, leaving twelve sons and daughters at home. His father-in-law got a bullet in his left arm at Bazeilles, and has never been able to use it since, so you see that the war wasn't all rose-coloured to the Germans either.

I kiss all the family—my love to you.

H. G.

Ezra Pound says that after he left Nuremberg he went to Munich, where he was employed on the manufacture of faked Rembrandts.*

Gaudier's stay in Munich made a great artistic impression on him; he started two large series of drawings relating to Munich life, and worked so hard (among other things he was learning Russian) that

* *Gaudier-Brzeska*, by Ezra Pound p. 49.

he began to have serious trouble with his eyes. He then returned to
Paris, which, as we have seen, became the stage of his revolt against
business life, and his new-found friendship with Miss Brzeska must
have contributed very considerably to his evergrowing discontent
with a life so little suited to his nature. To have someone to whom he
could open his heart, someone who encouraged his strong desire to
devote himself to art, gave him the extra confidence which he re-
quired; and he threw up an irksome job which he had taken with the
firm of Goerz, after leaving the bookshop where he had been placed
on his first arrival in Paris, and, as is described in the following letter
to his parents, accepted temporary work of a more congenial kind.

22nd June 1910

Dear Parents,
I have just seen Mr. Maurice—it seems that you are anxious about
me, and you think that I have run away abroad. I am safe and sound
in Paris, and hope to be here for some time yet. I've only changed my
job. I went away from Goerz without giving notice because they
would have made me stay fifteen extra days. I have now got a job as
a draughtsman for materials and carpets. I work ten hours a day and
get sixty centimes an hour [five shillings a day at that time], I believe,
I haven't been told yet, and even if I only get two francs a day I am
relatively happier, and I can no longer think why I was such an ass
as ever to go in for trade. I know that you will be annoyed by this,
but do for goodness' sake get it into your heads that I am an artist
and that nothing else holds any interest for me. At figures I am an
absolute nincompoop, and in a commercial life one must be inter-
ested in figures and in money. I shall stay here long enough to learn
the tricks of the trade, and then I think I shall go and work in Poland
or in Russia. Please don't write me nasty letters about this. With all
the will in the world I cannot conscientiously do any kind of work,
other than that of a sculptor of wood. Apart from this job I work very
hard at my modelling; the drawing here doesn't require any intellec-
tual energy, and when I get home I am still fresh and keen. I am free
on Saturday afternoons and Sundays, which is excellent.
 Love to all.

H. Gaudier.

In the meantime, Henri's and Sophie's health, far from getting
better, got worse, and Sophie went into the country to Royon. Henri
was not very assiduous with his textile firm, and often left it to
wander the streets, to observe people, to visit museums. He did odd
jobs here and there, and for some time earned a few francs a day as
a servant in someone's studio, but as these francs mostly went in the
purchase of prints and engravings, he soon became seriously ill for

want of food. He wrote to tell Sophie that he would come to her on foot, that his nose had taken to bleeding and that he was utterly run down. Sophie was afraid to encourage him; she had so often before been deceived in her affections and felt that closer familiarity might breed contempt between them. Apart from this, her own savings were so small, and her health so poor, that she could not contemplate looking after him at her expense.

His mother and father, who had a comfortable house by the Loire, were trying to persuade him to come to them, but he was stubborn. He writes to Sophie :* 'I told them I would not go. I would rather stay in the hospital than receive help from anybody whatsoever. I shall go and see them on Sunday week and let them understand I am going to stop a week, but I will not. I am quite decided not to give way. When I am with them they will try to get me into commerce again, and I would rather die than go again typewriting and making parcels—don't you think so? They seem to do it for love, but I cannot believe it. Anyhow, the matter is over, and I am in Paris, and will remain here, since you tell me not to go to you. I shall rather fight with the "harakiri" than to be stirred a foot out of my doors.'

Paris
4th October 1910

(To Dr. Uhlemayr)
Yesterday was festivity—to-day comes depression—I profit by it to write you a letter, for that will ease my heart.

The day of the *Mi-Carême* I carried on like a character out of Zola. I went on the razzle, and now to-day I repent and wish to be pure. After those violent joys—after such monstrosities I find myself in the most pessimistic state of mind, just ripe to deny that life holds any interest or happiness. My circumstances, which only yesterday seemed not at all unjust, appear to-day as bitter as one of those good wines turned rancid. I suppose that will make you laugh, but I assure you it's horribly true. This is what I have always noticed for the last few years since I learnt to look at life in a fairly abstract way, and became able to analyse my own feelings : with me every big pleasure, or rather, every big deviation from my usual life, is followed by a deviation in the opposite direction, and this is the reason for the pessimism and optimism which I hold in spite of myself. My natural state, my every-day feeling, is between the two. It is a succession of little variations, tiny contrasts, perhaps, but which all the same exist. I am never without a little joy and a little sadness. These small moments stretch out for several days, some cause or other favouring the intensive development of one of these two states, and this is what happened this morning after I had come home.

* Gaudier writes this letter in English.

As a rule, when I go to sleep I am glad to wake and see the day and look at a lovely engraving by Steinlen or a poster by Toulouse-Lautrec which I have, then I quickly get to work before I have to start for the office and the translations which prolong my material existence.*

To-day nothing of this.

I got in at six, tired, weak, annoyed with myself for having shouted all the afternoon in a 'rag', and for having wallowed all the night. I felt phenomenally lazy and depressed in spirit. To-morrow, however, that will be all right. Already I feel the change coming over me.

I have been reading Taine's *Philosophy of Art*. His theory does not seem to me to be very sound. It is true that environment does have an influence, but what has a much greater effect on the artist is love or hatred. He uses his settings to express these things—that is how I see it. Take, for example, Forain—the best of draughtsmen, in my opinion. This man has been made spiteful by the misery of his early years; he began his work in a spirit of implacable raillery against the customs and manners of his contemporaries; to-day the influence of his surroundings is modified enormously—he is rich. The setting has changed, but the artist has become even more intransigent and malicious than before. His drawings breathe the strength of a perfect anarchy. This powerful personality dominating its surroundings is a thing which Taine never explains. I do not believe that it is possible or useful to describe art in so rigorously scientific a way. To begin with, you lose the whole of the pleasure when you only look at a work to discover all the causes which went to its making—then art is so subtle and capricious a thing, so different in the hands of people who have developed together, that, considering the rarity of good work, one should find the pleasure it gives a sufficient justification for it.

I have started to read Bergson's *Evolution Créatrice*—it is an entirely abstract work, and so profound that I must study it carefully, and, above all, meditate about it before I can discuss it with you.

You will remember that last summer I deplored the lack in France of an illustrated anarchist review which should equal *Simplicissimus* in artistic value. This review now exists—it is *Les Hommes du Jour*, which for Art and Literature does what the *Guerre Sociale* does for Politics.

We are forming an anti-parliamentary insurrectional committee, who have in view a revolution only possible by force. Young people will come to us, and it is all that we need. . . .

You will think me very revolutionary. I am. Each day I grow more convinced of the necessity of a radical sweeping away—especially of

* Gaudier had gone back to work in an office.

machines, which must be utterly destroyed. It is mechanism which is now our master. To make matter obey him, man must abandon the wish to do colossal things. The other day I visited an exhibition of Japanese prints and sword-hilts. Since then I have not stopped proclaiming, in the teeth of opposition, that the yellow civilization is better than our own. Had it not been so they would not have so adeptly appropriated our infernal machinery for our own destruction. . . .

Miss Brzeska now persuaded Henri to leave Paris, and a month in the country brought back most of his natural vigour. Sophie was better, too, and decided to stay on in Royon all the winter. Henri, whose doctor would not allow him to paint, and advised him to stay in the country for another two months, implored her to come to him. He found her a charming little cottage not far from his parents' house, and after much deliberation and with many forebodings Sophie decided to go. There Henri came to see her every afternoon. He would arrive early while Miss Brzeska lay on her bed, a practice which helped her to digest her dinner. One day he told her that his mother was beginning to be annoyed by his daily visits; that she had accused Sophie of debauching Henri and so making him ill, and had added that soon there would be evil gossip among the neighbouring farmers. Sophie felt that there might be some reason in Madame Gaudier's vexation, and persuaded Henri not to come the next day, particularly as his visits occupied much of her time, and she was anxious to get on with a book which she was writing.

Next day Henri came as usual and said that he could not stay away, that it was so dull at home, that no one understood him, and anyhow, why should they be separated? Sophie was lying on her bed, and Henri, who sat in a chair by her side, got up every now and then tenderly to caress her mouth or her forehead with his lips. Although Sophie had never allowed him the passionate kisses of a lover, she did not feel that she need refuse him the indulgence of this small caress which he seemed so much to need.

While they were thus together there was a knock at the door; Sophie expected no one, but without getting up called out, 'Come in.' It was her landlord out of breath and red in the face. 'Come downstairs quickly,' he said, 'the police have come with an anonymous letter'; and before she understood what he meant, the police were in the room. With furtive glances at the bed, they asked her to read the letter, which accused her of using her house for the improper reception of men.

It seems that some farmer, who had unsuccessfully tried to rent the house in which Miss Brzeska was living, had started this scandal in order to revenge himself on the landlord. Henri and Sophie

were very much upset by this incident, and spent a great deal of time and energy, though without any satisfactory results, in trying to have the originator of this slander punished.

Henri's reaction expresses itself in a letter to Dr. Uhlemayr:

<div style="text-align: right">

St. Jean de Braye
11th November 1910

</div>

You will be surprised to see that I am in the country. I have been ill —anæmia—the result of all the energy I've put into this hateful battle for existence. All the same, I have won, for from the muddy channels of commerce I have risen to the less seamy realm of *Kunstgewerbe*. It is as a designer of fabrics that I now earn my living, and it is in this way that I shall continue through a long and tempestuous future.

But enough of myself—I want to speak of *la belle France*. It is indeed a lovely country, but the people who live in it are utterly degraded. Men more malicious, more treacherous, more miserly and grasping, you will find nowhere. I begin to establish certain maxims for my personal use : 'Beautiful countries are given over to savages.' 'Religion is a necessity to frighten ferocious beasts.' If our peasants feared an imaginary God, they would not act so wickedly. I have got mixed up in the most abominable affairs,* of which I will tell you later, and I have been able to judge for myself the value of a pure republican justice. I believe that my country has never before been in so advanced a state of decadence. The Latin race is rotten to the core. Its flag has become violet, yellow, and green, the colours of the putrescence which fills the romantic paintings of Delacroix, presaging storms, wind, destruction, and carnage. The French disgust me more and more by their idleness, their heedlessness, and their excess of bad taste—I have irrevocably decided to leave them to the Furies and to get quickly to the frontier.

I have tried to place caricatures in the Parisian papers; they took a few for *Le Rire* and *Charivari*—I don't know if they published them, but they paid well. I shall try again, particularly since my ideas become more crisp and precise, but there's the rub—at nineteen one is scarcely more than a child, and the battle is hard. One's line lacks snap and vigour, and one's outlook is narrow, there is a want of coherence. There are parts which seem free and original, and others which are full of outside influences and childishness. The editors see this clearly enough, and it is better for their papers, but it sometimes drives me to despair. Still, one has to sacrifice oneself a bit. One only has to take three vows; poverty, chastity, abstinence, and everything goes well. One leads the life of an ascetic, and art becomes the sole

* The slander against Miss Brzeska.

inspiration—and that is the only way to develop—by cultivating one's own innate powers....

Worn out and disgusted by persecution and injustice, they decided to leave France, particularly as it was almost time for Henri to start his military service; a duty he was determined not to do, his convictions as well as his character not easily submitting themselves to these years of slavery.

England seemed to be the most suitable country; for Henri, because he had already spent two years there, thought that with the help of friends he would be able to find work. Sophie, who believed in his glowing accounts of the English, agreed to accompany him. First of all, however, they went back to Paris, where they stayed for two months.

Henri looked for work without success, and Sophie had to provide rooms, clothes, and food, since he would accept nothing from his parents after the way in which they had behaved about Miss Brzeska.

They were not peaceful, these two months; Henri was nervous and irritated, and Sophie was frightened to find her small savings rapidly decreasing. There were many angry quarrels, with as many reconciliations, until at the end of 1910 they crossed over to London, where for the next four years, until Gaudier's death, these two were to live together under the name of Gaudier-Brzeska,* as brother and sister; each in his or her way passionately fond of the other, but seldom rising sufficiently above the daily grind of poverty to be able fully to appreciate each other's friendship.

* So far as I know, the linking of their two names into one was never more than a personal arrangement.

THE FIRST MONTHS IN LONDON

PART ONE

In London, Gaudier did not find work so quickly as he had hoped; his poverty-stricken boots and frayed collars frightened the few acquaintances on whose help he had counted. Sophie had drawn heavily on her savings for the expenses of the journey, and had to continue doing so to pay for the necessities of their daily life; this naturally alarmed her, because the precarious state of her health always made her desperately anxious to keep by her a small fund in case of need.

At one moment they were reduced to such poverty that while Henri was out, Miss Brzeska made a doll, took a shawl, which she wrapped round herself and 'her baby', and went to the street corner to beg. She collected sixpence in pennies, and with it she bought some bread, margarine, and tea; because Henri was fond of cakes, she also bought one small cake. When Henri got home he found an excellent tea all ready for him, and he asked Sophie how she had done it; she told him, and to her surprise he was very angry, saying that she must never do such things again. Instead, they visited the various public-houses of the neighbourhood, and Henri did drawings of the customers at a penny each.

At last, after two months of searching, during which they came very near starvation, Henri found work as a typist and foreign correspondent with a Norwegian in the City at a salary of six pounds a month. A month later Sophie got a temporary post as a governess at Felixstowe, in exchange for board and lodgings.

The two months in London without work for either of them, and the consequent poverty and worry, had exhausted her, so it was a relief to be in the country, though at the same time she was very anxious about Henri's health. He had no idea of the value of money, and quickly got through the six pounds he was earning, which left nothing for food; he had little rest, since his business occupied him all day, and his evenings were spent in drawing and study, so that he became enervated, underfed, hollow-eyed, thin in the face, and subject to dreadful fits of crying and anger. The doctor he had seen in France had told him that he would find it good for his health if he went occasionally to prostitutes; and Sophie encouraged this idea, even although it cost five shillings every time; but her economical

sense was outraged, though her heart was touched when Henri returned, having given the woman five shillings, and then been too disgusted and horrified to have anything to do with her.

He was very lonely when Sophie went away, and wrote her long letters full of love and affection. These letters give a very true picture of his life during the next month.

<div align="right">

C/o W. and Co.
22nd April 1911

</div>

Mamusin Dearest,

I expect you are feeling better by now—I know Pik is; he was very miserable yesterday, but he slept for ages the night you left, and last night, too. Wulfs* only came back yesterday evening at five o'clock, so you see I have had a quiet time.

I have disobeyed Mamus! I didn't go to the Park, but went to the Museum instead, where I found some marvellous casts of Michelangelo's study of a slave. I only worked from five till nine, and half an hour afterwards I was in bed. Yesterday evening I bought the frames (eightpence three-farthings each) and also a little brooch for sixpence—it is silver with blue enamel. I didn't choose one with brilliants, because they were very small and badly made—no use at all.

I have something very amusing—comic, rather—to tell you; the love affairs of the Jewess Rachel, the celebrated actress. It relates to the first time she lost her virtue. The Prince of Joinville, son of Louis Philippe, Admiral of France, had just brought home Napoleon's ashes. At a gala night at the *Comédie Française*, given in his honour, he saw our Rachel. He at once sent a message to her box with the words : *Ou? Quand? Combien?* to which the actress replied, *Ce soir, chez toi, pour rien*, and our two had a gay time.

And now for our own affairs. This morning I received replies [from J. A. Dickinson & Co.] to my advertisement of last week. They ask me to send them specimens of my work, and if it is suitable, they will give me a commission. So I am again going to disobey my Mamus. I shall work all this afternoon, this evening and all day to-morrow, without taking much of a walk, just as far as the river, perhaps. You must forgive me, Manus, because it would be stupid to miss a good opportunity. If I am successful it will be a help to you—so you see, you stupid little Madka! I won't write any more now, it excites me too much, and I must keep very quiet. I wish you the best of luck and health, and send you my blessing. Every day I say our prayer to the great sun, and he shines splendidly. I ask him always for endless benefits for Zosienka—that she may be happy, contented, sweet, and beloved. I send you a copy of the letter which I'll send to-morrow

* Wulfsberg was his employer.

with the drawing in reply to the advertisement, and also a Polish study.—Pipik.

P.S.—Dickinsons addressed me as 'H. A. GANDER'—*Mr Jars, mâle de l'oie en français.*

Zosienka Darling,

I am always the *p'tit blagueur français*. Having proposed to work all yesterday afternoon and all to-day, I only managed to draw from five a.m. till one to-day. I was dreadfully upset with Mamus's departure, and the move to new rooms, and then here I wasted ages hunting after subjects none of which pleased me. I have come miles out, far into the fields, and the lovely sun blazes. I have been very lonely since Mamus went away so quickly, but I am keeping myself well in hand. When I am in my new rooms, everything will change, and as I have heaps of work to do, I am sure to forget a little. What a curious thing life is : in order to have any peace at all, one must always forget. Don't you think, little Mother, that life would be marvellous if one were always allowed to remember? But for the moment we must work, and knowing this, I am sticking at it.

I went on with the study of form and the arrangement of Michelangelo's noted planes, but without discovering anything new; I only convinced myself that what I felt yesterday was true. There are always a dozen little 'kids' around me when I draw The Slaves. They are, no doubt, astonished by my methods, because I write as much as I draw; for a long time I look at the thing I want to understand, and then draw by system. What intrigues them beyond anything is that instead of drawing the fellow straight off, as they are used to seeing everyone else do, I draw square boxes, adjusting the sizes, one for each plane, and then suddenly, by joining the boxes with a few little lines, they see the statue emerge. They look at me with terror—with respect, perhaps—I don't know if it is because they find me so severe, or because of the drawings. Whatever it is, they amuse me highly. I believe, in the end, it is the drawing, because men respect and reverence, or rather fear, what they don't understand, and consequently what astonishes them.

When I tired of drawing Michelangelo—about eight o'clock—I went to see the Goyas. He is a Spanish painter—the first since Rembrandt who knew how to use aquatint with mastery. He did three series of engravings : *Los Capricos, Los Desastres de la Guerra,* and *La Tauromáquia.* Last night I only looked at the first two series. Mamus would delight in them, because although they are, for the most part, very scrupulous studies of life and movement; they are, at

34

the same time, real drawings, and are all impregnated with a very strong philosophy and sarcasm. In the *Capricos*, for instance, he has drawn the most outrageous things : an old woman, fat, abominable, naked, held by devils, who carry her in the air, and underneath he has written : *¿Adonde va Mama?** . . . The words he uses are so short, so strong, and so intimately connected with the drawings that it is impossible not to be bowled over with admiration. I tell you this, dear little Mamus, thinking that it will interest you, for it has thrilled me—I am quite captivated by it. The drawing is magnificent, and I believe that the best draughtsmen in this manner—Goya, Daumier, Gavarni, Toulouse-Lautrec, Phil May, Keene, Forain, Belcher—have been, or are still, the profoundest thinkers. So you see, we have heaps of lovely things to look at when we are together again in the winter : Japanese prints, French paintings, Belgian and German engravings, Goya, and many other things which I shall no doubt find. You will be quite confused by hearing of so much all at the same time, funny little Mamus; what with the orchids, the palm-trees, the drawings, you won't need Pipik any more, and to think you didn't want to come to London !

It is very annoying that I should have to reply to the advertisement just now, when I never felt so good for nothing, so empty-headed, jumpy, over-excited, and *zweifelhaft*. All the same, I have done a drawing, but as I have already told you, it took me from five this morning until one o'clock this afternoon. The little larks are singing all around me, and that makes me live in company with my precious Zosienka. You will see, little Mamus, we shall be happier soon, so have courage—for me particularly, as I am so easily depressed. I soon pick up again, but these sudden changes make me suffer physically very much.

Pik.

Still at 'Fifille'
25th April 1911

Pickna Zosienka,
You will scarcely be able to imagine the tremendous joy I had last night when I found your dear letter in my room; just like my beloved little Maman, I have been terribly over-excited and ill—although I feel a bit better now. It is strange that we should influence each other to such a degree.† Knowing this, I do everything in my power to be very quiet at these moments, I study the old masters, and so straighten out all the stupid ideas which upset my mind. The *zweifelhaft* worried me dreadfully yesterday. After taking all the morning over a drawing, I decided that I would go out somewhere in the after-

* The letter here contains many detailed descriptions of Goya's engravings.
† See letter of 19th May 1911, p. 42.

noon. But where? To the Tate Gallery? No. Museums make me sick. I should see nothing. To Kew? No, there would be such crowds there. Then where on earth? Perhaps to the Tate after all—no, I'll decide on Kew. All this took an hour at least, until, furious with myself, I took my head in my hands and shook it to bring back my wandering wits. I left for the train, and only at the station decided to go to Sudbury Hill, far away in Berkshire, in the west.

I saw the most magnificent country from the top of the hill—all central England, even the good old Blagdon Hills that I loved so much in Somersetshire; the South Downs as far as Portsmouth and, close up in the valley, Windsor Castle. Beyond all this, I imagined France lying far behind the Downs which fell away in front of me, and I was comforted, alone with the memory of Zosia, and with the phantasmagoria of Goya y Lucientes. The great beautiful sun sank to rest behind all the expanse of meadows and trees, and I prayed to him, the great artist, to make us prosperous. I should never be happy all day if I did not, each morning when I get up, kneel down before him and communicate with you, good little Mamuska. I am always very enthusiastic, but very weak, and this is why I need a beloved Maman, and a beautiful great God. We only follow the fine and natural religion of the ancients, and no one can laugh at us, for our prayers are addressed to a Being, true and real.

Do you know what I saw yesterday in the City? An old book by Emerson, in German, and the title was *Die Sonne regiert die Welt.* If Matuska will allow me, I will buy it later, but only if I can't find it in one of the libraries, for I already possess too much. I notice this particularly during a removal, though I am getting on all right with this one. Already I have half my things at Sterndale.* The rest are tied up here, and after three more journeys there will be nothing left. To-night I will sleep in your bed, and this will pleasantly crown the memories of this happy week. I shan't need a man to help me move the box, which we are destroying, and I shall have enough pennies to last me until April 30th, which is Sunday. I shall be bucked if W. pays me on the 29th. He probably will. I put myself out for Wulfs much more than I have done in other places, because I am fond of him, and so I work conscientiously for him. He is trying to get a certain job in order to do in a filthy pig of a 'business man', a hideous liar, woman-hunter, and rotter; so, sweet Mamus, you will pray for Wulf's success, won't you?

Don't be too disappointed that I haven't been learning Polish, and that we haven't spoken much. We will discuss all these things in our letters. We have been together for so short a time that we are quite justified in letting ourselves go a bit. We have so many things to talk about. At Kew, for instance, we could only talk of the flowers and the

* 39 Sterndale Road.

trees, and when we stayed at home there was so much to say—Mamus had to tell all that happened to her at Felixstowe,* and since that Tuesday Pik has seen little of her; so you see, sweet dear, you must not get anxious.

I promise you, Mamus, to look after myself better next month. In addition to the two pints of 'Lolo', I will eat raw eggs every day, and if I can get it, some raw meat too. Although I may control myself ever so much, I can't possibly promise not to be an enthusiast —it would be impossible. For that, I would need to see nothing, to read nothing, and never to think. I must get stronger, I agree, but it must be a relative strength, don't you see, my little Mamus? For certain things I shall do, as I have already told you dozens of times, I shall follow my instinct, and think as little as possible about them; and, little Mother, don't worry about the drawings, nor about your writings. You see that advertisement may easily lead to something, and now that I am feeling better and have not got to think again about changing my lodgings, I shall, through the help of the *Architect*, get to know other people, so that, without having an Abbey— you greedy kid—we will at least have a little house, or even a little flat for the two of us. The little Mother is, of course, an excellent housewife, and she must have her little nest. Is it in order to powder her nose? Pik isn't so ambitious on that head, although it is true he is just as keen—for his greatest joy would be to have a studio, also for powdering—people—in plaster!

Let's keep up our spirits with the big sun as our guide. You know Pik is very, very young, and Mamus is young too—we will have time to do such a lot.

Heaps of love, kisses, and sweet things to you, poor love. I will get better all the time now, little Zosienka.

<div align="right">Pik.</div>

<div align="center">Tes énormes fautes
horrible petite gribouilleuse</div>

'lui laissant le charge *de* gosses'—des gosses.

 un nombre vague, indéfini (il peut en avoir 10 comme 20, 30).

 Par contre, *de* 3 gosses—*de* quelques gosses, *de* plusieurs gosses.

'je suis forcée d'avoir des mioches' :

 c'est très bien là—pourquoi pas dans le 1er cas? *étourdie*.

la nature n'est pas *magnanime* mais *magnifique* :

 magnanime—seulement pour les individus.

'loin *de* méchants h . . .,' *des*—comme pour gosses.

abaye—abbaye.

* During her visit for an interview.

Beloved Maman,

First of all, I must give you a good spanking for having wished to go away from Pik so soon. She doesn't want him to work for her, she would like to earn her own living—stop there! Madama, it is high time that you settled down; you have collected quite enough material by now to construct something, and it is impossible that you should go on any longer dragging from place to place. I am very young, and I ought to study, but while doing so, I will earn a little. If Mamus would only consider her Pik as part of herself, she would not talk of being 'kept'—as if it were a question of two different people, of a fellow who had a woman for his kitchen and his bed. No, it is a question of art, and I'm your Pikus, as you know. I shall be desperate if you really wish to do what you say in your letter.* It is this splendid sunshine that has puffed you up with enthusiasm and recklessness. At heart you are still poor little Madka, who needs a good Pik to do all in his power to aid her to realize her wishes; he will do it, so give him your promise. Pipik takes your advice, you know, whenever it is possible, and today he took his first sunbath. We are a couple of miserable little insects—for I also thought he would shine just because we worshipped him—who is going to whip us for our presumption? Between you and me, I think it is the only way, all the same. It is lovely weather—magnificent—a most delicious springtime. The lilac is in flower in the gardens, and each evening I inhale deep marvellous scents which put me in a frenzy. You are quite right about my eyes; they used to say to me in France— mother in particular—'Why don't you look like everyone else? You have the eyes of a wicked madman. People will think that you want to steal something,' etc. And, certainly, it is true—and it is the Soul that I wish to capture.

Now let's talk about art. You say that it is monotonous to see [single] statues standing or seated.

We have :

> Victory : Standing
> The Slave : „
> St. John : „

and these are the best.

You are bungling the whole thing when you say that design and colour do not require much thought. It is only as a result of knowledge and ability that simple things are discovered. Philosophy is inherent in man. It comes long before these exact expressions. We always come back to the same thing, belovedest, that beauty can only be arrived at through truth of form and colour. It is not a scrap of

* Miss Brzeska was looking for a permanent position as a teacher in a school.

use theorizing in front of a mass of modelling clay. Life must come out of the clay by means of its external surface, and this is the *design*. If you discover fine design, it will bring with it life, and herein lies Art. No one will shake my belief in this. Conceptions, subjects, are but the frames of pictures—secondary things on which one should not count.

It is true that before beginning even a portrait I should know what the work will be, but if I am unable to render what I conceived, people will say that I am not an artist—thus art does not lie in the dream, but in the marriage of the dream with the material. Work, always work. And in order to work well you need a big intelligence, and that is all I can tell you, little Mamusienka.

réalisme

néoimpressionisme

I have been reading about the Neo-Impressionists. They are, like all artists, very idealistic : too idealistic I think—mystical and not at all independent. They are like Christian savages of the Middle Ages. Their principle is that drawing (painting, sculpture, architecture) should not represent such and such an object, but by means of some indications should convey to the mind the memory of a form, heighten the imagination and make you think of the thing represented. Example : a laughing man : they would not draw the features, but only make you think that the man laughs. This is a decadence, because they are mixing painting with music—an art altogether idealistic, since it exists to evoke, nothing else—while the rôle of drawing is to be pleasing to the senses in giving them something palpable, solid; in

other words, in giving a representation. If the representation is of a living thing and if it is true, it will be alive, but under no consideration should one imagine that it belongs firstly to the soul—that is a false trail. One's fingers should feel delight in touching the undulations of a statue, the eyes in beholding a painting. Philosophize after, to satisfy your humanity, but not before. In Art one must absolutely respect its limits and its logic—otherwise one arrives at nothing worth doing. The great masters are there to instruct us, and I wish to remain faithful to their tradition.

la maison de Rodin à Meudon

I heard Keir Hardie, the great English socialist—a magnificent old man—very enthusiastic. He was holding an open-air meeting in Trafalgar Square, and spoke of the exploitation of the miners by the owners of the mines. I'll send you the sketches I did of him and a little revolutionary pamphlet, copies of which were distributed.

I write in haste this evening so that you will get it to-morrow morning.

I beseech you, little Mamus, to forget what you said about plans for next winter. I do absolutely wish to help Mamus, and she ought to accept, otherwise it will be I who can do nothing because of the torment I shall be in on your account. Be a good little Madka, and since we so affectionately promised to live one for the other, you *must* accept. Poor little Mamusienka, you have made me very sad and I shall worry myself all to-morrow, poor devil that I am, and shall be able to do nothing.

<div style="text-align: right">Pik.</div>

Keir Hardie
Traf. Square
13 mai 11

HGaudier Brzeska

14th May 1911

I write again, little Maman, because my heart is very full. I feel very discouraged by your queer tone of independence. Up till now I have gone happily to business with the delightful vision in my mind of making it possible for little Madka to work quietly during the next year, of making her happy and of finally giving her this miserable little home that she covets. This evening she herself upsets everything.

Why, oh why, do you say such things to me?

I can't prevent myself from crying and upsetting myself dreadfully. I won't feel light-hearted in the City any longer, for I shall regret the sculptor's chisel so much more. Anyhow, everything looks black at this moment, when outside all is so beautiful, and I ought to be feeling stronger; it is another gift of the moon, I half expected it —the thirteenth of the month—a pinch still of superstition! I don't care much for myself—for my poor, broken carcass, so that it re-

quires something more than my own personal comfort to enable me to sacrifice myself to office work. For this I had my darling Zosienka, and now she won't allow it any longer, becomes disagreeable, and, for low-down, shabby questions of money, capable only of interesting hideous middle-class people, she gives me pain. I implore you on both knees, dear Maman, as the only creature who loves me, for the good of us both, to promise to think of yourself as a part of your Pik; otherwise, in spite of himself, he will go to the dogs through depression and disgust, and through all the devilish horde of troubles which upset his health. So for your own sake, you must absolutely stay, Zosienka. You can't go away from Pipik, I implore you, darling. I am an ass to upset myself like this, I know it; but these things make such an impression on me at the moment. I forgive poor Mamus, because she hasn't done it on purpose. Perhaps it was only by a kind of modesty or politeness—I understand my little Zosik—but she ought to be my own madka, for I am nothing but her pik, belong only to her, and am ready to sacrifice everything in order that she may feel better and be able to work—if she fails me I shall fail too, for I shall be incapable of doing anything. She will call me capricious—but I am not, Maminska, it is because I love you and I don't want to suffer for nothing. If I make myself stupid at a typewriter, I desire at least that Mamus shall profit; unless she does, I shouldn't have the strength to keep it up.

I got too upset last night, for I was very tired. My English colleague had gone away on his holidays and I have to do all his work—that is why I have written this sentimental tirade to-day. As it is wet, I have stayed in my room, reading and resting, and I understand better now what little Madka means—but Mamus, you must not compare yourself with Sarah Bernhardt, for she is stronger, she does not suffer as you do, and is not tormented by illness every month. Already this week you have had to stay in bed three days : Friday, Saturday, and Sunday. Think it over. I will be very quiet for your sake, poor little soul, and don't refuse Pik's aid, because he is your own boy and not a vulgar outsider. Darling, do write to me as soon as you can, for I I shall be frantic, what with this and the awful heat that we are now having in London.

Pik.

Friday, 19th May 1911

Adorable Maman,
Surely poor Zosienka is in pain, for since mid-day to-day Pik has suffered from every ill. What with a headache and a hideous stomach ache I listened so badly to what Wulfs was saying that I have had to do over again a third of my correspondence, which isn't exactly a help since I am all alone to do everything. I've been upset

since about two o'clock yesterday, when things started going wrong, and this morning I broke the big white jug from my room. It happened when I was in the bath : the old fools have turned out the bathroom, and taken out all the planks leaving only the bath. It's been like that for a week, and Pik has refrained all this time from having a sponge down. But this morning, because he felt more rotten than usual, he went into the bathroom—the beastly affair gave a great shake while he was pouring water down his back, and it made him jump out of his skin.

I dropped the jug, which broke into atoms, but happily did not cut me. What would have continued this litany of accidents would have been the second print in the Goya book—'The Pig has broken the Pitcher'—but there was no Mamus to beat Pik's bottom with a slipper. I shall keep very quiet for the rest of to-day, to-morrow and

Sunday, for since there is such telepathy between us, we must be sensible, mustn't we, Mumsie dear? We so often gain by it, that when we don't, we mustn't complain; it shows that we love each other in a perfect way, that our souls and bodies make one—Mamuspikus—so let's be happy, very happy; Pipik never expected to be so loved, and neither did little Mamuska.

For several nights I've dreamt about my beloved Maman—such lovely things, like the dreams of quite little children : little Mamus, magnificent, radiant with great suns all around her, bending low over Pik to bless him—and the sentimental Pikus, who always takes the mask to bed with him, wakes in the morning kissing it, in the belief that it is his real Maman. He gets up at once, washes and then says his prayer for Mamus and himself—with the sun so pure, he can only pray after having purified himself of dust and dirt, and then, naked, he adores; clothes are not creatures of the sun—only our bodies. I love to pray thus before so great a god, for I become one with my beloved and that fills me with voluptuousness.

43

Before that I had several nights of ugly dreams—that is, ugly afterwards, for I had 'enjoyment' during these nights. Pik had horrid temptations with stupid women, and once with men : he even committed the act with them, but he doesn't remember if that gave him pleasure. He was always very annoyed with himself when he woke, and washed three times as hard as usual, for all these things are repugnant horrors sent only by the moon.

All the time and quite regularly I am learning Polish, and by next winter I shall be able to read, for already I can manage without difficulty little things on the history of Poland and those stupid conversations at the end of the exercises. . . .

Evening

Dearest, if I said that you must come to me while you are writing the 'Trilogy', that was only so as not to shock you, because you would never let me say 'for always' on account of my sculpture; but I desire, and absolutely must see, that this Trilogy is written and written well. Even if for that I have to sacrifice art, study, everything, in order that Matka may work, I will do so—that's all I wanted to say to my precious Mamusin.

Now it's understood that when little Mamus grows old Pik will look after her as if she were his daughter, and will always adore her. While he has a drop of blood he will fight for his Mamus, just as his Zosienko will do for him—so don't let's torment ourselves any more—anyhow, I wrote that *tartine* because I was enormously tired and these obscenities all came to upset me, but last Sunday's letter has put all right. I am much too sensitive a chap, have too much the characteristics and manners of a schoolgirl, and Mamus must often scold me—but you see, Matka, it is being obsessed by art which leads to these stupidities, for art leaves no room to cultivate secondary ideas—so give me many 'thrashings'.

I am very sad also about Delannoy's death.* I am very fond of his way of drawing : it is strong, and now I understand why his latest things weren't so good as the first ones, it's because the poor devil was ill. I have most reverently put by the portrait; it's rather weak, but all the same one can see that he had character. You see Mamus I'm right again : that a fine and noble artist must also be a simple, good, and beautiful man. I will never give this up, and you can cry out that it is presumption to judge by a face, quoting the proverb *il ne faut pas juger les gens sur la mine*. It isn't presumption, but knowledge and judgement—humility is no good, you know that quite well, and preach it yourself, poor old Mamusin. Let's pray to the beautiful sun for Delannoy.

Dearest, the mistake you make is to confuse 'expression' with the

* Aristide Delannoy, born 1874, died 5th May 1911.

44

successive appearances of the face. Expression, as I tried to say, is the sum total of the vices and virtues of the whole [inner] life which shows in the aspect of each individual. I might no doubt say that one person has more expression than another if his enthusiasm, his anger, his passions are more lively in his face, if there is more sarcasm or gaiety in his laughter and more sadness in his tears; but that laughter and those tears are mere accidents caused by nervous excitements, in the course of which the whole expression is not changed, but coloured, or, if you like, veers towards a note of gaiety or sorrow. When I say that Mamus changes her *expression*, I only mean that her gayest laugh follows her blackest woe without transition, that her nervous excitements are so great and so varied that her real, innate, unchangeable expression, that of a good and energetic little mamiska, is constantly taking a different *colour*. When you laugh or cry you do not cease to be the little mamus.

A loathsome personality—like that pupil of yours for instance—can laugh, make pretty faces, or work herself up as much as she likes, her *expression* doesn't change, you still see her filthiness show through her coarse lips, her vileness through her low forehead or her ill-shaped nose, her stupidity and malice through her eyes. That is what expression is, and it can certainly no more be distinguished from features than the soul from the body. Now little Mumsie speaks without really thinking of all these enormous possibilities. It is true that a man can and does change the appearance of his face, as also his body—unconsciously in most people—and that this change directly follows his ethics. When Nero was young he was attractive to look at, but through debauch, slaughter and cruelty, he developed a bull's neck, hideous eyes, and a wicked mouth, thereby stigmatizing on the outside all that was within. How is it that depraved men and women develop these eyes, lips, and noses? They weren't like that when they were young, and if they had kept themselves from vice they would not have grown like that. One sees this side chiefly, as more people go from virtue to vice than from vice to virtue.

Now for statuary, I like best the 'Jean', I admire Michelangelo's 'Slave' for its magnitude, because heroism, creative energy, astonishes me; the Samothrace 'Victory' because its poetry pleases my senses; but I don't really understand one or the other, although I often make out that I do. I can't look at them for long without getting tired; but Rodin's 'John the Baptist', on the other hand, would hold me for days on end.

My aim has always been to convince you that a chosen subject may be very well executed, but, for all that, doesn't make a work of art. I agree, Mamus, absolutely agree so long as this subject has been lived—like your Trilogy, for instance—which is a very good subject into which you can weave many sensations; but never introduce

purely legendary incidents. Beware of your imagination—make it serve you to a good end by mating it with your observation, your knowledge of real life, true things that are beautiful because they exist. As I have told you, its conception is natural, it stands by itself as a portrait, so that's that. A St. John by Rodin is a subject, an old woman is a subject, a man with a broken nose is a subject, everything is a subject; but it has no need to be an old woman dressed up in the garb of mythology; indeed, it ought not to be; *finita la comedia*.

You are certainly right in saying that the beautiful and good are innate in the Primitives—yes, but they are very weak, and civilization must develop them so that ethics and æsthetics become their product. We find the truth of this not in savagery but in civilization. The savage acts by rage, vengeance, hatred; in a word, he is natural and spontaneous, he has no laws, it does not matter to him that his daughter should do as she likes, she is probably his wife and many other people's too. The rich Greek makes a law—he thinks of his fortune, his power, which he does not wish to lessen, and so he forbids his children to ally themselves with others, on pain of death, since this is the only thing which will stop them. This is criminal, not savage—it is criminal not because the death penalty is brought in, but because a man takes it upon himself to dispose of the liberty of many others. There you have civilization, and just as I hold no brief for a civilization which admits slavery, human sacrifice, etc., I do not wish a system of æsthetics, equally false, based on so absurd and illusory a thing as line. Line is a bar, a limit, an infraction of liberty, a slavery—while mass is free, and can be multiplied infinitely, treated in a thousand ways. It leaves me free, and on top of all that, it is true, it exists.

Æsthetics are certainly a product of civilization because one judges an epoch as much by its Art as by its customs; one wishes to see the level certain people have reached in their rendering and their comprehension of the beautiful. Our taste in all this has been falsified by a badly understood tradition which has always taught blind adoration of the Greeks and the Romans. Certainly they reached a high level, but we can and do arrive at an equally high degree without imitating them, *sklavisch nachahmen*. In my opinion the St. John is more beautiful than the Venus of Milo, for I understand beauty differently from Phidias and his followers. He is a beggar who walks along, who speaks and gesticulates—he belongs to my own time, is in my epoch, he has a twentieth-century workman's body just as I see it and know it; in a word, it's a lovely statue. I like it better than the others, because I believe that Art should be seen in the present, looked for in the present, and not in the past. I keep my head high before anyone who reproaches me for not having 'seen' the Greeks. 'Sir,' I would say, 'had you made me then I would have been able to see them';

but it would be my greatest shame if anyone could accuse me of not being able to see what was around me. I should have no excuse.

Mamus feels all that instinctively, and she has never asked herself why she does not place her novel among the knights of the Crusades. It would, of course, be ridiculous, and it would be equally stupid for me to draw according to ideas which came from the minds of antiquity, and which were brought into life by circumstances which are not in force to-day. That's what I want to arrive at and to hold until the end—that in art the sentimental subject has no place, and any imitation of a past time is an enormous fault. Flaxman added nothing to the human collection, for he imitated Phidias. Stevens nothing, for he imitated Michelangelo. If to-day we have only beggars, let us only sculpt beggars; if subjects suitable for gigantic paintings no longer appear, don't let us do gigantic paintings, for our successors should not be able to accuse us of having falsified our age. My belief in the eternity of life (but on this earth, in the breaking-up of life's forces to renew itself) makes me count it a crime to lie in this way, because I am surely also made of the past which I must respect, and of the future which I should venerate, since it is more important.

Artistic vision, sensation if you like, is not called forth because some picture is labelled 'The Battle of Hermann', in which Romans and Germans kill each other, but by some beautiful form which it contains. Now what I object to in such representational subjects is that the artist, not having been in it, cannot convey all the artistic feeling; his work lacks interest, and to gain ground he indulges in theatricalities and sentimentalities : in fellows who bleed, in children with torn throats, in women who cry, etc., not to mention the sweeter sides. Imagination exists to help us understand the present, not to create things of herself. I talk now like Mamus for the pleasure of talking, not to convince her, because at heart she is already convinced. If she had not this sense of the contemporary, this appreciation of art in immediate things, this working from the present in which alone I believe, she would not write a novel which is beautiful and vibrating with life though tragically true, but one full of soft beauties (of a knight Jehan who kills another knight at a tournament for the hand of a *damoiseau beau et gente que sera son noble épouse*.) She can speak thus of mythological things, stories which are in other people's worlds, but in her own world she would not dream of doing so, and in Pik's it is utterly forbidden to express anything other than that which is real. That, little Mamus, is what makes the greatness of Phidias and of Michelangelo, they did not represent Egyptians nor Gauls but their contemporaries. Rodin will be as big a man for the twentieth century as Michelangelo is for the sixteenth—but you must not compare one with the other—do you see, Mamuska? Yesterday I drew 'St. Jean' for you, and here it is. I would certainly pre-

47

vent Mamus from writing rot; that is to say, things without sense because unreal and out of date; and on her side she should save me from presumption (since she finds it in me) and from unreality.

I enclose you a drawing* which is worth ten thousand times all the Prometheuses because it is alive, its forms are right, as I have seen with my own eyes and felt in my own soul.

I need to discuss; but little Mamus is always saying to me; 'Modesty, modesty'. I am modest, but not humble; that is a Christian stupidity; I know what to do, and when I do something really good, or even fairly good, I say so without hesitation; but I see my faults, and the proof of this is that when I do something bad I burn it. Mamus jumps with rage during these *autos-da-fé*, but they must be, for none of this piggish trash must remain. You say, 'Pipik, perhaps you may make a mistake and believe a bad thing to be good.' Impossible in a drawing, though not in science. I may make a mistake in a calculation, but I see at a glance if the completed thing is good or not; there is an instinct inside me. To be modest is not to be puffed up— tell me, Mamus, have I ever boasted of myself as an artist? Never any more than you—this thing is so sacred that we would not dream of sullying it. I draw firstly out of love, then from egoism, and I wish that it should be good out of dignity, so as not to offend myself first and afterwards others, but so long as I do not offend myself I'm blest if I really care.

Beloved,
I don't want to accuse Uhlemayr before being quite sure that he hasn't replied.† I haven't yet been to see at South Kensington. Usually Uhl. does not write more than once every two or three months. I don't think he would be so rotten, and I hope for the best. ——, ——, and —— are idiots and I shall give them a miss, and if others act in this way I shall ignore them also—but always and in spite of everything I shall be pik to matus, just as she will be matus to pipik, although he is capricious, unstable in his thoughts, changeable in his ideas, but only superficially—at heart he is solid, about art in particular.

It is already eleven o'clock, and I have been writing and drawing for you during four hours, dear Zosienka, and I am happy, content, and quiet, although ill; but since you, poor dear, are ill too, I will not make things worse by grumbling—if the 'old boy' wishes to *couler qu'il coule*, *'et l'on s'en fout le tire re lire re lon'*, etc. Just as at the Panthéon—you remember those 'rags'!

* Drawing of little old seated woman, since lost.
† Dr. Uhlemayr had not written to Gaudier for a long while because at this time he was extremely busy. Gaudier feared that he might have been offended by the Gaudier-Brzeska arrangement.

I will bring anything you like, and I will have enough cash at the end of the month to come to you! Pik must be economical; since the most stupid fools can manage on tiny means, why shouldn't we, who are more intelligent than all of them?

There is a market in Leadenhall Street where they sell dogs, cats and birds. I go there, and I love to see the tiny dogs amusing themselves; it is much pleasanter than the heart-rending slaughter-houses of Whitechapel, with hideous Jews. When you write on Monday tell me what you think of Keir Hardie and of the pamphlet I sent. I hate those swine who upset you, and I pray the lovely sun to send them to sleep by its heat, so that you shall be left for a little in peace, poor darling.

<div align="right">Your own Pik.</div>

<div align="center">PART TWO</div>

<div align="right">*Sunday, May* 1911</div>

Beloved little Mamus,

It's you who are a stupid old boaster—what paradoxes you do fling at me!

'The true artist neither desires to be nor is aware of being one.' That is equivalent to saying that Michelangelo, a great artist, never knew that he was a better sculptor than Desiderio da Settignano or Giovanni de Bologna, who were his contemporaries, and that he could only do his Slaves well 'without being aware of it', and this after he had spent years in making studies to get into them the greatest possible amount of life, of rich modelling—or that Shakespeare never knew that he wrote far better than Marlowe or Milton,* and that his arrangement was always unconscious—or again that Rodin doesn't know in his heart that he is bigger than the others. Blast it all, if he hadn't known this he would never have struggled for so long. The truth is that a great artist is conscious of the talent and the power he possesses, otherwise he would not see his faults, and so would not be able to improve.

You ascribe strange laws to beauty—that's because, like the early Christians, you believe that the soul is separate from the body, and that pushes you to say that expression is a different thing from features. You give the paradoxical example of two people who have similar features but different expressions. What are features—what is expression? The features are a certain composition made by the nose, the mouth, the eyes of an individual, the expression is the sensation

* *Sic.* Shakespeare died before Milton had published anything.

which is thrown off by these features; now if two people have practically similar features, their expressions cannot certainly vary as much as if one was beautiful and the other ugly. It would only be possible if the features, although apparently similar (that is to say, the form of the nose, of the mouth and of the eyes), were *really* absolutely different (composition). The profane would say: 'See two people curiously alike,' and the 'wise man' would deny it to the last. As I have told you and will always maintain, the expression is inherent in the form and colour, and made by them; to arrive at it one must model and colour *truthfully*.

You say that Rodin's 'Old Woman' is ugly because shrivelled. It is age, and it seems to me vicious to generalize over life and beauty. A strong, vigorous man whose arms have been cut off is ugly; a tree fallen in the full plenitude of its life is ugly; a slaughtered lamb is ugly—because all that disturbs the design of life is ugly. An old man, decrepit (not disabled, for that is unnatural, a man with a wooden leg or crutches being ugly), is beautiful; a body, which has died naturally in old age, is beautiful, a well-set-up child, a sound man is beautiful, and Rodin's 'Old Woman' is beautiful—for beauty is life and life has three phases: Birth, Maturity, Death, all of which are equally beautiful. The forms of this Old Woman are lovely because they have character, like your hands, which are lovely; and just as you cannot see your hands as other than having character, it is impossible for you to speculate on what the statue might have been had it been void of character.

You talk of an artist's 'aim' and 'pleasure', *Life*, you say. But it is so in the essence of man, in his being, that in truth he has neither aim nor pleasure, but a *passion* to accomplish in order to accomplish, and where look for subjects if not in '*Life*' (since as I understand it there is no opposition between life and death), since only life surrounds us?

Now to get back to the Greeks and the beauty of the Greeks. I see that you won't give up your blessed lines. The 'Victory' is beautiful, not because its silhouette is abominably weak and monotonous, but because the masses of which it is composed have sufficient truth in their disposition to give the sensation of many rhythms: life, movement, wind, water, which are pleasing to the eyes. Phidias' statues are beautiful because the planes are well disposed, but the manner in which the work is done, the insipid draperies on the 'Three Fates' with their mawkish lines, are absolutely beneath consideration. Phidias' most beautiful statue is the Ilissos, and he at least has not got sweet lines, concession to an animal voluptuousness of the basest and most barbaric kind. True voluptuousness springs at the same time from the soul and from the body, and two people who love, and perform the act, will naturally have more pleasure if they have bones,

muscles, nerves, furrows of skin to caress, than those who have soft contours to press against, for in this latter case the human body would become mixed with the cushions on which it reposes.

Line is nothing but a decoy—it does not exist, and although the Greeks are praised for having put it to so good a use, I—and you can call me presumptuous—am sure that it has nothing essentially to do with beauty. There are few things so detestable as the Venus of Milo —and exactly because she is no more than a line enjoyed by pigs— an enormous stomach if you like, without lumps, without holes, without hardness, without angles, without mystery, and without force— a flabby thing made of wool, which goes in if you lean against it, and, what's worse, makes a fellow hot. Then in God's name tell me what hands could be more abominable than those of the Venus of Cnidos : tapering hands, butter fingers which flow without joints, without phalanges, without tendons, and with which she hides her *cucu*, that marvellous thing, that wonderfully divine delight? I loathe Praxiteles, for he, better than any other, has rounded the angles and levelled the depressions : stumps of marble very polished, very sweet, Mr. Praxiteles, Sir Scopas idem. But these are not men, only well-oiled corpses which one has set up; and they give pleasure because they are corpses, they are not forms which can give a local rhythm, do not evoke the base or the sublime, have no vibrating life-force; and that is why all the Greeks, with the exception of Phidias, Polycletus and Lysippus, are nothing but vulgar hewers of marble.

Your code for an honest life is conventional and was acquired by legions of individuals in the past, a perpetual adaptation to the needs of the moment. For Plato it is perfectly right for a father to kill his daughter if she does not wish to marry a particular person, or his son if he does not obey him : to me this is odious, and in the same way why should I, in æsthetics, necessarily be obliged to accept certain parts of their laws which to my senses are equally horrible and seem to me to be nothing but relics of barbarism?

That the Greeks were entirely right in balancing the masses, in studying planes and rhythms, yes, it was in this their grandeur lay; but that they were equally right for form in general, sweet lines, suave mouths, little feet, big breasts, no; there was their mistake, and I see no reason why I should adopt such ramblings. I understand beauty in a way which I feel to be better than theirs, and history and observation convince me that I am right; that is why I am so enraged against their damnable lines which have falsified people's taste, even that of my own little Mamusienka. Michelangelo has not manifested life in all its aspects, far from it. He has taken one aspect, and that without *desiring* it, but because it admirably served his technique— that is to say, the latent life of a man who thinks before acting : David, Night, Dawn, Evening, and Day, the Slaves, all without a definite and

positive movement, all undecided. Rodin has put into the St. John what he saw in his beggar, with less certainty it is true, because he is not perfect, and life is.

The single statue is the only true way, standing or seated, whatever you may say about its monotony. The greatest masters have only made single statues, groups are always inferior; that is why Carpeaux, big though he was, is less so than Rodin, for he never knew how to make single statues. He did not know how to find his rhythm in the arrangement of the shapes of one body, but obtained it by the disposition of several. The great sculptors are there to prove this. Think of the masterpieces which we like most, all standing or seated, and one at a time, and they are not in the least monotonous. The connoisseur loves one spicy cake, but the glutton requires at least six to stimulate his pleasure.

The great thing is :

That sculpture consists in placing planes according to a rhythm.
That painting ,, ,, colours ,, ,,
That literature ,, ,, stories ,, ,,
That music ,, ,, sounds ,, ,,

and that movement outside any one of these is not permitted, that they are severely confined and limited, and that any incursion of one into the domain of another is a fault in taste and comprehension.

Now Matka is far more presumptuous than Pik, for she will never admit herself to be in the wrong. Although the stories would never have been published in February, she still repeats to Pik that if he had subscribed, as she advised him to, she would have seen in the January number the advertisement which she has just read, asking for contributions by the end of May; yet if, having subscribed, she had seen it, she would have sworn the most foul oaths; for she would no longer be receiving the paper when the stories were published in July. Oh, you wretched little Matulenka, I did very well not to subscribe from January. I have always believed and thought that it would take at least three or four months to correct the answers and to distribute the rewards. Mamus has always mocked at me about this, we even had a row over it at Edith Road; I remember only too well, and in the end who is right? Mamus, naturally ! Eh, you beloved old stupid ! Prepare yourself to receive a spanking at Pentecost—learn from to-day how to lift your petticoats properly. Apart from that, I pray the sun, most fervently, to help us and to bring us a prize, even if it is not the first, in July when the results are published.

To criticize your work : Mamus is too bitter against men—males in general. The really intelligent have always taken women into their

confidence, it is only the vulgar who have despised them—see Julius Cæsar, Napoleon, Ulysses (if one is to believe Homer), Michelangelo and Colonna, and nearer to us, Curie.

Tell me that you will be pleased that Pipik should earn some money so that you can write your Trilogy, and tell me what you think about the question of Line—think it out logically and you will see that beauty doesn't depend on it in the least.

Devotedly, Pik.

Saturday, 3rd June 1911

I am at the Museum, Mamus dear, and here is a sentence by Rodin himself which exonerates the presumptuous Pikus, and plunges the poor *vieulle* into outer darkness : 'only one thing is important in sculpture—to express life', etc. ...

I have just got your letter, beloved. I must speak of Rodin first. You—you do nothing but blaspheme—that's the worst of you literary fellows : you judge everything by your own little standards.

I shall always maintain tenaciously that Michangelo was wrong in his mannered proportions which make 'supermen'. That's an unfortunate word which I don't like. If a man is imperfect you qualify him according to his merits, base, brutal, false, otherwise he is perfect— but if he is a 'superman' it must be that he is inhuman.

Paradox—you reproach me with it, but little Mamus, it's a way of amusing oneself which is no worse than wit and lying, and is more cultivated and with Pik quite natural, he curbs himself tremendously, but all the same it often darts out. It is funny, Mauclair is worried by just the same thing in Rodin, he says that all aspirations of the sculptor to be simply realistic are paradoxical—but my only feeling is that you idealists, with possibilities stretching before you as wide as the universe, take immediate fright at the idea of limitation and combat it. Our sculpture is limited—it is a mathematical art—if we take off a millimetre from ten there only remain nine; if you take a line out of a chapter it wouldn't be missed. To make reliefs *tell* you must exaggerate the forms—that is the logical upshot of our discussions and it shocks you—you say that it's a paradox. Poor little Mamus will again say presumptuous little ass, lunatic who is always reverting to old ideas, etc., but, Mamus, I cannot possibly get away from them, they are instinctive and necessary. I must deduce things mathematically, for in my head everything unconsciously takes the form of a cube so many centimetres wide, while in that of my little Mamus everything is a long vaporous trail. That sets up a balance; beloved Matka must always strain after ideas and be cooled down by the concrete outlook of her Pikus; Pik should sedulously force himself into form and be warmed by the ideas of his good little Zosienka.

So I'm very pleased with this *Wortstreit*, it does us both good.

53

Matka is on the side of Mirbeau (sometimes), or Mauclair always, and of Anatole France, Marx, etc.—they are great in literature, Pik is on the side of Rodin, and asserts that sculpture is far simpler than what these vain theorists?????!!! keep repeating over and over again.

I was in bed, and got up to shout you down. Will you please understand, dearest, once for all, that beauty does not lie in oily lines nor in the sugared accents of the voice. It's a mannerism in Mamus to find everything in herself ugly 'because people have always said so.' You must judge for yourself and let others be damned, but I know that deep down you don't really think yourself ugly. I don't know enough about music to be able to say whether or not your voice is true —but I love the dear voice of Maman, it is rugged and tempestuous, but alive and full of feeling, it expresses all the loveliness held in her dear heart and all the ideas in her little head—it is infinitely varied, as are all beautiful things, it changes completely with her changing moods, with her pleasure in Pipik or her rage against him, but above all it is sincere, and sincerity and truth are beauty—that is why in statuary the true copy of nature (not the servile one) is beautiful. Leave me in peace, you, with your oils and your flabby flesh of reverend academicians—remember that on their side is the woman with big breasts, and that on mine you will see her bones and her muscles. Beauty is character, truth, nothing else. This *bura* is now finished!

I have thought a great deal about the *Studio* and you will rant against my want of courage, but it is childish to waste one or two hours of one's precious time, and a penny, which is the important thing (we are poor and already my little toothbrush hasn't any hairs left), and to fuss oneself to death for fools that I have never seen. I'll have the most fulminating rows with fellows who know me, people who may be moved, but with the *Studio* . . . who will read what I say? Some kid who opens the letters, and it will only make him laugh —it isn't worth it. The world is corrupt, and the way for me to make it better is not writing letters, but joining my efforts with those of others to produce a work of beauty. If Mamus wishes to write herself, let her, for she is better at cursing than I am; also it will give her practice, it's part of her job. To me it is most profoundly repugnant.

I shan't be sending any more German exercises, we will do them next winter; at present Polish is as much as my head will stand, and as I've been pretty poorly I've not even done this since Thursday. It's most regrettable that this disgusting moon drives me to all sorts of things.

Yesterday I bought two little copperplates for engraving, 3 frs. 50, but if I had had your letter I should have spent 3 frs. 50 in quite another way—I should have sent them for Delannoy's portrait. But

all is not lost. Instead of going to Richmond on Sunday, I will only go to Battersea Park, and so save about 2 frs. 50. On Tuesday I will post the order and tell them to send the portrait direct to Mamus—it will be a souvenir of the anniversary of our love, and of the birthday of the charming Zosienka. I want this letter to bring you every tenderness, specially distilled in my heart for the 6th of June, the day which gave you birth.

The beastly moon is up, as I have already told you, and it has scarcely brought me luck : on the contrary everything is rotten. Not only the 'old boy' comes into the game, but also my nose has been bleeding. . . . Anyhow I do practically no work, eat very well, have a bit of a headache, am as irritable as the devil; but all the same happy, since the sunshine is lovely and Matuska beloved and good. She must not get at all worried because of these accidents—it will probably get better bit by bit.

You write in your story, *Qui sait si à un moment donné elle n'aurait pas pris un gros bonhomme . . . et qui sait si à un moment donné elle ne s'est pas fait immensément de mauvais sang à cause de cela.* Poor dear Matka, you must indeed have suffered to have let yourself go so completely—but you must not think of it any more now—you see you have a rotten little Pikus, and the warm sunshine caresses us.

I must impress on you once again the mathematical side of sculpture. Take a cube—it is beautiful because it has light and shade—now here is a collection of cubes which delights me—I can inscribe the body of a woman. It is not beautiful because it's a woman of such and such a type, but because it catches the light in certain ways. If you want to dream in front of it so much the better, but you must on no account tax the sculptor with having primarily wished to express vice or virtue. His first wish has been to make a beautiful statue, from a material point of view. What puts you people wrong is that the most characteristic types are represented by the most beautiful statues, and for this reason. Christians and Pantheists may insist that the soul is separate from the body, but this is not true. There is a live body, that is all. Now if the forms are fine in the sense of refined it is because they are allied to a fine and refined moral life, and these exquisite forms reflect an exquisite light; and the result is a beautiful statue. You are the compiler not I.

I long to make a statue of a single body, an absolute, truthful copy—something so true that it will live when it is made, even as the model himself lives. The statue has nothing to say—it should only have planes in the right place—no more.

You make a dreadful mistake in trying to compare Shakespeare with Rodin, it plunges you into an inextricable confusion, for one is a writer and the other a sculptor. You are wrong too, because Shake-

speare didn't invent his subjects, he took them as settings for his con-
temporaries, *überzeugt* that man does not change throughout the
ages. Queen Elizabeth might well have served as model for Macbeth,
and when you read *Hamlet* or *Othello* you don't for one moment ask
when or where they take place, because they are true for eternity;
and why? Because they are pure, they aren't muddled by painting or
music—they are nothing but literature. It is only these adulterations
which are dull. One quickly tires of Zola because he has mixed them
all up, and his work only applies to a certain class of people, to a
given period, and is not eternal. In the same way a man is disgusted
with his body after sexual relations, or with his entire being when
he is morally diseased.

Now for Baudelaire—I like him just because he has sacrificed the
fugitive to that which endures. He encloses his idea in a severe form,
the sonnet, and puts nothing but the essential, that which will remain
for ever. When the principal features are expressed the secondary

ones are easily imagined; if only the secondary are given, the principal ones are lost. If they are both given, then they lose in intensity and one can no longer distinquish. It is a law of art which applies to all its branches. To the first group belong Michelangelo, Rodin, Shakespeare, and Baudelaire, to the second all bad artists, and to the last, devils like Dickens, and Walter Scott. Now I like Baudelaire and Chopin, for as I have told you music should only express those mysteries which sleep in the deep recesses of our hearts; and if I am a complete being I am satisfied, for I have different pleasures. I am sensual, voluptuous, materialistic in front of a statue, drunk with the play of light and with the harmonious or discordant colouring before a painting, I think profoundly when reading a book, and when listening to music I dream and am exalted. You, you don't know how to enjoy, for you don't recognize differences, and judge always on a basis of your literary idea—which is fundamentally impossible, for whatever you may say, your sensations are different when you read or when you listen to music or when you look at statues—different at their root, of a different species if you like; and these differences form our taste, which will be proportionately heightened in accordance with the profundity of our differing sensations.

It is no use for Mamus to waste herself in theories, for she lies to herself all the time. All that she says consciously is at war with her talent, which comes from her unconscious self. It's of little use for you to bewail the periods which have gone by without art; and here let me tell you, if there are periods without great artists it is that they were not sufficiently interesting to come into the history of art, and we ought not to worry our heads about them. You write what you know about, what you have lived—you blame yourself for only writing your Trilogy because you have suffered, and because that so burns within you that you cannot choose but tell it. So much the better, for had you not this living idea you could do nothing, you would write historical stupidities without any life. Notice, a point though—in your Trilogy you could call the characters by Greek names, place them in Aulis if you liked, that wouldn't alter it at all; that is only setting, as in the case of Shakespeare; it is the fugitive, the famous 'local colour' which should be sacrificed to the universal colour, inspired genius??????!!!...

In Art one must exaggerate; as the sculptor deepens a depression, or accentuates a relief, so the writer accentuates a vice, diminishes some quality, according to his needs; and it is only here that the imagination comes into play. Grandiosity, sublimity and luxury with which you overwhelmingly reproach me go with that necessary exaggeration of the facts which helps to secure greater truth, and that is what I mean by a well-thought-out copying of nature.

Mamus really must think more deeply, she is too superficial in all

that she says, it's because the poor little one has never grown accustomed to look at different things in different ways—she muddles them all together, and that's why I ask her to be more careful about her style. . . .

I went to Kew yesterday afternoon and had an absolute orgy of beauty, and was happy that Mamus was seeing things even more beautiful. It is very hot, and I have but little courage. I'll do some drawings in the morning, and in the afternoon I'll go out again— probably to Kew, for I can make sketches of lovers who roll in the grass—you know how. I've been very lucky lately, for I've seen some lovely creatures—two superb women dressed so lightly that one could see their big bodies without corsets and their breasts small and well-placed on either side of their chests. One was a Hindu and the other, I don't know, probably a Russian, but certainly not English; and for a man, again a beautiful Hindu. He had a mouth so delicate and voluptuous that it looked like a ripe fig burst open in the sunshine: he had scarcely any clothes on either, and only the thinnest of vests covered a most marvellous chest. He walked like a tiger, proud and haughty, with eyes that flashed like steel. I think he was the most lovely man I have ever seen, the sight of him made me wild with pleasure; and, would you believe it, the English, with their hideous mugs, laughed like idiots as he went by. In this country it's a kind of crime to be beautiful. Pik would have loved to kiss that lovely mouth.

I have found some more coincidences with Rodin—he sees statues in the clouds, in the old trunks of trees, in flowers, vases, insects and birds, in the bodies of women—just like the Mamus! Now, don't be too proud, you rotten little Matusienka.

Pik.

Wednesday evening, 14*th June* 1911

Dear adored Mamuska,
I will arrive on Thursday morning, 22nd June, 11.1 a.m., at Felix-stowe Town (I'm getting a five days' ticket, costing 7/6) and will leave on the following Sunday evening, at 7.33, so that I shall have three nights and four days with you, my own beloved. It was thanks to you that I got four days. I was going to ask my boss for them bang out when a good wind filled with *kruczki polskie Zosienkie Brzeskie* blew in my ears; and without showing it, but looking a picture of innocence, I asked Wulfsberg if we were going to have Friday 23rd, the day after the Coronation. I knew quite well that we should, but I wanted to make him speak, and I fully succeeded—'Oh yes, Gaudier, it's only a question of Saturday—we will shut on the 22nd and 23rd—are you going to the country?' 'No, Mr. Wulfsberg, I ought to

58

go to Paris, and you see if we have Saturday it will give me four days, otherwise only two.' 'Well you know I'm very pleased with you and you've worked well, so I'll give you from Wednesday evening until Monday morning.' I said thank you, and off I am to Paris—Felixstowe—to see the Mamusi—it's all the same so long as it contains the Mamus. I'm so pleased, for the air will do me good—I'm about in the same state as I was last year when you came to Combleux. I couldn't get out this evening, for yesterday I caught a cold coming back from the country, or perhaps it was only because I am so run-down, and to-day I've been very unhappy—always *la bas*—I smelt bad and was afraid the others would notice it. I often went down to the wash-room and upset myself thoroughly. I'll go to bed at 9 and will get up and go for a walk from 5—8 to-morrow morning like Mamus' good little Pikusik. I've got lots of things to tell you about Mrs. Harriet Beecher Stowe, whose centenary is to-day—also about modern Tokio. I'll write all that to-morrow. Goodnight, Mamusin—I'll have a long sleep, and rest in your arms for the night.

Thursday morning

I haven't gone for a walk, for I have only just woken up, and it's 7.30. It was little Mamus who put me to sleep, dear gentle Zosia, and I feel much better than yesterday, fresh and rested, and I'm in a delirium of joy that in a week from to-day I shall press to my heart the real little Mamus of flesh and bone. I'll pamper her no end and make her very happy—we will wander along by the edge of the sea, we will bathe in the swift waves—at least Pik will, very early in the morning when there is no one about—what orgies of nature we will have together! It is so beautiful that it is almost unbelievable after the sordidness of this dirty old town. . . .

'People still recall Mrs. Stowe during her visits to England as a pleasant little lady with corkscrew curls and a quiet dignified manner. She had an earnest religious manner, *and took her mission as a writer very seriously and had little taste for the lighter social graces. Her highly-strung nervous temperament and habit of absent-mindedness made her adverse to crowded receptions, and she was content to leave most of the talking to her amusing and jovial husband, who had a fund of racy New England anecdotes.*' There is a strong analogy with Matka in her face and in her constitution too; see how she writes of herself : 'a little bit of a woman somewhat more than forty, about as thin and dry as a pinch of snuff—never very much to look at in my best days, and looking like a used-up article now.' This was at the moment when she wrote *Uncle Tom's Cabin*, one of the most decisive books of all times, for it played an eminent part in bringing about the War of Secession and the emancipation of the American negroes. You see Mamus is just the right age, '40', and the right appearance, 'thin

and dry', to write a book just as decisive, but better literature, more beautiful than hers. Have courage, little Mamus, it will come, work hard and I pray the good sun every day to bless you.

I will talk about Modern Tokio another time, for it's already late this morning and it would take too long. With regard to my making up to the old women, arrange just what you think best. I'll do exactly as you like, for Matka shouldn't be made to suffer because of these idiots. So you will decide whether or no you need introduce me to them, etc.—feel quite free and Pik will behave superbly, even to praising to the skies their pasty colour!

Remember I leave London at 8.10 on the morning of the 22nd and should be at Fel. at 11.1. The train will probably be half an hour late, so don't get worried.

Pikus.

P.S.—I think that as I am coming next week I will bring the Grammar book instead of sending it this morning for 3d.

For the last week I've looked every day in the *Morning Post*,* but there is nothing—At Whitsun there are many demands for London, but as I've told you already you must apply in person.

I kiss you passionately, my sweet Mamusienka, on your lovely mouth and on your impish eyes—I fold you to me in gentle affection and hope that you will be quiet and calm during your illness.

Saturday, 17th Evening

Poor beloved pet,

I was sure last Thursday that you were ill. You see I caught cold on Wednesday evening through lying out on a bank in the country. I was ill all through the night, and the next day was a kind of martyrdom, as I bled again and got enervated, so that it's probably all my fault that Mamus is ill. I'm better to-day, but in the night was much worse. God, what a horror all this is, but let us hope that some day it will all go away, my dear one; we will be strong and healthy and able to work. I also am happy and pleased to come back to be nursed in those dear maternal arms and to be able to cheer up my dear companion a little. I have lots of news—I will tell you 'of how' one day I ran into —— and his Jewess in the middle of the street, 'of how' he came to see me the next day, and I reproached him for all his rottenness to us and said that I would never go near his Jewesses. 'They have never liked you,' he said with *naïveté*. His editor is a fellow who knows 'Simpson', the artist who did those two fine advertisements for 'Oxo', as well as the man with a black hat and red feather. Simpson has seen the —— Magazine and admired Pik's drawing, and wants to know Pik and see more drawings. So I gave —— some posters and

* For a situation for Miss Brzeska.

some drawings to hand to the editor fellow. Let's profit all we can—
he is rotten and I'll be generous with my rottenness to him—I want
to give Mamus a nice companion for the winter. The old beast sug-
gested starting again the *leçons françaises* but I absolutely refused
him. He has no dignity, for if he loves his Jewesses he ought not to
speak to me again after all I said to him about them. He doesn't seem
to notice it. He hopes to have drawings for his magazine—the blood-
sucker—you wait, old fool—I shall know Simpson and that's all.

<div align="right">Pik.</div>

<div align="right">

Richmond Park
18th June 1911

</div>

I am very anxious about Mamus although she says she is better and
not worrying. The same worries I had on Thursday came again a
little while ago (about 11 o'clock), I very much fear the same will have
happened to poor little 'Tulienka'; I hope I am wrong, and anyhow
I'm keeping very quiet, not exciting myself, thinking of nothing but of
the happiness we'll have next Thursday. I have been lying out in the
full sunshine for the last hour, and now I am going to change my
place, for laziness is bad. In some ways I look ill, for my eyes and my
cheeks are sunk, but on the other hand I have a much better colour
than before. I am getting quite sunburnt, and Mamus will be pleased.
Since she asked me not to, I have not been to the Museum and have
done hardly any drawing—each evening I've gone into the country,
except the other day when this *choroba czurta* prevented me.

I shall only have 5 or 6 shillings after paying for my ticket—if you
want me to come, little Mamuiska must get some pennies—if you
think we are spending too much I won't come—think it over seriously,
and I will do just as you please.

<div align="right">Pik.</div>

<div align="right">*20th June* 1911</div>

You see, I've told everyone that I'm going to Paris; I really can't
borrow anything from anyone here, for they would say, 'How's this?
He's going to Paris, and he hasn't a halfpenny—he has to borrow';
and then they won't think so well of me. It's stupid, but they are
idiots, and I must act like them while I am with them; poor little
Mamus knows that well enough. Send me a form with a note to the
Post Office where you are known—but just as you like. I will come on
Thursday at eleven. I am enjoying it in advance, but am holding
myself in so as not to make myself tired.

Last night I had a great mouse-hunt. I caught one—the dirty little
beasts made a disgusting noise all night, and did *pipi* in my saucepan
on the sly. I guessed that they were probably hiding in my old rags
hung in the cupboard, so I shook them and two filthy she-devils fell

out. I only caught one, but as a punishment drowned her—I upset myself dreadfully in running after her. I went to bed at 8.30 and had a long sleep. This morning I'm a bit better, but I have a dreadful headache, stomach all upset, and still frightfully tired. The air of Felixstowe and the company of dear adorable Mamusienka will soon put me right.

I kiss you a thousand times and hope you are well. I'm sorry to be bothering you about these stupid money matters—I *do* lead you a dance.

<div align="right">Pik.</div>

LIVING TOGETHER

A quick series of postcards altered all these arrangements. Pik suddenly thought it would be better to go to a place nearer London than Felixstowe, and told Zosik that he would make inquiries. On Wednesday, 21st June, she heard from him that Southend was a good place, that she was to find rooms, and expect him the next morning. She took her ticket, but heard in the train that Southend was a much-frequented and noisy town. Nothing in the world would induce her to go to such a place, and at the next station she darted out of the train and implored the station-master to tell her of a spot which was both small and quiet. He suggested Burnham-on-Crouch, saying that it was a quiet little yachting centre, very beautiful without being expensive.

In her carriage was a young girl who came from Burnham, and she told Miss Brzeska that it was several miles from the sea, but all the same there was a salt-water river, where she would be able to bathe. It was unbearably hot, and when Miss Brzeska got out at Burnham, she was so overcome by the heat and so flustered by her journey that she forgot her luggage in the train, and went away with only her handbag and food-basket. Stunned and stupefied, her face so red that she looked as though she were drunk, she wandered about the streets searching for a room. In some houses the people did not like the look of her, elsewhere there were numberless children and dirt, and again in others the prices did not suit her. At the end of one little street she saw some green bushes, and instinctively went towards them. There, in the shade, she took off her shoes and stockings, which burnt her feet, and refreshed herself with fruit out of her basket. About six in the evening, when it was slightly cooler, she again took up her search. This time she found rooms in the house of two old maids, and next day Pik joined her. They bought their own provisions, which their landladies were to cook for them, and which these women stole most flagrantly. When Sophie tried to convey to them, by little exclamations of surprise, that she saw what was happening, they put on the table a large silver mug whose inscription proclaimed that it had been won by their brother for his honesty!

While they were at Burnham, Pik did his best to persuade Sophie not to try for another post, but to come and live with him in London. He told her he wanted her all the time, and that he had no one to speak to after he left his 'damnable box of an office'. It was surely

sufficient, he said, that one of them should groan under the yoke; and if he had to submit to this 'business', which he loathed, he would at least like to have the satisfaction of feeling that he was enabling her to be free. Sophie had only about eighty pounds left, and she felt that this must on no account be touched except in the case of some real emergency; but Pik explained that to furnish a room they would need so little, scarcely more than a bed.

'What do you mean, a bed? Are we not two?' cried Zosik.

'Yes, but I will sleep in a hammock.'

Zosik protested that this was insanity, that no one could sleep in a hammock.

'What, no one? Aristocrats, perhaps, or middle-class folk wouldn't, but I'm an artist, and artists must lead a Bohemian life and not make themselves weak by comforts. I tell you, I shall sleep in a hammock, or if need be on the floor, so you need not count a bed for me.'

Zosik said that she would need a bed, anyhow, and also tables, chairs, and a cupboard.

It was now Pik's turn to protest :

'What, tables and cupboards ! Why not heavy armchairs and carpets right away? If that's your idea of an artist's life, I pity you; a table and two chairs, perhaps, but even that is not necessary.'

'Oh, of course not. We can eat off the floor.'

'Well, why not? We can buy a few sugar-boxes, which will do splendidly.'

'But with winter coming on we shall need blankets, we cannot sleep in newspapers.'

'Pshaw,' said Pik, 'there are four months still before the winter comes; by that time I shall be earning more money as a draughtsman, and we shall be able to indulge in these luxuries.'

In the end, Sophie was persuaded, but first she made him promise not to put her in a rage—she was weak and nervy, and did not want to ruin her health after having more or less established it at Felix-stowe.

'I promise you, on the faith of an artist, to be a good Pikus to his Mamus,' said Pik, and the matter was settled.

The sunshine and the enjoyment of their first freedom together in England were too exciting to allow of arguments, and they had four lovely days together, bathing and running in the fields. They overdid it, of course, and their health was no better in the end. Zosik threw herself about and jumped in the water as if she were mad, and Pik ran round far too much in the heat. The river water was dirty and unhealthy, and once Pik fell into a ditch of green, stagnant mud, which gave him rheumatism.

Before Pik left, it was decided that Zosik should stay on at Burn-ham until the end of August, and that he should find suitable rooms

for them in London. A week or so later, he wrote to say that he had found two splendid rooms, far cheaper than they had anticipated. They were seven shillings a week, and, what was more, his boss had raised his pay from six pounds to seven pounds a month, so that in future they would be rich, and able to live together in comfort. He asked her to come at once, and said he would meet her at the station.

Sophie started, full of misgivings. How would it be? Would they get on any better than in their first Kensington rooms? As usual on important occasions, she became nervous and superstitious. She told herself that if he met her at the station it would augur their happiness; if he didn't she would know that she had taken a wrong step. At the station there was no Pik to be seen. She waited and waited, and then decided to look for him; and so, with all her luggage, trundled round the noisy station. After half an hour she was in despair and went to the waiting-room, where she stayed patiently for some time. In the end she got annoyed: she began talking aloud to herself, and the other women in the waiting-room looked at her as though they thought she was possessed. Pik finally found her, having himself searched for her during the last hour.

Pik's enthusiasm and gay excitement were, however, in no way daunted, and Zosik had to go round then and there to see the new palace. There was no gas, a smoking lamp lit the stairs. The rooms smelt and were dreadfully damp. Sad at heart, Zosik returned to sleep in Pik's room, while he went out to buy himself a deck-chair and slept at the new premises. Next day he went along to see Sophie, enchanted with his night's rest; the chair was lovely, he had bought it in the King's Road for five shillings, and you could see by the marks on it that it had already made long voyages; it had even been to India.

In the afternoon they went out to buy a few necessaries. Henri always knew best about everything, or so it seemed, for he was of a very decided nature. Sophie was trying to get a clean secondhand bed or a cheap new one.

'Why on earth do you want to spend a pound on a bed?' cried Pik. 'It's crass folly, middle-class luxury. In one of these streets I saw a notice advertising a bed and everything complete for five shillings.'

Sophie suggested that at that price it would be 'walking'.

'Anyhow, we can go and see,' said Pik.

The man in the shop said if was hardly a bed for a lady to sleep on—it had no springs, and the mattress was worn.

'You can, at any rate, show it us,' said Pik.

In an old, dilapidated room where the boards squeaked and sagged they found a huge *bahut de famille*. An enormous bed, *délabré*, *égratigné*, which a hundred years ago had been new. The brown sack which called itself a mattress contained a few handfuls of rags which

65

flaunted themselves at their ease in this tattered cover, giving the most distressing qualms as to its cleanliness. The idea of sleeping on such a *grabat* gave Sophie a shudder throughout her body, but Pik had energy for two and said :

'We can take it, it isn't dirty, and, anyhow, one wouldn't sleep on it without spreading a cloth.'

'How can we tell who has slept on this bed?' said Zosik, and the shopman hastily replied that he could guarantee that nobody nasty had been in it—his wife had taken gentlemen *en pension* and now they wished to let unfurnished rooms, so the bed was for sale.

'There, you see, Zosik,' broke in Henri, 'take it. We're so poor. We need other things as well—we shall never find elsewhere anything so cheap as this.' And as he saw Sophie hesitate, he said with an air of assurance : 'Well, I think we'll take it.'

Seeing the business settled, Sophie wished to get the thing a little cheaper, but Pik, with a lordly air and a cutting look, told her to be quiet with her saving of pennies, for it was cheap enough already; so that it was with some difficulty that she managed to have this ruined structure delivered without further charge.

They installed themselves that day—a small table for Miss Brzeska's work, two chairs, the deck-chair, a tub, and the famous bed made their complete outfit.

They soon found that their hoped-for little Paradise was a regular hell; there was a garage immediately outside Pik's room, and a chicken-run outside Sophie's. Sophie was particularly upset by all kinds of noises, and this situation soon drove her to a frenzy, greatly aggravated by the discovery of bugs in their rooms. On top of this, after three days Pik could stand his deck-chair no longer, and confessed that he could not do with another night of such torture. He was ill and tired, and as it looked as if they would soon be leaving, Zosik was against buying another bed, which would have to be moved, so Pik had to share hers. It was a strange loading—these two in this ancient sarcophagus of a bed, bug-ridden and held together by bits of string. Across the threadbare mattress by the wall Miss Brzeska had put her old travelling-rugs, sewn together and padded with what she could find, while Pik lay on the bare mattress at the foot on a lower level. Nights of torture; for with every movement each disturbed the other. The days were no relief, for there was a continuous noise, and horror of the dirt made the place seem worse than a thousand hells.

In a couple of weeks they moved to a house in Paulton Square, but conditions were not much better. They were dreadfully underfed, Zosik cooking all the food on Monday—meat and potatoes and herrings—to be eaten cold for the rest of the week, augmented by milk and bread in small supplies. It is little wonder that she found life a

constant irritation, and one quarrel culminated in Pik's throwing a herring at her. He was horrified by his action, and there was a most tender reconciliation. Throughout all this time Pik never complained, but was full of exuberance and excitement over the future. He was often touchingly attentive to Sophie, and with the money which she gave him for his fare he would bring her flowers and other small surprises.

Each month Pik would hand over to Zosik his seven pounds earned in the City, and as they endeavoured to spend each month a pound on things for daily life, cooking utensils, etc., they were often at the end of the month left with absolutely nothing, save the untouchable savings which Miss Brzeska held in reserve.

Their enchantment knew no bounds when they made their first friend. It was now October 1911, and they had been in London for over nine months, but had found no one to speak to. One day, outside the Victoria and Albert Museum, they saw a man who looked like an Indian, and Henri felt attracted by him. A few days later they found themselves together in the vestibule of the National Gallery, and all looked at each other, but were too shy to speak. A week later they were walking to the British Museum, and there was their friend ahead of them. Pik again hung back, but Zosik went to him and said that her brother was so anxious to know him. He was delighted, and they arranged for him to come to tea on the day after next. He was an Italian from Verona, called Arrigo Levasti, and he came very often to see them, for he seemed as lonely as they were. Then Pik, feeling it was wrong to hold anything from a friend, told him that he and Zosik were not brother and sister, and Zosik added that so far there had been nothing but a platonic love between them. Pik immediately said, 'That's not true,' which throws an interesting light on Henri's character; for later on, when they were to relate their history to Katherine Mansfield and Middleton Murry, he again made the same statement, adding that he and Zosik had often slept together. It shows that although he and Zosik lived together as brother and sister, he was ashamed for anyone to think it who knew they were not. After this their Italian friend's visits became rare, and by Christmas had ceased altogether, so that they were again left without anyone to talk to.

At Christmas Wulfsberg gave Pik five pounds as a Christmas-box, and Pik's first action was to buy Zosik a small porcelain oil-stove on which for several months she had set her heart. At the same time Pik's pay was raised by two pounds a month. In consequence of these sudden riches he and Zosik arranged to spend the following Saturday in buying Pik a trousseau, as he had had nothing since he came to London. They got a suit for twenty-six shillings, and Pik, ever so pleased to be so smart, thanked Zosik for getting him the suit. She

67

found it very charming in him to thank her for buying him something with his own money.

He was always full of enthusiasm for the future, but Zosik's mind was of a matter-of-fact order and could not easily take in Pik's quick flights. For instance, he had a habit of lying : he said that lies were interesting and quite indispensable to an artist; she believed in what might be called a boring truth. This led to many disputes. Also Henri was very definite; everything with him was positive or negative, and the less he knew about a thing the more emphatic he became. Naturally his ideas would often change, and Zosik, with her added twenty years, did not always make allowances for this. Whatever you asked him he was always ready with an answer, and made it with such assurance that it was impossible to contradict it. Next day he might be just as emphatic in an entirely opposite direction.

Out of his 'Christmas-box' Pik sent ten shillings to his youngest sister Renée, and his letter to her shows the simple quality of his nature and his enthusiasm for art.

<div style="text-align: right">

45 *Paulton's Square, Chelsea*
28th December 1911

</div>

My dear little Renée,
You will be tired of waiting for news of me, but I was hoping to receive Henriette's letter which Papa said was coming, before I replied. I send you a little present for your birthday, and this is how you will get the money. Go to the post-office the day after you get this letter—tell them your name : Renée Gaudier, and when they ask you who is sending the money you will say : 'Henri Gaudier, 45 Paulton's Square, Chelsea, Londres, S.W.' Don't make a mistake and they will give you 12 frs. 25 to 12 frs. 50, for it is ten shillings and not 10 frs. I am sending. Perhaps you had better ask Papa or Henriette to go with you. When you have got it you should give a little to Henriette so that she can bring you from Orleans a block of white paper (folio), there is some very good at the corner of the Rue Jeanne Darc and the Place de la Cathédrale at 40 or 50 centimes the block—a bottle of Chinese ink (marked J. M. Paillard) at 60 centimes—a penny-worth of good nibs (Gillott) and a nice new penholder. On top of that give her 1 fr. 50 so that she can buy you one of the series *chefs d'œuvres illustrés* or *Maîtres de la peinture*. She will get you *Puvis de Chavannes*, and if they haven't that, *Giotto*, and if they have no *Giotto*, then *Botticelli*, or *Fra Filippo Lippi* or *Uccello*, *Ghirlandajo* or *Cimabue*, and if they have none of these, any Italian she can find with the exception of *Raphael*, *Veronese*, *Carracci*, *Romano*, *Titian* or *Tiepolo*, and all of the French, English, German, and Spanish. But surely she will be able to get *Puvis de Chavannes* or *Giotto* or *Cimabue* at Loddé's in the Jeanne Darc. Also she must bring you a

box of 5 elementary Bourgeois water-colours for 40 centimes from the Galeries Orléannais and a good brush, not too fine, for 30 centimes, also at the Galeries where they sell double ones, and a big mug.

So

A Book	1·50	
Paper	50	
Pens	30	anyhow about
Colours	40	3 frs. 50
Brush	30	
Mug	40	
	3·40	

With the rest you can buy 2 francs' worth of good chocolate to celebrate New Year's Day, or jujubes—just as you like, and save the rest carefully in your money-box, and if you haven't got one, in any little box.

As I've already advised you, don't draw anything except from nature. Draw branches now that there are no leaves, birds, the cat, particularly since he's so fat and beautiful according to Henriette.

But for every drawing take an entire new sheet of folio paper. The little page which you sent me was very pretty, but too minutely drawn. Thus, with big strokes, boldly. Don't be frightened, make mistakes, as many as you like, but all the time draw very, very strongly.

Do things like these—

anything you like, in Chinese ink without using a pencil, and get used to colouring them afterwards just as you think, but if you put a lot of *yellow* remember that you should have *violet* near by, if *red*, then have *green*, if *blue*, then *orange*.

> Yellow with red and blue
> Blue ,, red and yellow
> Red ,, blue and yellow

so that one colour always looks well with a mixture of the two others. In the box which Henriette will bring you, you should keep only the carmine, the Prussian blue and the gamboge—throw away the black and sky blue. . . .*

Pik had an absolute passion for creating and, not content himself with doing new things each day, he spurred Zosik on to finish books and articles. He hoped to see them published and known by the world from one day to the next, but Sophie found their rooms far too noisy to be able to concentrate on her work. Pik for some months had been doing nothing but posters, and he was certain that he would sell these for large sums of money.

In the meantime they knew no one, and suffered greatly from the cold and from hunger. Although he was now earning nine pounds a month, they found it very little for the two of them to live on. They had clothes to buy, a bed for Pik, and extra bedding, and in addition

* The remainder of this letter is lost.

to this, Pik was trying to pay Sophie back all the money she had spent during their first months together. They thought they ought to make every effort to re-establish her small reserve fund.

Their landlady used constantly to poke her head into their room : she was obviously insulted by their having no furniture, but as they paid their rent regularly and kept their rooms clean, she could say nothing. She was nearly eighty years old, this landlady, and constantly the worse for drink. Often Pik and Zosik, after hearing a terrific crash in the basement, would go down, to find her lying unconscious on the floor, and with great difficulty they would undress her and put her to bed. She never thanked them for these attentions, but seemed rather to bear them an increased grudge, keeping out of their way afterwards.

FRIENDS

It was not until January of 1912 that Gaudier first met an English-
man publicly interested in art. He had seen an article by Haldane
Macfall in the *English Review*, and was very much struck by certain
statements, although he thought it weakly written and long-winded.
Mr. Macfall had said, among other things, that he would fight any-
one whose ideas were contrary to his, whether he were a bishop, a
butcher or a burglar. Gaudier wrote to Mr. Macfall, telling him that
he was a French artist, all alone in London, and earning his living
in the City, and that he would be immensely pleased to make Mr.
Macfall's acquaintance.

One day he came back from work full of excitement, and little by
little, with much playfulness, he told the whole incident to Zosik.
'He certainly won't reply; such fortune could not possibly come to
us,' said Sophie.

'That's just where you make a mistake,' said Pik, pulling a card
from his pocket. 'The old fellow has already replied, and I'm to go
and see him next Saturday; what's more, he will help me to sell my
posters; we will take a nice house with a studio, and then I shall start
to do some sculpture. Not a bad prospect, eh?'

They waited for Saturday in the utmost excitement. Pik put on his
new twenty-six shilling suit, and Zosik bought him a special tie for
one and sixpence. They felt that the doors of Paradise were to be
opened to them at last, and they built fantastic castles in the air of
how they would get a footing in many interesting houses, and both be
universally recognized as great artists.

At 2 a.m. Henri returned from his first visit in the 'World'. Zosik
was waiting anxiously for his news, but he said that he would tell
her in the morning : he was too tired, and also it would only excite
her and keep her from sleep. In the morning Zosik was early awake,
and eager for his story as soon as he had opened his eyes.

'Well, disappointment is the lot of little sparrows like us. The
author whom we thought so big, genial, and famous has none of
these qualities, and lacks refinement and culture. To begin with, I
was frightened of him——he has an atrocious mouth, a cow-like head
. . . and a moustache brushed up *à la Guillaume d'Allemagne*. He
seemed extremely alive, talked a great deal, gesticulated, and was
very much taken up with himself. All the same, he's not a bad chap,

and I'm very glad to have met him. His wife, too, who smoked like a factory chimney, seemed a pleasant, intelligent woman.'

Gaudier's accounts of people were nearly always brutal, and his anarchistic temperament made him speak particularly harshly of Mr. Macfall, who was a retired Army officer.

One result of this visit to the Macfalls was that Gaudier was to go there with Miss Brzeska on the following Wednesday, and take with him some of his drawings; and more immediately, two men whom he had met there, Hardinge and Alfree, were to call on them that very evening at nine.

Zosik leapt from her bed. 'What! You tell me this right at the end instead of at once, so that I could jump for joy! Oh, what a devilish little tease you are; you wait till I pull your stork-like nose!' and Pik huddled under his blanket to escape her impetuosity.

They were very happy all that day, and Sophie used all her ingenuity in making their rooms look as nice as possible. The idea that people might pity them for their poverty, or think them dirty because poor, humiliated and tormented her. But Pik said that these were only stupid, sentimental ideas, that artists did not pay attention to such things, and that her being unable to work when things were in a mess was the one thing which made him feel that she was not a real artist; for himself, he could work under any conditions, and soon he would be famous. Henri felt that he owed nothing whatever to Providence, that it was sheer will-power and perseverance which had won him his scholarship, and that only submissive people were imposed upon. 'I have always been in revolt,' he said; 'even when I was a child, I would fight my parents until they had to give in.'

Hardinge and Alfree were to come about nine, but at ten forty-five no one had arrived, and Zosik decided to go to bed. At eleven, when all the room was disarranged, there was a ring at the door. Hurriedly they covered up the bed, slipped various objects out of sight, and scrambled into their clothes. Pik ran downstairs to open the door for their visitors, while Zosik tried to collect her wits. She was very anxious not to appear a fool before Hardinge, who was a writer.

They were both full of enthusiasm over Pik's drawings and posters; he had never shown them to anyone in England before, and though at the worst of times he was certain of fortune, he now felt that he had indeed arrived. After a quarter of an hour they left and Zosik and Pik were no longer alone in the world.

Next day a postcard came from Macfall telling Henri to take his posters to ———, adding that he would pay well. They would make at least fifty pounds—how rich they would be! They would go to Canterbury and see the Cathedral.

That day Pik went to work singing. He came back very dejected:

73

they did not want any of his things. His Negress, being naked, was therefore indecent, the Bagpiper was too crude, and the Mermaid had not got a pretty enough face. This was their first disappointment, but it was soon forgotten, since each day there was a regular rain of postcards from Macfall, suggesting an orgy of prospective fortune.

His encouragement, sincere as it was, did not seem to lead to anything material, though it tided Henri and Sophie over a very difficult time by keeping their hope at white-heat, and so numbing the pain of their daily life. Mr. Macfall tried very hard to get help for Gaudier. He introduced him to many people, and it was entirely due to him that Gaudier began to be known. He was not in a position to do anything big, and certainly he never realised that quite small help would have made all the difference in their lives. This was, I think, the case with most of the people who met them.

Henri would never ask for anything, or suggest that he was in any way poor. If he showed his drawings and they were liked, he would offer them as a gift. He was so generous and enthusiastic that the idea of there being any immediate necessity for help simply did not occur to anyone. Miss Brzeska had saved several remnants of furs and silks from the past, and always tried to make an impression of financial ease. She pretended she had a bank account, talked of cheques which had got mislaid, and of money orders which were on the way from France or Austria; while Pik's untidiness, on the other hand, would pass for a manifestation of the artistic temperament.

Miss Brzeska, who, during the last year and a half had been of so much use to Henri, now began to stand in his way. Her disposition was too difficult to allow of her being generally accepted, and many people who would have liked to befriend Henri refrained for fear of Sophie. Henri, on his side, was always so loyal to her that he preferred to keep people at a distance rather than have her feelings hurt.

Sophie's visit to the Macfalls was not a success. The fatigue of getting there, the heat of the rooms, and the unwonted meeting with a number of people, went to her head, and she became over-hilarious. In the course of the evening she dirtied her hands on some charcoal, and Mrs. Macfall took her upstairs to wash. She was there persuaded to have a glass of whisky to steady her, but instead of doing so it made her ten times more excitable. When they returned, Mr. Macfall was telling one of the guests, Miss Bagnold, that a drawing she had made was full of genius (he had set his guests to do caricatures of each other), and Sophie, unable to control her irritation any longer, said in a loud voice : 'Not at all, her drawings are stiff and photographic, their only merit is that they strike a likeness. Miss Bagnold is a writer, not an artist.' Her manner was strident in this drawing-room, and soon everyone was on their feet to leave; and

Mrs. Macfall was telling her that she would miss her last 'bus, and Mr. Macfall was holding her coat for her.

Miss Bagnold describes one of these dispersals:

'One night we came from Macfalls', Dolly and Lovat and I, and some others whose names and faces are gone, and we were again on a tube railway station. Though we still expected it, the last train had gone. It was winter, and a wind like a wolf galloped down the tube tunnel. We stood in its passage, Gaudier talking. He did not drop a subject when he had added a little to it. He did not throw a word in here and there, and make a crisp sentence sum up a bale of thought. What had been talked of a quarter of an hour before at Macfalls' was still being followed up. Gaudier, his long front hair hanging in a string down the side of his white brow, was throwing his future and his past and his passion into the discussion. We lazier English stood and shivered, and tried to back out of the wind. Gaudier felt our bodies moving, grouped, away from him, and I remember as he talked, and his eyes and pale face shone, he put out his thin arms and surrounded us and held us fast in the wind so that our edging movements should not distract him.

'Lovat was the first to have the wit to be excited about him. But they soon quarrelled. His young vanity could not stomach Gaudier's blows.

'I did not really like him. But that is no judgement on either of us. Gaudier never seemed to like anyone. He rushed at people. He held them in his mind. He poured his thought over them, he burnt his black eyes into them, but when in response they had said ten words, they were jabbed and wounded, and blood flowed.'

To us who know in what poverty they had to live—having to count each penny and make full use of every scrap they had—Sophie's account of Mrs. Macfall's visit to them a few weeks later is full of humour. She came with her husband and Mr. Hare one evening about half-past ten. While Pik showed his drawings to the men, Zosik answered her questions.

'Don't you suffer from the cold like this, without a carpet?'

'Well, you see, we are just leaving' (there was no question of a move at this time), 'and as my brother is occupied all day at his office, we have taken the chance of the week-end to roll up the mats and covers.'

'Oh, so you have mats and covers as well?'

'Yes, we have mats for the floor and covers for the beds,' said Zosik with absolute assurance, although she knew that Hardinge must have reported quite otherwise.

Then looking at their awful bed, terribly bent and untidy, Mrs. Macfall asked:

'Is this your brother's bed or yours?'

75

'It is his. This is his room. Mine is across the passage.'

'Oh, really! Have you got a good landlady? Does she do your meals for you?'

'Yes, sometimes, but when we are tired of home cooking we go to a restaurant, or we buy cooked foods, ham or cold chicken.' (Cold meats and potatoes cooked once a week!)

'Have you got a good charwoman to come in and do the rooms?'

'She is not over good. I always have to supervise her, and even do the work after her; but what can you expect, they're all alike.'

This was too much for Pik, who had been listening to all this with one ear while talking to the two men, and with an impertinent laugh he said:

'Why are you telling all these fibs? You haven't got any char-woman.'

Poor Zosik was quite confused, but almost at once replied with force: 'Don't you meddle with my affairs: you are out all day, you know nothing of who does the work.'

Pik subsided and the conversation continued:

'Why don't you take one of these self-contained flats, like ours, for instance? They don't cost much, only about seventy pounds a year.'

'Yes, certainly, that's very little, but then, you see, your husband doesn't need a studio, whereas my brother must have one, and that would make our rent a hundred pounds or more!'

'I suppose that *would* be too much?'

'Yes, just at the moment, for Pik isn't earning much, and I daren't plunge more deeply into my own capital; I've already had to go pretty far, since for a long time after we arrived Pik could get no work at all,' etc.

Mr. Macfall and Mr. Hare were very encouraging to Henri, and the party broke up with warm hopes that they would all meet on the following Wednesday. Mr. Hare tells me that Mr. Macfall, in writing to him about Gaudier, spoke of him as a young genius, but said that Miss Brzeska was a far bigger person, and wrote amazingly good stories; a remark which, when she heard it, gave Sophie a great deal of pleasure.

Mr. Macfall interested Lovat Fraser in Henri Gaudier, and Fraser called to see Henri, and ordered a large mask from him, for which he paid five pounds. Henri went back with him to his studio, and was enchanted with his work, but Sophie did not like Fraser at all. She thought him affected and moon-faced. He told Pik that he should give up everything and be a sculptor, and Pik explained that he really was a sculptor, but had been doing posters as a pastime.

One evening, just as they had packed up their few belongings and were going to leave for other lodgings, there was a ring at the bell.

76

It was Mrs. Hare, who brought with her particulars of a real live commission. There was a proposal to make a small statue of Madame Maria Carmi, who was then taking the part of the Madonna in *The Miracle* at Olympia. Mr. Hare had spoken to Lord Northcliffe and a few others, and Lord Northcliffe had already said he would give fifty pounds. It was hoped that they would raise a subscription of two hundred pounds, and they would like Gaudier-Brzeska to do the statue.

With some difficulty they managed to accomplish their removal, and to get to Mr. Hare's house in Kensington in time to be taken to the show. At first Henri could not get into the right mood, and spent his time drawing horses, but towards the middle of the performance he took fire and did many excellent drawings of Madame Carmi.

Mrs. Hare has a very beautiful one, which reveals in an amazing way his sculptor's instinct. He did a statuette, and two plaster casts were made, one of which Gaudier coloured.

Lord Northcliffe did not like them, gave Mr. Hare five pounds for the artist, and the idea was dropped. Mr. Hare bought one, and the other was sold at the Leicester Galleries in Gaudier's posthumous Exhibition.

Gaudier now began on busts of Mr. Macfall and Major Smythies, a friend of the Macfalls. He had said that he didn't require his sitters to sit, and indeed liked them to walk about; but Zosik noticed that it was a great relief to him when Macfall said he would prefer to sit down. The beginning of this bust did not go well, and Henri was about to destroy it when, much to his disgust, Macfall leapt up to save it, and carried it away.

The work on Major Smythies was more successful. The Major watched the building up of his head with great interest, but objected to everything, as is, perhaps, not surprising : his nose was too flat, his forehead too high, and so on. At first Gaudier took no notice, but after a bit changed his tactics. 'I believe you're right. See, I will alter it.' And taking up some clay, he proceeded to make the alteration. After Major Smythies had gone, Zosik protested against his being so weak-minded as to be deflected in his own vision by an outsider.

'Poor Zosik,' said Pik, 'to be so blind. I only took up a little clay and put it on the bust so as to satisfy him, and then, when he wasn't looking, took it off again, and he never noticed.'

Gaudier was to do these busts for ten shillings each, and he hoped that Major Smythies would have his cast in bronze, which he did at a cost of twelve pounds.*

When Sophie told Pik that he should not dispose of his work so cheaply, he said : 'I'm a sculptor. I need clay to work with. For ten

* This bronze was presented by Major Smythies in 1922, through the National Art Collections Fund, to the Manchester City Art Gallery.

shillings I can get two hundred pounds of clay. I'm too poor to buy this otherwise, so it's better to take the money and create a work of art than to be puffed up with dignity and achieve nothing.'

These two busts caused some little talk in London, and Pik hoped, through the help of Macfall, to do several of Oxford undergraduates; but this seems to have come to nothing, though it kept him in a ferment of excitement.

Sophie made several attempts to interest someone in her writings : she lent a specimen to Mrs. Hare. A few days later Mrs. Hare suggested to her that she should take a house, and have a few paying guests, so as to live more comfortably. Zosik took this suggestion that she should become a landlady as a direct reflection on the quality of her work, and was bitterly hurt. She was convinced that she was a great writer, and her whole energy went in trying to crystallize her ideas; but her surroundings and the lack of food were too much for her, and she achieved nothing; nor was she fortunate enough to meet anyone, save Pik, and for a brief moment Mr. Macfall, who would encourage her in her work, for her insistent nature drove people away from her.

In spite of this lack of sympathy from outside, her life with Henri was founded on the idea that they were both artists—she a writer and he a sculptor—and much of their time was spent in helping each other. Henri once said to her : 'Without my Mamus, I should have had nothing to show anyone; for as soon as I have done anything it disgusts me, and if you had not saved my works, I should have destroyed them all.'

One of these works was a 'Woman and Child', which Mrs. Hare bought for three pounds. She had asked Henri how much he wanted, and he, in his usual way, had said : 'Oh, do take it as a present if it pleases you.' Its casting had cost him twenty-five shillings, but nothing would have induced him to mention this; and when Mrs. Hare offered him three pounds, he felt rich indeed.

Henri found the Hares' friendship a great comfort and had it not been for Sophie there is no doubt that they would have better understood the difficulties of his life, and contrived some way to alleviate them. But Sophie had to be reckoned with, and Henri's friends found this too difficult a task.

It was at the Macfalls', as we have seen, that Pik met Miss Enid Bagnold, and he thought her extremely beautiful. She came to sit for him, and he expected that she would come every day; but her own activities diverted her attention, and week after week went by, filled with excuses and postponements. She herself tells the story of her finally sitting for him.

'It's a horrid story. I went to his room in Chelsea—a little, bare room at the top of a house—it was winter, and the daylight would

not last long. While I sat still, idle and uncomfortable on a wooden chair, Gaudier's thin body faced me, standing in his overall behind the lump of clay, at which he worked with feverish haste. We talked a little, and then fell silent; from time to time, but not very often, his black eyes shot over my face and neck, while his hands flew round the clay. After a time his nose began to bleed, but he made no attempt to stop it; he appeared insensible to it, and the blood fell on to his overall. At last, unable to stand it any longer, I said : "Your nose is bleeding." He replied : "I know, you'll find something to stop it in that bag on the wall"; and all the time he went on working, while the light got less and less. The bag was full of clothes belonging to Gaudier and Miss Brzeska, most of them dirty, most of them torn. I chose something, long-legged drawers, I think, and tied them round his nose and mouth and behind his neck. "Lower!" he said impatiently, wrenching at it, unable to see properly. I went to my seat, but after a time the cloth became soaked through with blood. The light had gone, and in the street outside there was a terrific noise. It was a dog-fight, one large dog pinning another by the throat, and Gaudier left his work to come and watch it. He watched it to the finish with dark, interested eyes, his head against the window, and the street-lamp shining on his bloody bandages.'

Gaudier had found the previous uncertainty of Miss Bagnold's sittings a great trial to him, since he could not start a new work while he was expecting her from day to day; he therefore decided to give it up, and asked Zosik to sit for him instead. The history of this sitting throws an interesting light on their personal lives.

Gaudier's attempts to do Zosik had always resulted in such solemn effigies that this time she decided she would do her utmost to encourage a gay one. Although she was very tired with her work, and her nerves were on edge with the perpetual noise outside their rooms, she spent the sitting singing old songs from Rumania, Poland, France, and Russia. They were both for the moment in a frenzy of delight, and forgot that any cloud had ever dimmed the edge of their horizon. All their first happiness came back, care-free. The sitting lasted a long time, and in the end Zosik was terribly tired; but the portrait was a miracle, and they kissed each other for joy. Then, next day, came a little dispute. Zosik had given Gaudier two shillings for his fare, and he had promised to return one and ninepence. In the evening he came back with nothing—he had spent the money on sending photographs to people in Germany. Sophie was annoyed at his having broken his promise, and bitter words followed. Sophie went out for a walk. It was late when she returned, and Pik called to her from his bed with a gentle voice, but she would not go to him. He got up and came to her : 'Don't be angry with me, Sisik—I was very annoyed when you went out, but I'm sorry now, and I broke——'

Sophie's mind flew to a vase they had bought, of which she was very fond, and she would listen no more. She flung invective upon invective at him, and in the end they separated for the night. After a sleepless night, she went into Pik's room, and he welcomed her with his usual happy 'good morning'. She repulsed him, but he pursued her until her rage burst forth once more, and entirely destroyed her self-control. After many bitter remarks from Zosik, Pik said :

'Well, since you hate me, I'll finish my work,' and taking the wet cloth from the bust of Zosik, he gave the forehead a half-hearted hit.

It was only then that she realized it was not the vase he had broken, but that he had taken his vengeance on the bust. It had, as a matter of fact, only a few dents in it, which were no doubt repairable, but Zosik was overwhelmed by the idea that, unable to beat her in his rage, he should have vented his anger on the clay head; she remembered the hours she had sat, the trouble she had taken, and with one wild leap she fell upon it with her fists, beating it as if she were threshing corn.

'See,' she shrieked, 'I'll help you in your work !' and blow after blow fell upon the bust, until it was again nothing but a lump of clay.

Pik watched her with a little smile—timid and naïve: then he ran after her, but she fled exhausted to her room, and locked the door. Later on, when she was quiet again, she came out, and Pik said in his calm way :

'I'm not angry that you spoilt the bust—it didn't really satisfy me. I'll do another, a better one. Sisik will sit again.'

The next excitement and disappointment for Henri arose through a simple misunderstanding. Mr. Macfall introduced him to Mr. Benington, a photographer in the West End. Mr. Benington had seen Gaudier's head of Macfall and had expressed his enthusiasm. Mr. Macfall had passed this on to Henri, and hinted that Mr. Benington would have his head modelled for thirty pounds, and most likely have his wife done too. Gaudier was almost beyond excitement, but as Mr. Benington had never had any thought of sitting for his portrait, and did not know that Henri had any such expectation, many weeks passed without any conclusion being reached. In the end, he took several photographs of Gaudier and of his work,* but still did not know that more had been looked for.

Henri also met two Canadians, who suggested that he should go with them to Canada, where a sculptor was badly needed, and where they would all make their fortunes. With so many distractions, Henri began to be casual about his office—he arrived late and left early, and talked of nothing but escaping from so paralysing a position.

* Mr. Benington made a much larger series of photographs in 1918, at the time of Gaudier's posthumous Exhibition.

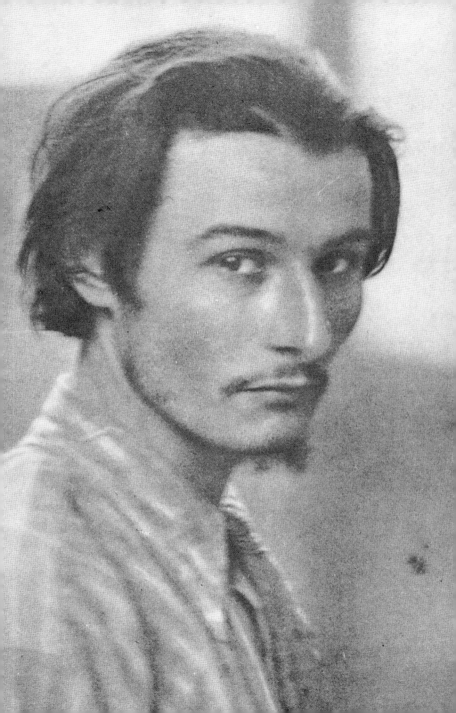

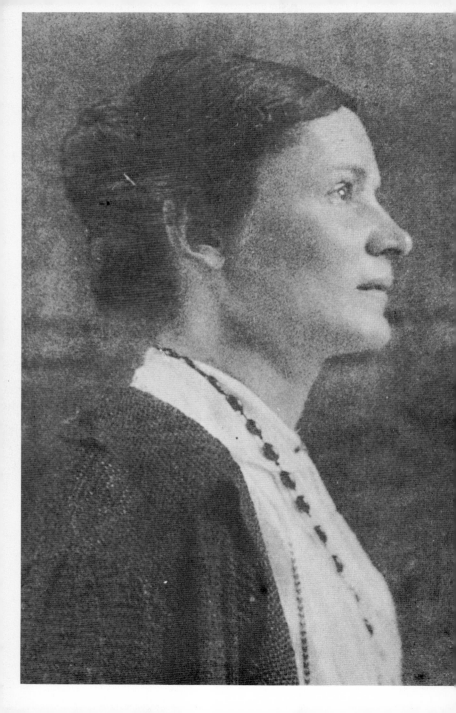

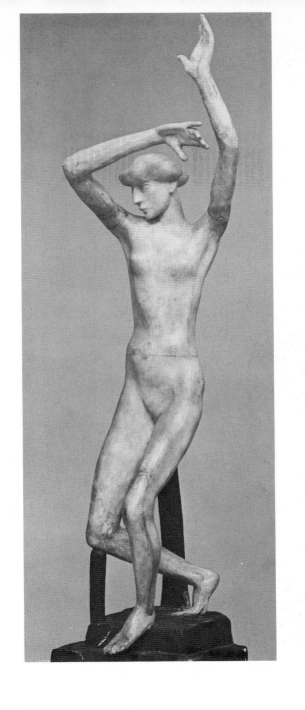

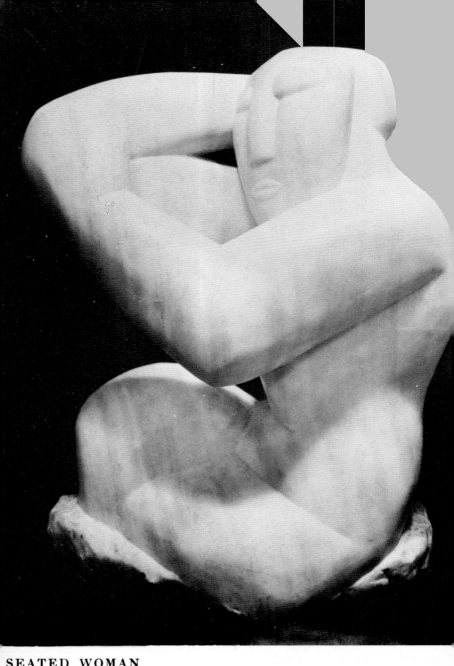

SEATED WOMAN

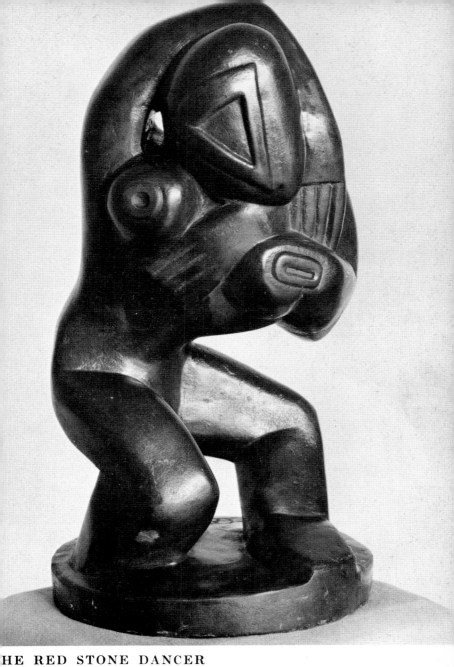

HE RED STONE DANCER

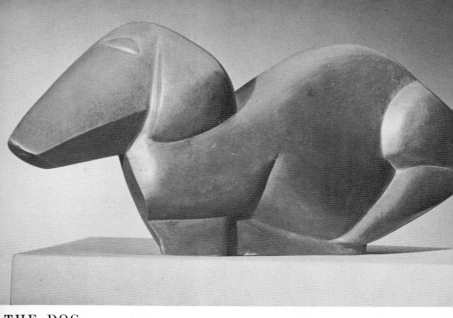

THE DOG

THE DU**(**

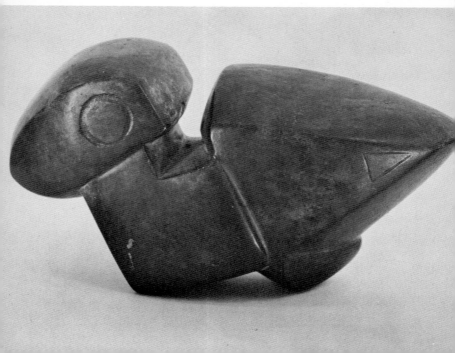

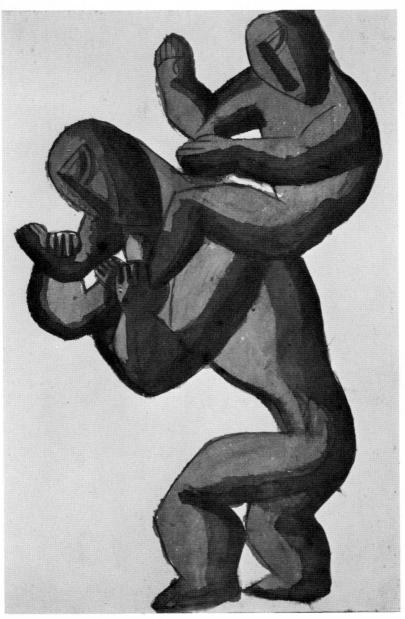

WRESTLERS

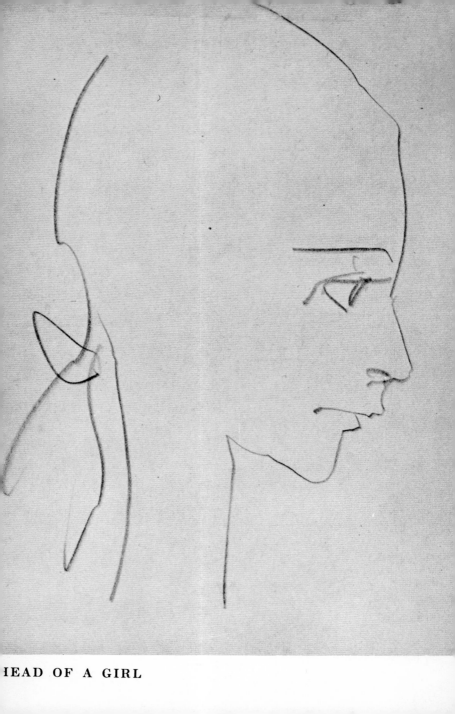

HEAD OF A GIRL

He was still interested in his small sister's art training, and sent her some of Mr. Benington's photographs, as the following letter shows :

15 *Redburn Street, Chelsea*
19*th June* 1912

Dear little Renée,

I am so glad that you have passed your exam—you see now how easy it is, and you probably had great fun that day at Chécy's with your little friends.

Your drawings were good, and you should do them all the time, concentrating each time more. I send you a small money-order with this so that you can buy yourself colours, etc.

I thought you would like to have photographs of the statues which I have done lately. I give them to you because you are so good and so pretty. I am up to my eyes in work, but I shall try to come one of these Sundays. Keep well, water your little garden if it doesn't rain, and my love to you.

Henri Gaudier.

Do you eat lots of raspberries, you greedy one, and do you pick the roses? Give Maman a good kiss for me, and Papa and Henriette.

MORE FRIENDS

It was at this time that Henri became intimate with Middleton Murry and Katherine Mansfield, the editors of *Rhythm*, who had asked Mr. Macfall to introduce Gaudier to them, as they wanted his drawings for their paper. Pik went to see them, and came back enchanted. He had never met anyone so charming or so sympathetic. They were both young, he said, very young : Middleton Murry was strong in body, with refined features and a magnificent head like a Greek god, an Apollo or Mars; while Katherine Mansfield was not at all silly or vindictive; she hated women, particularly English women, finding them heartrendingly conventional. She was a curiously beautiful person, Slav in appearance, and very strong-minded.

Pik had never seen anyone like her before, and he did a drawing for Zosik, who was all impatience to know what she was like; and from the drawing Zosik thought that she must be like Catherine of Russia. 'I am sure that we shall become enormous friends,' said Pik, 'they are very fond of me and told me so, and Katherine Mansfield gave me an Indian knife as a token of her friendship.'

It is not surprising that they should have been drawn to Henri Gaudier. He was at this time full of a youthful attraction, like a young eagle flying in space. He was delicate of build, soft and feline but of a sinuous strength, with large, piercing eyes like a leopard's.

They had promised to call next day. Zosik was all excitement to see these demi-gods, and awaited their arrival in a ferment of nerves. It was raining in torrents, and Pik went out to buy a few plates and glasses; for so important an occasion they did not think their two tin plates and broken mugs sufficient. The visit was a great success; they praised Gaudier's drawings and talked nicely with Sophie. They went away in high spirits, arranging for the Brzeskas to come to them the next day.

When they had gone, Pik and Zosik were full of their praises, Pik saying that he was ready to have his head cut off for them. He wanted to sit down at once and write them a letter.

'What now, almost before they are out of the house?' cried Zosik.

'Yes, they are such darlings, Sisik dear, that we must tell them about us—but I won't write, I'll tell them to-morrow when I see them."

Zosik asked him to wait for a week or so, but Pik felt that that

would be dishonest, since they loved them; and then—flip—before she knew it, it was done.

In exchange, Katherine Mansfield told her own experience, which ended with these words :

'And then we got into this bed and we laughed and we laughed and we laughed without stopping, and since that time we have always slept together. But perhaps I am scandalizing you by talking of such things.'

'Not at all,' said Pik. 'We have also already slept together.'

They spent several hours in happy conversation, and Pik in an access of affection pressed Middleton Murry in his arms and fondled his head with his hands. Katherine Mansfield joined them in this demonstration of love, while Sophie sat at some distance in her chair. During this first visit Sophie talked far too much, and also Pik persuaded her to sing, which made her over-excited. After that it was Katherine Mansfield's turn; she had a sore throat, and went to sing in an adjoining room. When Middleton Murry said how good her voice was, Zosik replied with disconcerting frankness : 'Do leave the poor child alone. You can hear she has a bad throat and can do nothing.' Pik refused to leave until long after midnight, and they had to walk home in drenching rain.

Pik wanted to model their heads, but Katherine Mansfield said that they were going away in a couple of days to Sussex. They asked him if he would come to stay with them, but he said that he could not promise, as the week-ends were the only free times he had, and he could not spare them for pleasure alone, if it were to the detriment of his work. Few things could have been pleasanter for him than a visit to people he loved, living in a nice country house, and his refusal shows in a marked degree how seriously he took his work. He suggested, however, that they should take 'this poor girl Zosik' for a few weeks, which produced, after a prolonged blankness, an 'Oh yes, yes, do come'. Pik thought them perfect, and told Sophie that to be suspicious of them was as futile as objecting to spots in the sun.

Middleton Murry and Katherine Mansfield were often in town, and Gaudier began a head of Murry. They talked of going to live together on a Pacific island, and Pik laughingly told Zosik that she must, of course, come in order to teach them to cook. Pik got it hot from Zosik for putting her at so venal a valuation. While they were bickering Katherine looked puzzled, and Sophie said : 'You are surprised to see us so quarrelsome.'

'No, you fascinate me, I can't make you out, you interest me tremendously.'

Encouraged by this remark, Sophie felt that while Pik was working on Middleton Murry she could confide in Katherine Mansfield;

she felt that at last in her she had found a friend to whom she could open the pent-up torrent of her heart. She launched into a most intimate recital of their ascetic life, the daily routine, the poverty, the nervous irritations, their platonic love and her fears for Henri's health, his headaches, and his useless expeditions to King's Cross. Katherine listened to her with a strained expression, and then Sophie, in order to get closer touch and give herself assurance, took her hand and pressed it warmly in hers. Katherine Mansfield gave a slight shudder but remained silent, and Sophie, in order to break down this wall of ice, opened the deepest abysses of her mortified soul; she made her own heart bleed in living over a second time all these past torments, and, as she lived them again, they seemed to become part of herself, and to be conquered. Suddenly Katherine Mansfield, with a more marked shudder than the first, withdrew her hand; Miss Brzeska received a moral shock, slowed down in her outpourings and then stopped altogether.

Katherine Mansfield was looking at Middleton Murry with queer eyes, questioning, enigmatic; then he got up with : 'Tiger, darling, we must go.' Before they left, she said to Sophie : 'A Polish writer is coming next Wednesday, you must come then and finish your Polish tale.'

Pik was as enthusiastic as ever. 'They *are* darlings—I've not made his head half magnificent enough.'

But Zosik protested that they disliked her, to which Pik replied that it was impossible that such dear people should not like his Sisik —he would, however, speak to them about it when they met on Wednesday.

Zosik was very excited by the idea of meeting a Pole, who might, incidentally, help her with her work; but she dreamt that when they got to Murry's house they found the door barred by a huge cat. When she told this dream to Pik he laughed at her fears. Just as they were leaving, a telegram arrived, saying that Katherine was feeling unwell and would they please not come, and that a letter would follow. Day after day passed and no letter arrived. Pik was in the utmost distress; he wandered about their rooms and in the passage like a lost soul, and finally wrote to ask for a reason. Then came an express letter to Pik from Middleton Murry to say that he had been forced to telegraph at the last minute, for Katherine had come in late and very tired, and had not been able to bear the idea of sitting for an evening with Miss Brzeska; would Pik forgive them and come alone that very evening. The letter ended by saying : 'You are a most exceptional boy, and I am sure that one day you will be great; every moment I spend with you is for me an immense pleasure. Wire if you can come.'

Gaudier felt very much annoyed and quite disillusioned, but he

decided to go and settle the matter by a personal explanation. 'I still love Middleton Murry,' he said, 'since all this fuss is only an intrigue worked up by Katherine Mansfield, whom I have never really liked; and although nothing would have induced me to write such a letter to him, it only means that he is weak-minded and not that he is a fool.'

Zosik told him that it was his own fault, since, had he supported her in public instead of abusing her, they would never have dared to write in such a way.

Next morning he told Zosik that although they had been very nice to him he had been bored to death, and had been very distant all the time. He thought that they must, after all, be stupid people; for, incredible though it sounded, they had never noticed the statue of Charles I in Trafalgar Square, and they were people who considered themselves to be artists.

He said that Katherine Mansfield had suspected him of being homosexual, and had begun by asking him if he had not a passionate nature; in order to lead her on he had said 'No'; on which she had plunged deeper, suggesting that he sometimes had peculiar longings like the great French sculptor, or like the English writer who was driven out of England. 'Perhaps,' said Pik, while laughing in his sleeve. He thought that she was too cunning to drive him away from Middleton, since she saw how useful he could be to them. He felt sorry for Murry, who seemed to be entirely in the hands of Katherine Mansfield, who made love to him all the time, until he was squeezed dry.

They were both coming the next day, Middleton Murry to sit for his portrait and Katherine Mansfield to make it up with Zosik. Sophie said that she would go and rest, and would only come in for a few minutes at the end of the sitting.

At about four Pik called to her, but she took no notice; he then put his head in at the door with: 'Come on, it's all right, she isn't here.' Poor Murry looked like a ghost, and Zosik at once felt tenderly towards him and made him some mint tea. He told her that he was terribly upset by Katherine's nervous behaviour. Miss Brzeska described the rest of the episode thus:

' "You won't be angry with me, will you, because I love you—I love you really," and taking my hand, he kissed it.

'Pik was much touched by this, and came over and enfolded us both in his arms, and there we stayed a little while with my head on Middleton's shoulder. I longed to give him a maternal kiss, but feared to disgust him. Then with a little hug we all separated, and with rich handshakes, we swore eternal friendship.'

On the first of September *Rhythm* was published. Gaudier expected to get a few copies, as it was the first time his drawings had

been reproduced in this paper, and he wished to send them to a few friends in France. He was very much upset because his name was wrongly spelt 'Gaudier-Bizeska'; he thought that Katherine Mansfield had done this on purpose, so that Zosik's name should not appear. By the tenth two copies arrived. Murry had been out of town some little while, and the friendship had suffered so severe a shock that Henri, who was going away for a week's holiday to a place near Murry's country house, swore he would not see them.

A week later he returned, full of life and energy, and there was no end to all that he and Sisik had to say to each other. He had been to stay a night at Murry's place—they had met each other on the cliffs. Before dinner he had overheard the following conversation relating to Sophie :

M.M. : 'I think she should come here now, there is plenty of room. Just let us speak to Gaudier about it.'

K.M. : 'Oh, no. I don't want to see her here—she's too violent—I won't have her.'

M.M. : 'But, Tiger, look here, she's not like that—I don't see why——'

K.M. (violently) : 'Leave me alone, I don't like her and I don't want to see her—she'll make me ill again.'

This was a relief to both Henri and Sophie, for they now knew where they were, and Sophie found much solace in the fact that Middleton Murry had spoken nicely of her at a moment when there was no reason to do so except that of genuine good feeling.

The worries of the last few months had been, all the same, too much for Sophie, and she decided that she must go away to the country, recuperate her strength and get seriously settled to her work. After a good deal of letter-writing to and fro she decided, on the enthusiastic advice of Pik, to go to an old house in Frowlesworth. Her experiences there and her meeting with a woman she called Niemczura, are most interestingly described in some of her writings, and were the topic of an amusing set of drawings in one of Gaudier's letters.*

Gaudier's last letter to Middleton Murry is a characteristic one, and it is quoted almost at length, since it throws rather a special light on his nature. It is a pity that a letter which Henri wrote earlier cannot also be quoted, and which Middleton Murry said was so charming and so interesting that he would keep it until Henri was famous. When asked, he replied : 'I am sorry that I have not the letter which Gaudier wrote me in 1912. Probably I destroyed it at the time of our quarrel, as young fools do.'

* Page 103.

My dear Murry,*

I was last night with M. . . . and was most surprised to hear you were in town. You apparently did not think fit to let me know, just as in the same filthy way you never informed me of the *Rhythm* show, against your promise, nor sent it to me either last month or this. Your acquaintance has been for me one long suffering—not only for me but also for the object of my love, which is twice worse. I met you at a dangerous turning, the brains burned by the recent summer, thirsty for good friendship, only with one drawback : poverty. Being then freshly strong, promising all kinds of things and favours, you behaved stupidly, thinking I was lashed to you, and that I would not mind any dirt. I was confirmed into my thought of the wickedness of Katherine Mansfield by a conversation I overheard when at Runcton. It was about my poor Zosik. You pleaded, and this to your honour, that you could receive her in your house, but K. M., with a fiendish jealousy, upheld to the end that Zosik was too *violent*. You will remember the whole story, which I need not trace more. I was wounded, and if I came once more it was only to take my Zosik's MSS., which with the same prejudice have been absolutely misjudged. I kept my mouth shut all this time because I knew you were in devilish difficulties all the while. Now you have got over it and there is no reason why I should not say what I think and feel.

I loved you innerly and still sympathize with you as a poor boy chased by the Furies, but I must reproach you your lack of courage, discrimination and honour. Katherine Mansfield I never wish to see any more. I must ask you to kindly send back to me three books that my Sisik lent you, *Bubu de Montparnasse*, *Poil de Carotte*, *Cantilènes du Malheur*, against receipt of which I shall let you have *The Cherry Orchard*. I cannot send you your book and wait for you to send mine on—you have no word whatever and I cannot trust you in the least.

You must not think for one minute that I want *Rhythm*—it is vice-versa. My drawings have been among the best that have appeared in your paper, and more in the ideal of it than the putrid trash you exhibit this month of Yeats and Peploe. I will not barter the purity of my love, nor my conscience, for a halfpenny worth of *réclame*. You had promised me money for what had appeared, and you might have thought me anxious only for this money's sake—you are not in a position now to give me this money, and you might think I retire for this simple reason. It would be bad for you, but I

* This letter is a rough draft of a letter which was probably never sent, since Gaudier thought it best to obtain the return of some books before sending it. It was written in English. Middleton Murry does not remember if he received it, but has still one of the books.

suspect it greatly, so you will please me to retain Heal's £2—for the advertisement in this month's towards the paper expenses. I shall never more contribute, and wish to cease all relations whatsoever, until being freed from the thraldom of your present love you reflect upon your actions and find yourself a much better and more reliable man.

Before putting the seal upon our short but unhappy acquaintance I wish to point out to you, as a friendly counsel, that the less K. M. writes for you the better it will be, either under Petrosky's name or her own—for it is not sincere but pure affectation : not art. Also that you discriminate more in matters poetical and pictorial and never insert any such rabble as Simpson's drawings or any such that do not represent concentrically Fergusson's idea—the only man with a real will in your agglomeration.

I wish you to read this letter twice over as I cannot express myself well in writing. My Zosik has been a month already in a most lovely Worcestershire cottage, on a hill, where she works, is free, and has not the sorrow to see herself insulted as she was in the grossest way, by whom you know.

<div style="text-align: right">H. G. B.</div>

A GROUP OF LETTERS

PART ONE

During the last three months of 1912, while Henri was for the second time alone in London, his letters to Sophie again vividly convey his thoughts and his actions. During this period he received letters from France, summoning him to return for military duty, but against this he had steadfastly set his mind, and would listen neither to argument nor to exhortation.

For the week-end of November 10th, he managed to go to see Sophie at Dodford, where she had gone after leaving Frowlesworth. She was in nice rooms at a farm-house, and Henri had heaps of gossip to tell her, among other things that Macfall had spoken of her as beautiful. This delighted her, and Pik was charmed that she could still be pleased with anything so frivolous. Miss Brzeska said that 'he was affectionate, animated, and vigorous, and his eyes blazed like torches.' They forgot how quickly the time had passed, and it was one a.m. before Pik went on tiptoe to his own room. The next day they went for a long walk in the country. In the garden of their house there were some old jars and a fifteenth-century Christ, which they decided to buy if they could get them very cheaply. Zosik had already bought four Indian curtains costing thirty shillings, and these were going to adorn a charming flat in London.

This week-end visit had rather a special value for them; their love for each other found peace in which to flower, and had Henri not feared to lose her continued companionship, he might have awakened in her a return of that physical love which he himself had always felt for her, but to which he had, so far, never confessed. As it was, he went away full of fondness for her, which became a little dulled through being perpetually unsatisfied.

<div align="right">

15 *Redburn Street, Chelsea*
Friday, 11*th October* 1912

</div>

Dear Old Thing,

I miss you terribly—this place seems so big without my Zosik, and I'm very far from working well. I have every good intention, but I sleep much too much and can't break myself of this. Yesterday evening I made a fairly good composition for Tomsy* and I will paint it

* Mr. Hare.

on Sunday. I don't feel fit for much—to begin with I'm put out by this damned military service, my running away from which seems to irritate them most terribly. Secondly, your portrait doesn't progress very well, poor darling, anyhow I'm about dished with it, and then that ass ——, the fellow I met at the British Museum, is supposed to come here to-morrow, and that takes away the last grain of hope that I had. But on Sunday I feel that I am going to work well, and I hope that next week will not be so sterile as this one. May it be the same for you too, my great big girl, and may the good sun protect you. It is a shame that all I do turns out so badly, particularly when it is for you, dear Zosik. I went to the Luggage-in-Advance office and they assured me that you should have your luggage to-day. If not, send a line to the station-master at Ullesthorpe and Lutterworth to ask them what the hell they are up to.

Zosiulo, don't be angry with me . . . in shaking the kettle to make the water come out I've broken the handle, and yesterday the lamp-glass burst in my face without any apparent cause, and I spent half an hour looking for the little bits of glass—my cauliflower was full of them—for I was having dinner. I take baths, like Sisik, only with less hot water, for it's more refreshing. I'm sorry that everything is so dirty in your Boarding House, and I'm afraid you will blame me for having got you into it, but you will remember, Sisik, that I told you not to go unless you wanted to. If you can't find anything else it would perhaps be better for you to go to Worcestershire, or even somewhere in Belgium, if you prefer that. I feel that it would be nice in the Ardennes—it's like the Black Forest, but we will go into all that later, and in the meantime I wish it was Christmas so that I might be with my Sisik, and that I was ten years older in order to be richer, and that my Sik had a lovely country house of her own. Don't you worry about 'Poorhouses', my Zosisik, your Pipik won't let you go to one. If I am still poor when I am old I would kill us both rather than go into such charnel houses.

They are dirty devils who wish to frighten my Sisik. Stay where you are as long as you can—rest yourself—take a bit of breathing-space, or clear out quickly if it seems to you a better idea and you can get something advantageous. Good-night, old darling, I send you thousands and thousands of kisses and now I'm going to bed, as to-morrow they wash the place.

Good-night dear Zosikmaly—the fog is so thick that you can't see the lights of Radnor Street, and it comes in through the cracks of the windows, and if you stop them up it comes down the chimney.

I have been a soldier since three o'clock this afternoon and consequently beyond benefit of civil law—may the good sun burst all the officers of this filthy regiment! Good-night.

P.S.—Your card must have come while I was in bed—I got it this morning at 6.30, and I'm anxious about the luggage. Poor dear, you absolutely must get away if everything is so disgusting that you can't sleep. Your rascal of a Piknis sleeps far too well in your bed—I'm tired out, and this is perhaps the reason. Next week will slip away more easily—there won't be so many distractions, and perhaps I shall manage to get in some work. Zosiulenko, who is this Niemczura? A cook or some kind of servant, *albo*? *dama*?

P.P.S.—I add this little page so that there shall be three. I dreamt about Wulfs last night and about my Zosik. He wanted to have novels and stories by Zosik for his daughter . . . and then stupidities, for we found ourselves, he and I, in a great room full of enormous machines, etc. Dear Mamus, I do not feel alone because I have a good Zosik, and I kiss her tenderly and warmly. Be good, dear love, and don't stay any longer in that foul hole where you were stuck by the moon. Good-bye, Zosiulik.

Pikusurinia.

15 Redburn Street, Chelsea
Sunday, 13th October 1912

Zosisikoiv Smarkoisowi,
I've been reading your letter over again, and you do seem to have got into a beastly hole, my poor dear, to be so embittered. Poor, poor darling—the old woman with cancer, the workhouse, the Vicar, the Niemczura, etc., and bad food and a rotten bed—it's really disgusting. My dear, I understand so well how you get annoyed with me, and I'm sorry I took all you said so seriously, and particularly that I scolded you about it. I am also furious that I haven't enough money to send you a box of food—but I'll do that as soon as possible. That ass Fraser is doing such rotten things, affected and stupid and crude in colour. It is true that the colours are brilliant, but they have no relation to each other.

It only costs 10s. to 12s. 6d to go to Belgium by boat from London. If we have a few days at Christmas or the New Year we could perhaps go there together.

Your Pipik who loves you intensely, who loves you more each day,

Pikus obesrany
if you wish him for a friend.

Zosik,

The Lousadas don't come back for a fortnight—I telephoned. I got 10s. for overtime last Saturday and I send it to you, for I expect you need it, poor dear, since you left with only £2. Send me a p.c. to say how much you will need before the end of the month, and I will borrow it off the rent. . . .

Mother now writes to say that she thinks I have acted wisely (in refusing to do military service), and that her first letter was wrong, which cheers me up very considerably.

I've done an illustration for Tommy and finished your *glowa szkaradna*, which I'm pleased with. I saw the bronze group at Parlanti's on Saturday, and I agree it's a scandal that such a beautiful little group should be flung away for a profit of £7—still it is better than nothing. I hope that you are getting more sleep and that you are feeling quieter. Poor darling, may the good sun bless you.

<div align="right">

Your Pipik.

H. Gaudier-Brzeska.

</div>

P.S.—Naturally, no *Rhythm* yet. Oh, the rotters! ! I am writing from the studio. The boss is at Cardiff from this afternoon until Wednesday. I'm going to work hard. I will write a long letter at the end of the week, for this is only a line to go with the ten little shillings. Don't worry, Zosik, we are very near each other. I get your letters the day you write them. I work hard in order not to get depressed. I had potatoes and rice, which gave me wind in the belly, but I have had some peppermint and feel better.

<div align="right">

16th October 1912

</div>

Sweet Heart,

There is a hurdy-gurdy playing blithely outside, the Scot and the Scotswoman are dancing, and Pik has made a crackling fire to cook an *ogonek*.

For the last two years Pik has never vacillated nor oscillated about militarism. Naturally when I receive such a letter as the one I sent you, I can't help inveighing against all the prejudices with which the rich stuff the poor in order to keep them in slavery. I've written a strong but very dignified reply. I have said that I do not recognize any patriotic duty; that if they did not wish to wrangle with me they should not have meddled with my affairs, and that if my sisters, particularly the elder, because the young one seems to have said nothing, make such a fuss, let them go to the Devil. The final touch to the whole thing was getting this letter from G——, which I enclose :

Conseil Général du Loiret.

'Mon cher Gaudier,

'Je viens de voir votre père qui m'a mis au courant de ce qui vous concerne. Je n'ai pas besoin de vous dire quel coup votre décision lui a porté. Vous l'avez rendu profondément malheureux, si malheureux que je dois vous l'écrire. Je vous ai, d'ailleurs, témoigné toujours assez d'intérêt pour avoir le droit encore de vous donner un conseil.

'Je sais les raisons que vous avez données à votre père. Laissez-moi vous dire qu'elles ne sont pas sérieuses. Dans tous les cas, ce n'est pas à vous de vous en faire juge. Mon plus jeune frère vient de finir son service militaire. Les deux années qu'il a passées au régiment ne lui paraissaint pas moins dures qu'à vous; il avait aux jambes des varices qui l'ont fait beaucoup souffrir pendant et après les marches. Il n'en a pas moins fait allégrement ses deux années, sans se plaindre, heureux d'accomplir son devoir. Il faut vous dire que le service militaire est un devoir, et qu'on est toujours heureux de faire son devoir.

'Puis, dans quelle situation vous mettez-vous? Vous vous fermez les portes de la France; vous ne pourrez plus revenir à St. Jean de Braye; s'il survenait dans votre famille qui a été si bonne pour vous et où tout le monde vous adore, vous le savez bien,—s'il survenait, dis-je, quelque malheur dans votre famille, vous ne pourriez même pas accourir au chevet d'un malade qui pourrait mourir sans que vous auriez la consolation de l'avoir vu. Mon pauvre enfant, avez-vous bien réfléchi que, par là vous vous mettez hors de la patrie et hors de la famille?

'Vous travaillez, vous avez du talent; je crois que vous réussirez. Vous êtes-vous dit que votre situation nuira à votre succès d'avenir? Je ne sais si vous avez suivi, il y a à peu pres deux ans, les histoires d'un auteur dramatique de grand talent, Henry Bernstein, qui avait fait précisément ce que vous avez fait, et qui a eu l'humiliation, dans son succes, d'être contraint de faire amende honorable publique. J'aurais voulu avoir conservé le lettre pu'il écrivit alors; vous l'auriez lue, et vous auriez compris quel poids vous vous attachez pour la vie !

'Vous savez tout ce que votre père a fait pour vous; vous savez combien il vous aime. Votre décision l'a peiné à un point que je ne saurais dire; elle l'a beaucoup vieilli; je vous assure que je n'exagère pas. Je vous en prie, revenez sur votre décision tandis qu'il est temps encore.

'Il est tard, il n'est pas trop tard. Vous serez évidemment puni, mais j'interviendrai de mon mieux pour que les choses n'aillent pas trop loin. Ce sera quelques mauvais jours à passer, mais vous vous

éviterez tous de regrets pour l'avenir, et vous enlèverez à ceux qui vous aiment un souci si douloureux.

'Croyez bien que c'est un ami qui vous parle, et qui vous parle parce qu'il a de l'affection pour vous. Je crois vous en donner en ce moment la preuve la meilleure.

'Venez vite, man cher enfant, réparer le faute que vous avez commise; je souhaite vous avoir persuadé. C'est le meilleur vœu que puissent former mon amitié pour votre père et ma sympathie pour vous.

'G.

'Personne ne sait rien encore dans le pays, que moi, qui ne dirai rien.'

I have answered in a cold, strong, dignified manner :

le 16 Octobre 1912

'Monsieur (pas cher et autre),

'Votre lettre fait preuve de très grde. sentimentalité. Vous êtes un barbare si vous vous glorifiez de votre frère qui souffrait tant de ses varices. Votre sympathie pour moi s'est montrée à mon retour d'Allemagne. Vous m'avez proposé une place de 50 frs. en disant c'est un peu de vache enragée à manger : Je ne vous reconnais aucun droit de me donner des conseils—je n'ais commis aucune faute envers qui que ce soit. J'ai reçu du gouvt. français 3000 frs. avec lesquels je me suis formé, vous et autres politiciens ont . . . Je considère ces 3000 frs. comme venant du peuple, et je les rends au peuple par l'art.

'Je serai naturalisé anglais dans 2 ans et si je ne puis pas un jour travailler à Paris, n'ayez crainte que je fasse comme Bernstein—j'irai droit en Allemagne, et vous aurez alors le piteux spectacle d'un artiste français érigeant un monument commémorant une défaite français pour se venger de la bassesse et étroitesse d'esprit de ses contemporains.' Etc.

About eight large pages of abuse of this sort in short pointed sentences. Christ! What a brute! None of this is for one's father or for friendship or anything of that kind, but purely for himself, because he is the Maire of S. Jean de Braye, and he must see to it that there are no 'bad examples' in his district. Oh, I let him have it at the end, where I said, *C'est malheureux, déplorable, que le jeunesse française ne se révolte pas en masse contre cette infâme conscription.*

Will that make the Zosik pet happy? Naturally I have not written to Middleton. I will buy a copy of *Rhythm* in order to have a record of my drawings, but I won't ask for anything nor lower myself. If he pays me, as he said he would, so much the better—if not, fft! Anyhow, I'm not going to humble myself any further, and if he pays

me and writes to me I shall tell him quite clearly what I think,* as I have just done to G——.

I'll have £7 or £8 from the group. You know that the casting of Tommy's two plasters is not yet paid for, and that will be £2 or £2 10s., and the bronze brings £10. Wretched Zosieki! believing that I wanted to hide £2 from her in order to buy chocolate. You look out for yourself if I ever catch you!

And now, my dear, it is really impossible that we should continue to live apart—stay for a month where you are to set yourself up, and then come back. I'm doing everything now—it is all quite clean, I don't waste time and I'm working hard. I shall be able to do just the same when you come back, and we shall get along beautifully. Zosik only needs a rest and change of air. I really can't live for three months without my Sisik. I miss her so that I cry most of the night (without knowing it at the time, since I sleep well—but in the morning my pillow is wet and my eyes all swollen.) We must come to some arrangement, once and for all.

I've done a little jungle cat that I like, and I'm going to do another at once.

A bientôt, my unhappy and beloved darling. Najukochanek, you will come back to your Pisukonik at least after Christmas for two or three months, won't you? That is if you can work well, for I don't want to allow myself to be led away by sentimentality to sacrifice your work. You are the more intelligent, and it is you who must decide. I don't want to have any responsibility in the matter.

<div align="right">Pikus Gaudier-Brzeska.</div>

<div align="right">

Chelsea
24th October 1912
</div>

Najukochanisku Zosisik.

Your letter made me very unhappy. From one end to the other you do all you can to find fault with me, and you don't enter at all deeply into what you say; and what is more you cite instances that are historically false; the case of Rodin for one. I am more bothered by the thoughts of your ridiculous 'moral aim' than by your attacks against me. I have certainly got many faults—indeed, like everyone else, I have got every fault in a greater or lesser degree. Yes, I know I'm a spendthrift, but conceited, to the degree of having a wicked letter piled up against me in order to prove it? Never. Since you are so good a partisan of the old mystic philosophies which search into cause and effect, why don't you weigh a little what you are saying? You accuse me of being conceited, and then in the next line you say that I am perpetually changing my ideas and my opinions, even about art.

Surely this very fact proves that I am not at all conceited. Life,

* Letter printed at the end of Chapter 7 (page 87).

according to Bergson and the later philosophers, is simply intuition of the passing moment, and time, which flows continually, eternally, makes itself known by change. The conceited man is one who stops at a certain phase of his work or of his thought, and cries out loud, like you, 'When I say something, I believe it—I'm sure of myself', etc. I'm not a bit like that. I look at things a great deal and I draw a great deal. I notice how everything differs, mingles with and knocks up against everything else, I am never sure that what I think is true, still less that what I have thought or said is true; and I can't bring myself to sacrifice new ideas, quite different from those I had yesterday, just because the old ones happened to have the honour of passing through my head and I advocated them ferociously.

You can talk till you are blue in the face,* art has no moral aim, and when it has been great has never had one, in any of its phases. It is simply an interpretation of life; and life has no moral aim either —though one can draw a certain amount of morality from it to help the intellect in its battle with the elements. Ethics are a very secondary thing, but the consciousness of change is of the utmost importance, for without this, work cannot renew itself, art is gloomy and sad, and is no longer art.

When you have fully realized once for all that I am a poor Pikus for whom the only country in which he can work for the next few years is ENGLAND, perhaps you will at last understand. You don't, I think, realize that I have to be in a filthy office all day long, and that every minute I am devoured by the most torturing desire to be cutting stone, painting walls, and casting statues? You always seem to forget this, and that isn't at all nice of you. I only know stupid people, but through these I may be able to get out of the hell of ship-broking, etc., and naturally I won't risk my chances of this for the sake of the 'senseless honours' of pride. I hold Machiavelli's opinion that when you wish to attain an end you must use every possible means, and when you consider everything with a clear understanding, the misery I endure in business is far greater than the little troubles of the soul and mind which I experience in my dealings with these fellows whom I have to see.

You have a very good example of this—I too—this example being yourself. You have ruined the best part of your life because of this pride which you place above the work which you could and should accomplish. This leads you inevitably to that narrowest kind of egoism which puts the self on a pedestal, labelled *Don't touch*, and makes hay with the primordial conception of the individual as part of a society, having relations with the other individuals who compose it.

All you say against me makes me mad, because none of it is my

* 'chante autant que tu voudras.'

96

fault—but yours—caused by the falseness of your principles about life itself. My love for you is entirely intuitive, whereas yours for me is a reasoned thing, and therein lies the first obstacle, causing all our differences of opinion. As you are so set on being alone, please stay alone and I, on my side, will manage as best I can. You insist that I am not sufficiently interested in your work—that I don't ask you questions—that I haven't read anything of yours since people here said it wasn't worth anything. That is a hideous lie. What can I ask you? During the two years that we have been together your work has only been in a state of preparation, and but for slight alterations, is always practically the same—except that it gets more drawn out and amplified. You never set yourself a limit, and of its final form you seldom speak. Since I know the story from A to Z, what is the use of asking you questions about it? I have, as a matter of fact, read all the little notes you have put in the margin, and that is more than you can say for yourself about my drawings, which you never dream of looking at unless you want me to give you one, and then you go and hide it. The whole fuss is, of course, only a trifle, but you seem entirely unconscious of the fact that I work very hard to earn our living, and don't want to stop my artistic activity. You exaggerate every little fault; you never try to understand why I do this or that, but you expect me to fall in with all your quite arbitrary actions, which are the result of conceit and egoism, and utterly lacking in importance. It is this particularly that upsets me, and if it goes on too long it will wear down my love for you. I can't see why you don't adapt yourself a little more to circumstances. You reproach me again with not having written to you—this is utter madness, for I wrote you three letters at the end of last week. Then you say I never tell you about what I read. What time have I to read? You know quite well I have scarcely the time to work. All the same I am sending you some newspapers this morning, not because of your scolding, please note, but because I had already thought of sending them to you. You ask too late for provisions—I haven't enough money, and you will have to wait a bit. It is just as well, perhaps, not to send anything to Frowlesworth—but rather to Bromsgrove—however, please yourself.

I have seen a lot of fellows who know Murry, and they all say that he was quite a different person a year ago—gay, strong, alert . . . In spite of all Sisik may say, I'm sorry for Murry, and I don't at all hate him. As for *Rhythm*, no one knows exactly what has happened. . . .

Macfall has produced a hideous article—'The Splendid Wayfaring', which you will find in the *Art Chronicle*. He asked me for drawings to adorn it, and I gave him about sixty. The stupid editors made a fuss because my monkey had only three legs. Macfall had to

go to them three or four times in order to convince them, but I believe all the same he himself wished I would put in a fourth.

The Lousadas come back next Sunday evening, and I shall probably have some ready money the week after. . . .

25th October 1912

My dear, why do you say so many horrid things about your Pipik, who doesn't deserve them—it is not really nice of you—still, poor little one, you are hungry and alone, tortured by this Neimczura and this clergyman, so that it is silly of me to take it so much to heart.

I'm always very sincere with you, Zosik mia, only, as I always point out to you, I don't attach any importance whatever to what I have said or done, but only to the present. You know very well, beloved, that I love you with all my heart, so don't be sad, and clear your mind of all these horrid black ideas which keep coming to you incessantly. When you are a bit rested you will be quite happy again and come back to your Pipik—you wait and see. I shall be so happy when Christmas comes and I can talk with my Zosisik. I am working a great deal and hope that you are doing the same in Ambrosia.*

Your Pipik, who loves you dearly and who is always near you.
Pikusik.

Chelsea Monday, 28th October 1912

Mon bon Dziecko Ukochany,

I will go to Euston to-morrow evening and try to find out what I can about the hours of the country trains. I enclose a letter from the old woman at Bromsgrove which came at the same time as yours. Naturally my Sisik likes feather beds—get a big bedstead, *bedsiemy spac mitsammen* at Christmas ! ! ! ! !

It is absolutely true, without any doubt whatever, that you talk through your hat—you place Bergson with Nietzsche, Schopenhauer, etc. Bergson expressly demonstrates that the world is positive, real; and that it is pernicious and useless to rack your brains to find out if the world was created by a God or not. He emphasizes intuition as more valuable than reason—for reason is scientific and leads to the absurd . . . To make this clearer for you, I send you a little book which you really ought to read.

I regret much that I have said and done. You see, Zosik, I have only just opened my eyes on the world, and I'm dazzled. My feelings do not agree with my reason—my words fail to convey just what I am longing to say. My touch with all things is very slight, and the primitiveness of my nature always gets the upper hand. As a punishment, I have sworn to translate the whole of the *Divine Comedy* for Sisik,

* A reference to Ambrosia Cottage, where Miss Brzeska was staying.

for I see that Dante suffered just as I do from this curiously ambiguous situation.*

As to my ideas about art, I'm perpetually modifying them, and I am very glad I do. If I stuck to some fixed idea, I should grow mannered, and so spoil the whole of my development. As far as I can see at this moment, I believe that art is the interpretation of emotions, and consequently of the idea. For this emotion I recognize as necessary only the discipline of technique, and at this moment I think the idea comes better the more the technique is simple and limited; on the other hand, I fully recognize that the more you limit your technique, the greater danger you run of falling into mannerism, which is the negation of all the emotion which we experience in front of nature.

Again, in this emotion I see three divisions; linear emotion, produced by the rhythm of outlines and of strokes, sculptural emotion, rendered by the balance of masses, such as they are revealed by light and shade, and lastly, pictorial emotion, produced by various coloured pigments. These three technical emotions seem to be very closely united in a vast intellectual emotion, which I do not know, but which, in the corresponding realm of spirit, I feel, in the form of pleasure, suffering, sorrow, joy, etc., and that's where the mystery lies. I used to think that to reproduce each form exactly was enough; then I thought it was only the light that mattered, and that if each variety of light was rendered perfectly, that which it lit would be thus rendered also. You will see for yourself that it is best for me to free myself gradually from all these prejudices—that I should deny, so to say, all that I have thought instead of becoming ridiculously engulfed—an example of pigheadedness. To tell the truth, I am sure of nothing, since it is only now that I am beginning truly to feel life.

According to the little book which I am reading about Dante, 'the devil lived on very good terms with very few people, because of his terrible tendency to invective and reproach, and his extraordinary gift for irony and irresistible sarcasm'—just like my own funny little Sisik.

To be quite honest, Sisik, I love you passionately from the depth of all my being, and I feel instinctively bound to you; what may often make me seem nasty to you is a kind of disagreeable horror that you don't love me nearly so much as I love you, and that you are always on the point of leaving me—however, the more I know you, the more I realize that you do love me very deeply.

Cheer up, Sik, dear. I'm feeling well and looking after myself—

* Gaudier translated only the first five Cantos of the *Inferno*, a work which Miss Brzeska spoke of as *œuvre très mièvre—ennuyeuse jusqu'à l'indigestion d'Esprit et du tête*. He had a Tuscan edition with a 'hideous English translation', which helped him where the passages were obscure.

for example, last Sunday, the landlady cooked me a good joint and potatoes. I have provided myself with lots of vegetables and fruit. Yesterday morning I got up at six o'clock—had a bath, went to the Park for an hour, and got back to the house at eight o'clock. I worked hard until seven in the evening, went out for an hour, and to bed at eight. Next morning I was up at six again. I did a fairly big canvas in oils yesterday without any hesitation—I did it in one go, and am pleased with its colour and composition. It is a Whitechapel Jew selling his wares.* In the afternoon, I half-finished the plaster group : two women running. Now that it is finished it seems to me like an allegory—the Spirit of Liberty drawing women towards a nobler life. Since you left I have done innumerable drawings—about 600 to 1000, your portrait, which I have begun three times, and which has taken me ages (it is finished now, and I am delighted with the beauty which comes out of it, and the absolutely refined charm of the face), a little statue of a monkey, one of a lynx, one of a puma, the group, the picture mentioned above, and several illustrations of the Tomego Zajaia.†

I know a bookseller, Rider, a pleasant fellow. It is he who has put me in touch with [Frank] Harris. He has suggested that I should show in his shop little statues and pictures for sale—I'll take him my Jew and the plaster groups of Russian dancers. Zosik was right : Parlanti has given me back the plaster group—*mea maxima culpa!* Lousada has come back. I spoke to him on the telephone this evening; he is going to send me a card telling me what evening he can see me, and I will take him the bronze that Parlanti is bringing tomorrow. The Hares always ask for news of you directly they see me, and I think it would be nice if you wrote a little letter to Tommy. I don't think very much will come of Tommy's mythological stunt, and that's all to the good, since I about burst myself over each blasted design. I'm much better working at my own personal ideas. . . .

Wulfsberg has promised to make a contract with me before the 1st of November. There is a rumour in the office that he is going to take me with him to Christiana (he said something about it to the Norwegian, but it is very doubtful). If he does propose it, however, I really ought to refuse, for in Christiana we would have to work from 8 a.m. to 9 p.m., and on Sundays until 2 or 3 in the afternoon. The town is a frightful nest of *can-cans*, where everyone knows his neighbour, and where it would be impossible for me to do any kind of work. I ran off to see Tommy to ask him to keep an eye open for a job for me. I'll also have a look round myself, and I'll ask Lousada

* This canvas was reversed later, and the bas-relief of Wrestlers worked on the new surface, so that the painting of the Jew is now at the back of the Wrestlers.
† Drawings for Mr. Hare.

and also Rider, who, with Frank Harris, is running the new review, *Hearth and Home*. It pays well, and there might be an opening there. All these are safety measures, for I don't think for a moment that Wulfs means to take me to Norway—it would cost him far too much.

You are quite right in thinking that the Past continues in the Present, and forms the Future. This is one of Bergson's big premises, and his theory of change is based on that. On the other hand, you

La contrée des pleurs
leva un vent violent qui attisa un feu pourpre
toute sensation fut vaincue dans mon être
et je tombai comme un homme
que le sommeil saisit

have no right to judge me so severely. I am very young, and you are grown up, *nel mezzo del camin di nostra vita*, as Dante said of the man between thirty-five and forty years; quite formed, while I am only in the making. What is more, when you first knew me, I was ill —then when I found work, I fell into another abnormality, the one

in which I now am—driven nearly mad by too much work, and wishing all the time—no matter how—to get out of business. . . .*

My little darling, a thousand kisses on your sweet body. Keep cool! I only added feather-bed, large bedstead, on your card, because I understood that you would have two rooms—see? I enfold you in a profound embrace, and send much love from your insufferable but loving

<div align="right">Pikus.</div>

<div align="right">Chelsea, 31st October 1912</div>

Ukochano Brzesko Brzescych,
By all that's marvellous I send you four fat sovereigns, all in gold in this sweet letter from your beloved??? Pipik.† I will send you your little package to Dodford—it will probably be there on Monday—I will do it up this evening, and send it off to-morrow morning. I will put in it:

deux pains à 2 lbs. Allinson
beaucoup *des* citrons (il n'y a pas encore des oranges)
beaucoup *des* bananes
2 douzaines *des* punaises bien vivantes!
une boîte des allumettes vestas en cire

but I can't send you any acid to clean your washbowl—it's too dangerous. To begin with, it might get broken on the journey and burn everything in the box, and besides, some always remains in the basin, particularly if it is not very good, *et çà te ferait tomber les kouaki de la pisia et te donnerait le colique.* I send you some soda instead—it is the best. And what will my old donkey say if it finds chocolate from an A.B.C.‡ and good apples?? Eh?? You old miser!!

Don't miss your train on Saturday and don't tire yourself out by worrying. If you take the ten o'clock train, which I suggest, you will do very well, because you will have a little rest at Leicester and again at Birmingham—enough, but not too much.

You will find with this the third Canto of Hell. I am tremendously interested in this *Divine Comedy* and also in Dante's personality. He had something akin to Shakespeare in that he didn't rack his brains to find new things, but borrowed all the old Troubadour songs, and particularly those of Pons de Capdiul and Guiraut de Borneil, adding to them his own ideas. It was the same thing for the Hell. Much is taken from Virgil's *Aeneid*, but whatever is used brings out Dante's idea.

I send in the box of fruits a little Life of him similar to the one about Bergson. . . .

<div align="right">Pik.</div>

* The letter here contains three pages and a map about the Balkan War.
† See Note at the end of this letter. ‡ Aërated Bread Company Restaurant.

du Dante —

Je t'enverrai le ptit livre de sa vie, un pareil à celui de Bergson dans le colis de fruits etc.

sisik — niemezura — sisik — niemezura

sisik — niemezura — niemezura

sisik après la victoire

sisik

Note to the previous Letter

The four sovereigns which Henri gave to her played a very prominent part in one of the many trials of Miss Brzeska's life.

In 1918, she had come up to town to make some arrangement about Henri's posthumous Exhibition at the Leicester Galleries. She went to stay with the Pissarros in Hammersmith, and was to go on to dinner with Mrs. Bevan in Hampstead.

A little before luncheon some discussion arose, and Mrs Pissarro laughed. Miss Brzeska, quite mistakenly, thought that she was laughing at her, and left the room without a word. It seems that she went upstairs, fetched her handbag, and, not waiting to put on a hat, rushed into the street with the intention of going at once to Mrs. Bevan. Her poor mind was in so sudden and complete a state of confusion that she could not think of her direction, and some time in the afternoon found herself in Hyde Park. She walked all over the Park, and on into Kensington Gardens, talking aloud to herself all the while. She walked about all through the night searching for the way to Mrs. Bevan's, and by morning, tired and exhausted, but talking and swearing more loudly than ever, she dropped into an A.B.C. near Paddington Station to have some coffee before catching the early train to her home at Wootton-under-Edge. While she was in the A.B.C. the police came, and took her to the Paddington Infirmary.

Mrs. Bevan was informed, and went to see her, and the Doctor in charge thought her well enough to go home—Mrs. Bevan arranged to take her to the station and see her into the train. Before leaving, Miss Brzeska asked for her things, which had been taken away from her the day before, and these were returned, with the exception of her money, among which were these four golden sovereigns given to her by Henri in 1912, and since then most jealously guarded by her. Although several people wrote to the police, pointing out that these sovereigns were more in the nature of a keepsake than money, and that notes in their stead were no use, they were not able to obtain their return. From ten in the morning until nearly one Miss Brzeska endeavoured by argument and invective to get her sovereigns back, but in the end had to take the train to Gloucestershire, feeling again at the edge of her sanity.

City.
31st October 1912

My dear child,
I hope that you are no longer feeling so poorly, and that you aren't tired. I have sent you this morning four sovereigns well done up in an envelope, and registered; you will probably get them at the same time as this.

Savoff, the Bulgarian, has fought the Turks 50 kilometres from Constantinople. The battle has gone on for the last four days, and is not yet finished. The principal armies are engaged. Apart from that, Turkey is in the hands of the Slavs, who say quite openly that they will divide it among themselves, and Austria accepts. This is all very good news, because after this war, there can be no further excuse for another.

Pipik.

15 *Red. Street*
Sunday, 3rd November 1912

Beloved,

For many months I have been a martyr to my need for music, and I have just satisfied this desire. I have heard with the utmost ecstacy Beethoven's 5th Symphony. There were very few people in the Albert Hall, which is immense, and I sat alone in a corner with my eyes shut, and didn't open them until the last note. I can't describe the Symphony to you, but the whole has a suave amplitude, and gives the impression of a very beautiful young woman's torso, firm but soft, seen at first by rarefied lights, and then with strong light and shade something like this, but with sounds instead of tones.

Beethoven has my complete admiration. I like his music more than any other.

To tell the truth, I haven't worked very well this week—my eyes have hurt me—I have drawn intermittently, and have done a little sculpture. I stuck at the little group which I told you about, and finished it this morning once for all, after having changed it for the better by broadening the planes.

On Friday evening I washed out the big room, and as I had made a fire, I profited by it to have a good bath, which set me up. Yesterday I wasted a good hour in *zweifelscheissen* in the French quarter, looking for gingerbread for my Sisik, and didn't in the end find any. I didn't want to waste money on the 'bus, so another hour and a half was lost in getting home. I did up the parcel for Sisik, sent it off, and

106

by then it was dark. I went out to buy paper, and in the shop heard of a studio where for 5s. I can go and draw from the nude from 8 till 10, Tuesdays and Fridays, for five weeks. That works out at 3d. per hour, which is ripping. When I began to wonder what I was going to do, there was only time left to go to the Museum. I rushed off filled with shame at the thought of half a day lost, and plunged with vigour into *Art*, a book on Rodin. I read it all through. I read it all between 5 and 10 o'clock, passionately and with understanding, and found heaps of things in it that interested me.*

All our sympathies are with Rodin, are they not, my Zosik? Things used to be much worse in the Middle Ages. The other day I read of Van Eyck, who was sent to Portugal to paint the portrait of a Princess, betrothed to the son of his patron, the Duke of Burgundy. Van Eyck had already painted the Retables at Bruges, and was in the maturity of his talent. The story tells of the journey, the festivities, the lords, the tournaments, and at the end, *et certain maistre Jean Van Eyck, petit valet de Monseigneur de Bourgoygne, qui, dit-on, sait peindre sur bois à la couleur a olle qu'il a inventée et auquel dame l'Enfante fit insigne honneur et trop grande grâce de lui laisser peindre son portrait.* On the journey he slept with the servants, and attended to the horses.

Speaking of horses, I went this morning to Hyde Park to the famous Rotten Row. My God! A rottener lot of broken-winded old hacks you never saw anywhere! To get over my disgust with these horses, I made a pilgrimage to Kensington Gardens to Watts' statue, which looks splendid under the airy lights between the big walks.

Yesterday evening I delighted my heart with the *St. Jean Baptiste*, this afternoon with Beethoven. I also had a superb pomegranate, pink, large and beautiful like a lovely *pisia* of dear Sisik, which I kiss distractedly, so much does she delight me. I have my doubts all the same! I am now going to the Library, will eat when I come back, then go for a walk, and so to bye-byes.

<div align="right">Pipik.</div>

P.S.—I kiss my dear Zosik, all over her dear body, and I recommend her to the care of the beneficent sun. I couldn't put the bananas in, it would have made it too heavy : 5—15 lbs., 2s.; 15—20 lbs., 4s., and it was almost exactly 14 lbs. Next time I will put in other good things : the old man promised me that you would get them on Monday.

Ten thousand kisses full of love, close caresses, kisses, kisses— Zosienkoju. The Bulgarians are at Constantinople—good-night, darling.

<div align="right">Pik.</div>

* Gaudier here gives Miss Brzeska a five-page précis of *Art*.

Tysięcy pocałunków dla
mojej ukochanej, biednej
drogiej Rosii

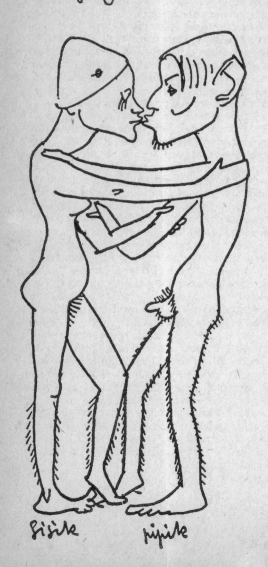

lisitka pipitka

Dear Old Thing,
Our little differences are most excusable—not only are we of different
sexes, but also of different nationalities. We are not the same age,
nor have we had the same experience, nor do our talents follow the
same course. In spite of all this, one thing remains. My Zosik loves
me so much, and she is right in saying that if I have perfect confi-
dence in her, and love her, it is because of her intelligence. I know I'm
a queer devil. I try to excuse myself, and Sisik only tries to make me
see where I am wrong in order that I may correct it once for all.
When I am in a good mood, and have thought things over properly,
I see that on the whole she is right. So let's finish all these harangues,
and we will always love each other, just we two, because this is the
only happiness on which we can count.

You mustn't get worried about bad dreams. In these last three
years, while we have been in a weak and nervy condition, we have
had dreadful nightmares each night, but they have never come to
anything, for, say what you will, our situation is getting better. Last
night, for instance, I dreamt that, with my Sisik, I saw lions on a
plain. We had a hut, and it was raining; all that we noticed was that
we were able to go inside the hut, and we were delighted to think
that we should have fur coats made of lion skins—we started off with
our guns well loaded and—not a lion to be seen ! It's only the reaction
of the imagination and of nerves too highly strung. Don't worry
about the boss, that will be all right. He has dismissed the little Eng-
lish fellow, saying that —— and I are quite able to do the work with-
out him. He goes to Norway on the 25th, and won't be back until
April 15th, so that he will probably arrange everything before he
goes away. To-day he is in Paris running after a wood contract for
next year.

If you are happy where you are, don't put yourself out, but work
well, care-free; whatever happens, I will be prudent, and won't in-
dulge in any stupidity, such as : taking a studio, giving up commerce,
etc., in fact, anything which might worry you, and prevent you from
writing well; for if there is one thing which I consider a labour of
love for my Sisik, it is to enable the poor darling to work. I am so
pleased that this time you have struck a good place,* and I commend
you to the great beautiful SUN, that he may help you.

My dear, it is much too much *de luxe* to take your baths in front
of a glowing fire, it is not at all good for you, brings on all sorts of
dreadful illnesses—you should have cold water—really cold. I take a
cold bath every morning, at first I used to add a little hot, but that
was sheer cowardice, and it didn't go on long.

* Miss Brzeska had gone to Dodford.

I have taken the Nijinsky to Bob Rider,* and have promised him 4s. in the £, so long as he sells it as best he can—also the head of Smythies, in order to try to get some commissions for portraits—when my 'Jew' is ready, I will take it too. This evening I am going to the life class, and I shall enjoy it. I shall see *panis toutes nues*, blast it all, and good ones too.

Leave the sweet little flowers to grow where they are—when the poor things arrive they are all mutilated, squashed, lifeless—they cry and make me sad. Send me only your good kisses; kiss the little flowers for me, but do not destroy them, *ou gare à ton sale cucu quand je viendrai.*

I am going to start to do coloured drawings for tiles, and paint friezes for wall-paper; it amuses me much more than doing illustrations, and perhaps I can make something of it, for with the people I am in with at present, there is nothing to be got except by being exploited, and for the little statues I have to have ready money. All good things to you, beloved. I embrace you most passionately, and will write more to-morrow.

Thursday

Madrozka Milosé, I didn't go to draw at that class the other evening, because I got a letter from Lousada asking me to take him the bronze. I send you only £5, for I must keep a little for plaster for a portrait which Bob Rider has got me, a commission not yet definitely decided. The fellow is a friend of Rider's, and likes the portrait of Smythies, but he can't pay £10 for the plaster, because he is poor, so Bob is going to arrange with him for £5. Marsh† has written to me again, asking me to dinner at the 'Moulin d'Or' next Wednesday. Shall I square that by giving him 2 or 3 drawings, or not? What do you think?

I think I shall be able to sell some of the drawings for decorative tiles. Keep well, my Mamusienka, dear love. Be happy. Are you working well? Have you received the little parcel?

Pik.

* Gaudier wrote of Mr. Dan Rider as Bob Rider.
† Mr. Edward Marsh. In replying to one of Mr. Marsh's letters Gaudier says: 'Your envelope bearing the Admiralty seal gave me a sort of fright—I had a vague idea I was going to be arrested for some reason or other—the look of governmental authority is always more or less frightening to people not accustomed to it.'

Mordo jedna napisaj mnie że "tu as bien reçu
cette lettre avec les pieniądze"

Zosik a beaucoup des sous !!!
et pipik pas du tout, Lilim.
il braille—

PART TWO

12th November, 1912

My dear love,

Now that I have got over all the fatigues of the journey,* two real
impressions remain with me. In the first place, that sweet sensation
of perfect and profound love which unites us one to the other, and
next, the pleasantness of Sisik's curtains, and the grace of all the
sculptures which decorate the garden. Dear, you are in a charming
place, and the air is making you much stronger. All the lovely coun-
try, not grand, but very intimate, very human, and rather Celtic, with
a gaiety of its own, has made a great impression on me, and even
more on the Zosik, because she has had longer with it. . . .

The terra-cotta mask which I took away has no charm in a room,
and I'm sorry I brought it—it's a good work, but to come into all
its beauty, it needs the open air—the side of a hill. The four walls of
a dirty room spoil the poor thing. I have hidden it so that I shan't be
annoyed.

Yesterday I finished the two tiles which I had in hand—they are
the best in colour I have done so far. I have seven. I'll go on doing
them until the end of the year, and then try to sell them in January.
This evening I started the nude—but there, again, I don't feel too
happy, for now that I have communed with the body of my dear
Dziecko, I don't find these models very beautiful, or even desirable
to see. Anyhow, one must work, and put little Eros under the lash,
when he tries too hard to tyrannize. I now feel just the same towards
my good Zosik as I did during those first days at Combleux, when
even to speak to someone seemed to me a sin against our love. . . .

I read that the place left empty by the Gioconda has been filled

* Gaudier had been to see Miss Brzeska for the week-end.

by the portrait of Baldassare Castiglione, the perfect gentleman of the Renaissance, the author of a book very celebrated at that time, *The Courtier*. . . .*

I feel compelled to tell all this to my good child because it pleases me so much. I adore all those rich stories of the Italian Renaissance. They savour in a peculiar manner of the lovely Latin civilization, which reveals the ancient customs of Rome, and are deeply impregnated with one's own pagan Christianity—of which Christ and the Virgin are the supreme gods, and in which each saint has his own special and well-defined province.

My old dear wished to see her Pikus until the last moment, so she stretched her poor head and only looked at the front of the train. Although I cried out 'Zosik!' and made the most vigorous signals of distress, she would never look round to my end, and so, my poor darling, I saw you longer than you saw me.

I had £5 4s. 2d. from the boss for my expenses, so with the money I gave you, I have gained 30s. on the trip†—not counting the celestial joy of spending two such good days with my sweet lover. It was therefore one of the most splendid windfalls of our life. My dear heart of Zosienka, I kiss you with such passion, I lavish upon your lovely body all the deepest expressions of my love, and my soul is inseparably held in yours. . . .

14th November 1912

My precious love,

I called on Marsh last night, and there saw the most magnificent examples of Girtin's work—it impressed me immensely, and Constable and Turner and Cotman—in fact, all the best 18th to 19th century English landscape. I am still enchanted with it all. . . .

I went with Marsh to see Gibson—he isn't at all the sort of chap I thought he was, but much more sympathetic. All the poets have joined together to hire a big house near the British Museum, where they live and work, and have underneath it a shop where they sell poetry by the pound—and talk to the intellectuals. Some of them have huge, vast rooms, while those like Gibson have only a tiny hole. He is boxed in a room, over the door of which is written, 'In case of fire, access to the roof through this room'. I have asked him to come and see me some day, so that I can see what sort of a fellow he is. Marsh thinks he is very talented.

This morning I had a letter from Frank Harris. He says that he will come on Sunday, and I have laid in two cwts. of clay. He continues, 'I would be very glad indeed for you to model my bust, if it is worth doing, but I go to New York to lecture at the end of the week,

* Gaudier here gives a short Life of Castiglione.
† Gaudier included this week-end in some business he had to do for his firm.

and I don't know whether you could do it this Saturday or Sunday. I would put a room at your disposal here, or I would come to you, whichever you prefer, please let me know. I have known Rodin for 25 years; I bought a dozen bronzes from him quite 25 years ago, and have admired him this side of idolatry ever since. It is twenty years since he asked me if he could model me, and I did not think I had done anything that deserved such an honour, so I refused.' It seems to me that to seek out a sentence like that last one, a man must be pretty conceited and pleased with himself. By special arrangement, there is a portrait of him by Fergusson in the last *Rhythm*. I admire this enormously—Marsh says that he would never have recognized Harris—Murry swears that it is the spit of him. In any case, for Fergusson to have knocked off so good a picture, the old chap must be a jolly good model, and we will put him through the mill with pleasure,* particularly as I am now dying to do a portrait.

I have been reading the doings of the Prince de Condé in the *Revue des Deux Mondes*, and I was very much interested. What corruption under Louis XV! [etc.] . . .

The Lousadas want to change the colour of the group to light green. It has now a marvellous patine of old bronze. I have written to Parlanti to make it green like the leaves of a cabbage. We will laugh, for they are so close that they will never buy anything big from me,† so I may permit myself the pleasure of letting them go to the devil.

It is Maud Lousada who writes in the name of the Holy Duality, of which she is the Divine Spirit.

I went to the life class. It is kept by four stupid old women. The model—a lovely young boy—wore a tiny little cloth, and the quick sketch wasn't a quick sketch at all. The model takes his own pose—which is, of course, a good thing—and keeps it for ten or fifteen minutes. I should have liked to have a model who didn't pose at all, but did everything he wanted to, walked, ran, danced, sat, etc. To-morrow we shall probably have a woman.

My dear love, you are surely not working so assiduously that you couldn't find time to send me even a postcard, and me away from you and all, and so very anxious to have a word. You know very well the agony of being lonely, and you want me to write to you in the middle of the week. I have far less leisure than you have, and it makes me sad to see that you forget me. So make honourable amends next week by sending me a little postcard. I have not had time yet to translate 'Hell' for you. Monday, 2 tiles; Tuesday, class; Wednesday,

* Et nous le stigmatiserons avec plaisir.
† The £20 which the Lousadas paid for this group (*L'Oiseau de Feu*) was, all the same, the highest price paid for any of Gaudier's works during his lifetime.

Marsh; Thursday, cleaning the rooms; to-morrow, class; Saturday, Zoo and the Museum; Sunday, Frank Harris; and the rest of the time sleep and the office, from which I am now writing to you, in a moment of leisure. I love you so much, little Zosik dear, and I kiss you passionately from the head to the foot of your lovely body, and pray the warm sun for your happiness and the success of your work. I love you tenderly, and wait feverishly for the first chance of seeing you again, of possessing you fully and fondly.

Friday

I cleaned all yesterday, and then had a hot bath in front of a good fire, and slept without my clothes, in order to make believe that I was with my Sisik.

Don't talk to Tommy about the vases; he might want to have a share in the transaction, and we want it for ourselves—don't speak to anyone. As for the agate, I forgot to tell you that it is only volcano lava. I examined it very carefully and it is entirely without value. The stone Christ is certainly 15th century or earlier; I believe that without going wrong you could put it at the 12th or 13th century. English sculpture has always been behind the French of the Middle Ages by a couple of centuries. In French Art, this style of Christ would be of the 9th century, considering the crown and the form of the cross and the work around the eyes and cheeks, but the moustache and beard are of a 12th or 13th century French style, so you might say that the whole piece, which is English, existed at the end of the 15th century and the beginning of it might go back as early as the 12th century. You must not dream of paying more than 15s. or 20s. for it—that is why I telegraphed.

Of the pottery vases, only consider the one with the smiling figures—the one standing alone in the garden, not either of those at the foot of the little stairs, and don't pay more than 10s. to 15s. After these purchases let's buy nothing more—for this reason—if we carry on like a couple of profane collectors we won't be able to enjoy the little money we have—there is nothing more horrid than lots of repulsive fragments which have no relation to each other all huddled in one dwelling. One ends by hiding them, and then they are no use. My Zosik is too much infected with the desire for property. The curtains and pots are quite enough, and it is not really worth your while to go charging all over the country for the remains of antiquity. We want neither to tie up our capital in antiquities nor to set up as antiquaries. We have need of all our activities to carry on our own affairs, and to publish your book. Remember, dear Zosik, that for that you will need a very great deal—so better buy nothing at all if you are not already committed, and leave the pots where they are. The memory of them and the desire they provoked are better than the possession. I don't believe that it is at all desirable to have them,

and as for considering it an investment, they are not worth the trouble we should have—we should never sell them unless we had to, and then no one would buy them. I hope so very much that you have not yet committed yourself to anything.

I implore my Zosik to work hard and regularly, at least five hours a day. You must remember that each month you lose a week by your illness, and we are such poor devils that we must keep ourselves very much in hand and not waste our time, but produce.

My Zosik disappointed me—I had looked for a long letter, but there was nothing. You don't seem to have cared to hear about Castig-lione—it makes me feel that it is no use bothering to tell you about

things. You complained at the beginning that I never talked to you about things—but how can I if you pass it all over in silence?

It distresses me to see how you waste the good sunlight. You don't get through all your affairs until 11 a.m. and then you go for a walk until 12—lunch 1 o'clock, and you don't get up from your rest until half-past two—and there's the day spoilt, you haven't time to write to me, and you ought to—whereas I, with many more preoccupations, visits and work, am expected to talk to you about all that is going on, keep you up to date, etc., and you give me no encouragement, for you don't seem to notice it at all.

Zosik, love, please be a little sweeter and a little more noticing, I'm not at all annoyed—I know you are a dawdler, and I wish you weren't. If you want to make me happy at Christmas you ought to be through a good quarter of *Madka*.*

I kiss you a thousand times, dear beloved, and wait with great impatience for your news—send me a postcard on Wednesday—I shall get it on Thursday. Dear love and affection.

<div style="text-align: right">Pik.</div>

P.S.—The wills I made are wrong. I will do them again, and they need 6d. stamps.

<div style="text-align: right">16th November 1912</div>

Dearest and Best,

I went to the Zoo. The beasts had a curious effect on me, which I haven't hitherto experienced; I have always admired them, but now I hate them—the dreadful savagery of these wild animals who hurl themselves on their food is too horribly like the way of humans. What moved me most was a group of four chimpanzees. They were like primitive men, they walked helping themselves with their hands, and looked like old men, their backs all bent. They discussed things in little groups, shared their food without dispute but with much wisdom—the strongest giving bread and carrots for the oranges and bananas belonging to the others. It's most depressing thus to see our own origin—depressing, not because we sprang from this, but that we may so easily slip back to it. Our knowledge is great, but how empty! How ephemeral! So small a thing, and we lose all. We no longer know chemistry as did the men of the Italian Renaissance, and it will be a long while before we re-discover their secrets. Art comes instinctively to us, but it is so uncertain, I have in front of me photographs of all Rodin's best works; the more I admire them the further I feel myself removed from all art, it seems so easy, so limited! We are part of the world creation, and we ourselves create nothing. Our knowledge allows us to make use of all the forces already in

* One part of Miss Brzeska's *Trilogy*.

existence—our art to interpret emotions already felt; a big war, an epidemic, and we collapse into ignorance and darkness, fit sons of chimpanzees. Our one consolation is Love, confidence, the embracing of spirit and of body. When we are united we think neither of outer darkness nor of animal brutality. Our human superiority vibrates through our passions, and we love the world—but how insignificant we really are, and how subject to universal law! Mere midgets in the wide universe, but masters of our particular planet. Oh, Zosik, Zosik, how strange it all is; in my memory, I compare the slender springing grace of a lovely man with this hairy mass of monkey flesh, the mastery of an energetic head, full of individual character, with the stupid masks of chimpanzees who can scarcely raise the beginnings of a smile. These comparisons are so terrible, so formidable in the mind; for if the blind masses of humanity, which always persecute their pioneer spirits, had the desire, or rather the power, then would our tall and erect stature be bent, and we should be covered with hideous fur; the grass would grow over our finest works, and we should return to bestiality.

These wicked people who are so ignorant, we hate them—don't we, dear love? These brutes who have eyes for nothing save their animal passions, who think only of eating, who fight each other, and wallow in dirt—foul, disgusting fellows who only crush people of our kind, whose instinct is for beauty, for ideas and for reflection. Sweet dear, I am so blessed in being able to love you, and blessed be the day when the great sun guided me to you; without your love I should have been flung into an outer darkness, where bones rot, and where man is subject to the same law as beasts—final destruction, the humiliation of extinction. Dear, dear love, I press you to me with all my force, and only your help enables me to work. I thank you, dear Sun, lovely Star, for having created women and men that we may be united, mingle our personalities, melt together our hearts and, by the union of our passionate bodies, better liberate our souls, making of us a single creature—the absolute human which you have endowed with so many gifts.

Good-night, dear heart, sweet Sister, Mother. Think that we are together in the same bed, and by our perfect union, making prayer to God.

Sunday, 17th November

I woke up full of life, and was quickly at work. I painted. Yesterday afternoon I went to the Zoo and drew a little, not so much as I would have liked, because of the dark day and the distraction of my thoughts —all the same, I have a few drawings, and I painted two buffaloes, one white and one black, each against the other, and I am happy.

I am sorry that I did not take Smythies sooner to Bob's. I should

have been ready to sculpt Harris. He promised to come to-day, but a telegram has called him to America; he says he will come in January. On Friday evening I met at Bob's a young actor called Wheeler. The same sort of type as Murry. He works like Pik by day, and acts in the evenings and on Sundays. . . .

I went to the class again on Friday, they had a man again, but old, brutal, with a great belly. I worked well, and I asked the old woman when we were going to have a woman to draw. She promises one for this week. I am anxious to see if the old bitch will make her wear a rag as she did the boy—just as if she were in her *suiski czerwone*—for all I know, they'll hang another over her breasts. The people in the class are so stupid, they only do two or three drawings in two or three hours, and think me mad because I work without stopping—especially while the model is resting, because that is much more interesting than the poses. I do from 150 to 200 drawings each time, and that intrigues them no end.

Zosik love, I really must stop writing to you for to-day, for my little fire is already almost out and I must cook my supper on it, as they haven't yet put in the gas.

I have hung my beloved's mask above my bed, and the shadow it makes on the wall is so utterly like my Sisik's that I am constantly startled, thinking it is she. Kisses, sweet dear, I hold you to me in love and tenderness.

Tuesday

Sweetheart, the lousadsiny invited me to supper last night, and they are coming here one of these days. I have only got £1 10s. left for the month, and, poor love, I cannot send you the stove, etc., but if I sell something, as I hope to do, then I will. Pet, I want so much to write to you this morning, but I have heaps to do and really must stop. I kiss you incessantly, I'm filled with longing and am always thinking of my Sisik and want so much to make love with her. *Je suis lourd à cause de cela et je vais essayer encore une 'tite putain quand j'aurai des siousions* ("Five shillings, lay your money down, sir! Lay your money down!"), *à la santé de ma mamus, car ça m'empêche de bien travaillerr*——

'*Zosisik, ne sera pas zalouse, n'est-ce pas bon petit amour, c'est seulement pour vider ces vilains workis*——

Friday, 22nd

Dear love, you can't imagine what a state of mental depression I have been in lately. I am a bit better this morning. I have no real reason for detesting Tommy and Chuquie. They've always been very kind to me; it is just my own stupid ideas. I went to see them last night, and

118

I like them better than ever. Fraser asked very anxiously after my Zosik, if she were well, etc.

Dearest, I can't make any headway, these cheap lodgings depress me, and I'm going to clear out in the first week of December. I will take a nice little studio, not on the ground floor, because ground floors will always have the same disturbing effect, and will be so much money lost.

Boss won't make a contract, either with Watkins or with me, and that's all to the good; but what isn't good is that he is only going to give us a £1 rise—we are going to try our best to leave him while he is in Norway. Zosik mustn't worry herself about anything. I shall always find work of some sort or other, and she has only to breathe the good air, and not force herself to work until the New Year. It is better to have an end in view, don't you think? Poor darling, don't write such long letters, it only makes you over-tired. I am a graceless creature who always will clamour for more honey, though the poor bee gives her very guts to provide it. Sometimes I am too hasty with my Mamus, and sometimes I accuse her of wickedness just to stimulate her to reply. How strange these sensations of love are—I almost become jealous of myself! . . .

Poor darling, I haven't even a little sovereign to send you. I should have to borrow, and you wouldn't like that. Next Saturday is November 30th, and I shall then be able to send a little. I went to see Rider at his house in Hammersmith, and he spoke of Harris, but this for next week. Ten thousand kisses.

<div align="right">Pik.</div>

<div align="right">*Sunday, 24th November*</div>

My dear Love,

I am going to have a rest to-day, and I profit by it to write a long letter to you. Darling, when I say I am jealous of myself, it does not at all mean that I doubt your affection, it only means that I love you so much that I don't wish to see or speak to anyone. Zosiumo, you are such an intelligent Zosik that you should have understood that when I wrote to you as I did last week, I wasn't in a normal condition. The truth is that since my return I have been utterly upset—one day I was full of the most exuberant joy, and the next in the worst of depressions.

I came back overstrung by sex feelings which have lasted almost until now, and it is because of that that I am taking to-day quietly. I won't work at all. I shall buy slippers and an umbrella and stock my larder from the 'Home and Colonial'* and soon be all right again, so don't worry about me. . . .

* Henri had a horror of umbrellas, and all this is only a figure of speech for coddling himself.

Wheeler came yesterday to help me take the Bagnold head to Fraser's studio. We hired a little hand-cart, and we laughed enough to piddle our pants. Wheeler has an engineer brother, who is going to try to get me some regular and paying work in Birmingham, little ornaments, heads of lions, etc. He's buying a tiny statue for himself for £2. Fraser's studio is a magnificent place, a huge room with two walls entirely taken up by windows, a gallery at one end, and two rooms above—all lit by electricity.

He has got a lot of pictures, but all scenes of carnival, a life superficial and automatic, with no kind of depth or idea. In order to flatter me, he has had a beautiful book bound, and stuck in the drawings which I gave him in the hopes of further passes to the Zoo. On the cover he has put in huge letters of gold, 'Studies by Henri Gaudier-Brzeska, 1912'. The tiles and the masks which I did at his house last March are framed in white passepartout, and look very well. Now don't you go accusing me of inconsistency, and of flattering Fraser. There is nothing of that. For the last six weeks I've made no attempt to see him, and then last Thursday I met him at Bob's, and he asked me to come with the Hares on Saturday and bring the head of Bagnold—she wants to have it cast, and is ashamed to ask me, because she has left it so long. I was full of curiosity to see Fraser's place, and also glad to get rid of these big heads of Bagnold and Murry.*

You remember my speaking of ——, he is a queer devil. I told him I should like to see a couple in the act of love, and so he is going to arrange a meeting, but the difficulty is to find a woman. He suggested that I might draw his children—the little two-year-old girl is very beautiful, he says, lovely limbs—I must profit by this. I have worked well these last two evenings at the class. Tuesday a girl, without a rag, and Friday a beautiful youth with a wrestler's loin-cloth of black silk bordered with a lovely Indian stuff. If they all wore that sort of thing it would be all right, but a tiny covering is ridiculous.

On Friday I found waiting for me a reply-paid telegram from Marsh, inviting me to dinner. As I had the class and was terribly keen to work, I sent a letter yesterday morning returning the reply for 6d., inventing the little lie that I only came back at 10 p.m., and his telegram asked me for 8. One must follow the advice of Sisik and make oneself 'hoped for'.

This afternoon I am going to see some Americans, Gaylord Wilshire at Hampstead, a syndicalist—very keen on the bust of Haldane Macfall. A well-known collector, Judge Evans, is also very taken with the bust, he is going to come to see me in a fortnight's time, when I am settled in my studio. On Wednesday, I went to look up Dan Rider, and he took me to the Café Royal, and there I drew while he slept, because he had a ghastly headache; after that he took me to his

* Gaudier afterwards destroyed the head of Murry by throwing stones at it.

house in Hammersmith, where we had a magnificent evening. He is very natural and open, and we soon became good friends, when we found that we were both passionate naturalists. Like Pik, he has studied and adored ferns, the reproduction of plants, sea-stars, the collection and life of shell-fish, flowers, insects. He talked a great deal about Harris, whom he admires tremendously. According to him, he is a most honest man of the Castiglione type. He knows all the big bugs, is an intimate friend of the Princess of Monaco, of Lord Howard de Walden, of whom you will have received Rodin's portrait before you got this letter, and Bob really thinks that he will try to push me, because he liked enormously my Nijinsky and Smythies. It was Bob who introduced Fraser to Harris, and though Harris hates Fraser's affected ways, he has introduced him in many places, and has done a great deal for his reputation. Bob thinks me much better than Fraser, *un dieu sur une pelle à pain*, which naturally pleases the old Pikus, who loves to be admired, but who, at the same time, sees its exaggerated stupidity, and is amused by it.

Zosiuno, you need have nothing to fear—whatever happens we shall be much better off than we were two years ago, when we knew no one but Slocombe. Poor darling, I am sorry to have bothered you by speaking to you of your work. Don't harass yourself, dear. Stay quietly in the little spot where you are, and I will fight in London, as far as in me lies, for our common good. We ought to be successful, because we are one with the dear sun, and that great god of ours has not ceased to shine since I began writing to you. I kiss you so lovingly.

More to follow.

Pik.

Monday

After I wrote to you yesterday I went to see Epstein. While I was ringing at the front door his missus stuck her head out of the window to see who I was. Epstein came to the door and asked me to come upstairs. There is an enormous difference between old Epstein's place and that of Fraser & Co.—Little Epstein, dirty and dusty and covered with plaster, sitting on the sill of his window, cutting at marble. In the room, two bunks mean and miserable (like Pikus' chair), one bigger than the other—a little table, very small, and nothing else. No picture nor image, nothing on the large white walls, only the torso of a woman, half-broken, in a corner. He spoke to me about his Oscar Wilde in Paris. When he arrived he found that the sexual organs had been covered over with plaster—later the Prefect of the Seine covered the whole monument over with straw, as being altogether indecent. Epstein took off the straw, then the plaster, and restored to his Wilde his *couilles de taureau*, which hung down at least half a yard, and through the petition of some artists he was able

to get the better of the Civil authorities. Later on he showed me a little bronze, very beautiful, quite the nicest work of his I have seen—alive and sincere—a seated woman with her arms above her head. ... We smoked together, talked of castings and marbles as usual, and I left.

I had no sooner got back to my room than I hared off to Hampstead—it is a beautiful suburb, built like Rome on seven or eight hills. I walked for two hours on the Heath in the fresh air, and discovered magnificent views of hills, like those of Malvern, but much more numerous, closer together and covered with trees. I went to the Americans' and was pleasantly surprised. I expected to see only business men from Wall Street, clean-shaven, hideously square shoulders, puffy skin and nasal accents. He is a little fellow about fifty years old, with a beard, a shy appearance, delicate, and not annoying, to look at. She, a large woman and more interesting. American skin, but hard, red, with few lines—you know, *peau de buffle*, hair dressed *à l'Allemande* in bandeaux, with a turned-up nose. In their room were assembled about thirty people, French and English. An elderly author, very interesting and sympathetic, with white hair and beard, Whiteing his name is and *No. 5 John Street* his work. I must try to read it : his ideas on Art are sound and he spoke very clearly, I had a long talk with him and I like him. The party was freer than any I've been to before, it was possible to get into little groups and speak for a long time independently.

A Russian actress, ——, a woman with a monocle and pretty stupid, asked me in French to explain to her futurism and cubism. When for a joke I made her believe that it had something to do with homosexuality, she asked me to go and see her on Thursday evening after dinner. She is at home on Wednesday afternoons, and as the boss is going to Cardiff this Wednesday, I rang up to say I was coming in the afternoon, which suits me better. She had asked me to come alone with Mrs. Wilshire, and it would have been no fun for me to have a *tête-à-tête* with the two of them; by going in the afternoon I have always a chance of meeting other people.

There was at the Wilshires' an old French woman characteristic of all that dirty middle-class race, dropsical, double-chinned, skin speckled with these little coalish black spots that you only see in the Latins—toads' paws on dirty tripe, and she lording it about—I wished her to the moon and the devil. I will write to you after Wednesday about the Russian, she speaks very good French, German and English, and is an actress. ...

I have been telling the tallest stories. The Americans call me Brzeska, and several of the French when they heard that I was *polonais* said to me that I spoke French and English like a Russian, and several others who had thought I was Italian saw very clearly from my type and my walk that I was Slav. What fools ! What asses !

It amuses me once in a while, and I shall go once more before I have my studio.

<div align="right">Pik.</div>

My dear good love,

Yesterday I went to the Russian, she is rather stupid, and I won't go again. In the afternoon I went to see Wheeler's brother, who is director of —— and a pleasant fellow; he has travelled a great deal and is particularly fond of the Poles. Making use of Sisik's description, I talked to him of Cracow and Zacopane, which he knew, and he was very keen on the Tatra : so all this affair served to adorn the conversation and prepare the ground. He gets big contracts of copper, wire, carriages, motors, etc., for firms in Birmingham, and he has a great deal of influence with these people. He is going to give me an introduction to one for motor mascots : they have already complained that they have to get them from France, because there was no one here who could make them. He has recommended me to another for electric radiator ornaments. On top of this he is very much interested in sport, and has commissioned me to make two little statues in plaster —one of a wrestler and the other of a bather—which he will have cast in bronze by one of his firms. In his office he has the very wrestler that I liked so much—a wonderful boy, strong, taut and finely square. I am going to see wrestling in the evenings two or three times, which will give me good sketches; I am also going to see some boxing matches and diving, and I'm terribly excited about it.

I will do him two little statues, the height of your little dancer, for £4 and 30s. extra for the plaster; I shall make £4 nett. Not much, I know, but the devil of it is that I must hit it off with him in order to get more work. He has promised also to give me some introductions for advertisements. He seems very honest, and I don't think he is promising all this in order to get a couple of works cheap. Anyhow, I'm prepared to expect the worst and count no chickens, save those of seeing beautiful athletes in action. The old hag at my evening class promised a magnificent model for to-morrow—a beautiful Frenchwoman. The fellow who was there on Tuesday was a poor little Italian workman, and it is from him that I have made my best studies. The old woman and the other idiots in the class think I am mad. As I have already told you, I work all through the evening without a stop in order to get my full six-pennyworth. They try to talk to me during the rests, but I don't reply. Only when I have finished, if they speak to me I reply, and if they don't, I just clear off, saying 'good-evening'. For fun I speak to the Italian models in Spanish, this gives me prestige and makes me seem queerer to the class—but I do it really from a desire to speak nicely to these poor devils, who seem frightened in

the midst of such unimaginable brutes. It is impossible for you to picture these asses.

This drawing is very far from the mark and will give you only the dimmest idea of this band of coconuts. There is among them a young blood who has always something to show or say in order to draw attention to his stupid person. One day it was a Russian ikon, which he neither understood nor admired, and another day it was a German amber and meerschaum pipe; but what took the cake was on Tuesday. It was raining cats and dogs, and the fool came in a hideous pair

maîtresse élève élève élève élève

of suède boots, quite new. He fidgeted about so with these boots that the old hag complimented him on his footwear—he took them off and showed them to everyone—not to me though, for I have sent him packing a couple of times already, and he doesn't dare come near me. He kept saying, 'It was when I was going to Russia some years ago, I bought them in Sweden for shooting, you know they are very comfortable for shooting'. Pah! I can see the fool from here! *Un très sale coco.* Anyhow, it didn't interrupt me, because I forgot it all as soon as I began working.

Yesterday, after I had been to the Russian's, I went to Macfall's, he lives quite close. He spoke again of his hideous painting, accusing Fergusson of having copied it; that Fergusson only did his still life under the influence of Macfall; that he (Macfall) introduced to the world Turner, Steinlen, Nicholson, Orpen, Fergusson, and Simpson; that he (Macfall) is very busy, but will find time to introduce me to the world; that he will write an article on me, the great Macfall,

Gaudier-Brzeska no more than a toad. He told me to do something for the Royal Academy. At this I laughed in his face, and told him that he didn't begin to know the slightest thing, neither of drawing nor of writing. . . . In the end, I told him quite gently that I didn't look for help from anyone, and we parted the best of friends.*

<div align="right">Pik.</div>

This afternoon I went to the British Museum. I looked particularly at all the primitive statues—negro, yellow, red, and the white races, Gothic and Greek, and I am glad to say I was at last convinced of a thing which had for a long time bothered me. I had never felt sure whether the very conventional form of the primitives, which gives only an enormous sensation of serene joy or exaggerated sorrow—always with a large movement, synthetized and directed towards one end—had not a comprehension more true, more one with nature : in other words, ampler and bigger, than modern sculpture from the Pisani through Donatello up to Rodin and the French of to-day. Having very carefully studied the two aspects, at the moment I think not. Up to what point I am absolutely justified I can't at all say. My first reason, and the one I consider most sound, is that primitive sculpture seen in large quantities bores me, whereas modern European sculpture seen in the same quantity interests me infinitely, without boring me, and if I go away from it, it is because the strain of looking at it and understanding it upsets me, tires me. I have to go away, but with regret and with the firm intention to come back soon. All that seems to mean that I am an individual—a Pik Gaudier Brzeska—and it is my individual feeling which counts the most. Why? I do not know nor do I wish to know. I accept it as a fact which does not need explanation.

Now, when I think it out I see that in modern sculpture the movement, without being so big, is nearer to the truth. Men do not move in one movement as with the primitives : the movement is composed, is an uninterrupted sequence of other movements themselves divisible, and different parts of the body may move in opposed directions and with diverse speeds. Movement is the translation of life, and if art depicts life, movement should come into art, since we are only aware of life because it moves. Our expressions belong to this same big movement, and they show the most interesting aspects of the individual; his character, his personality. What kept me in doubt was, I think, the very simplicity of the early primitives in rendering movement, their conception of things in general being very simple, that of the modern being more complex. To-day it all seems to me the other way round—the movement of the primitive is a misconception of true movement, is a fabrication of his mind, an automatic creation which corresponds in no way with the natural movement of the living

* 'Amis comme cochons'.

being. In one word, it is complicated because he does not take the trouble to probe deeply, but invents, creates for himself. The movement of the modern seems to me to be simple because, putting aside all his natural capacity as a human automaton, he uses his energy to see well, in order to render well what he has felt well in seeing well. . . . To conclude, in order not to afflict my Zosik's ears too much, I am in entire sympathy with the modern European movement—to the exclusion always of those moderns who belong to the other class, those who invent things instead of translating them.

Pipik.

London Saturday, 30th November 1912

Dear Sisik,

At last I send you the gingerbreads, poor dear. It seems a long time to have to wait for four wretched buns. Yesterday evening I met Enid Bagnold in the King's Road*; she asked me to do a plaster cast of her head, and I told her it would cost £3, so I shall make 35s. on her, which will do for casting a statue, which I will begin to-morrow—I have sent Parlanti to get the model from Fraser. She asked after you and wishes you etc. etc., anything you like. She asked me if I wasn't lonely. I replied rather evasively that I was working. That made her laugh in a rather cynical way and say, 'O well, I don't think you mind much' . . . *Sale garce abominable*! I'm not quick at repartee, and while I was chewing over what to say, she started talking of something else. The girl at the Library also asked after you. I told her you were in the country and she said, 'Oh, that's nice', and that you wouldn't come back for several months, 'Oh, that's nice'—everlastingly 'Oh, that's nice' . . .

Tommy is still trying to do business with the 'Madonna' since Carmi is in London in a ghastly piece called *Venetian Night*. . . .

Many kisses and my love in your heart, dear Zosik.

H. Pik Gaudier-Brzeska.

15 Redburn Street, Chelsea, S.W.
Tuesday, 3rd December 1912

Sisik dear,

I went back to Hampstead on Sunday, worked in the morning, and needed some fresh air by 5 o'clock. I talked all the evening to an American woman : she has a pleasant face, but there is always this twist of the lips in speaking—this nasal tone that drives you mad. She is receptive, admires artists, because they can probe to the depths of existence; admires good music and interested me very much with stories of the customs of Red Indians and their music. They weren't

* Miss Bagnold was studying painting with Mr. Walter Sickert.

snobs, these American devils I saw—but there is plenty of that to make up for it in the English who go there. There is something queer about them all. There is no need to be sincere with any of them. The Wilshire woman is intelligent; he is very reserved, smiling, and rather shy—they both have a bit of a lost look. I can't make them out. Anyhow, one can always study people, as there are always new ones there, so I'm told, and you always can talk to one or two people without being disturbed during the whole evening.

Wednesday

You are a wretch. You write me two very abusive postcards, and you carry on like a fiend instead of keeping quiet. My poor darling is very upset I know, but I cannot help feeling that the excursion to Bromsgrove was terribly rash, and to be so afraid of getting the old illness again is unworthy of a courageous Sisik like mine. Anyhow, another time Sisik won't go on like this, but will behave like a sane person. As for the buns, etc., I couldn't get them on Saturday for two reasons : (1) I had to look for a studio and had a rendezvous at 2.30, and I knew you weren't dying of hunger; (2) I couldn't get the books, as all the shops shut at twelve and I only got out at one, and also I knew that you didn't need books any more than bread.

Friday

Beloved, I am very tired; I have done nothing but rush from one place to another, and on top of that have done a lot of work. Last night I went to see the wrestlers—God! I have seldom seen anything so lovely—two athletic types, large shoulders, taut, big necks like bulls, small in the build with firm thighs and slender ankles, feet sensitive as hands, and not tall. They fought with amazing vivacity

and spirit, turning in the air, falling back on their heads, and in a flash were up again on the other side, utterly incomprehensible. They have reached such a state of perfection that one can take the other by a foot and, without exaggeration, can whirl him five times round and round himself, and then let go so that the other flies off like a

ball and falls on his head—but he is up in a moment and back again more ferocious than ever to the fight—and Pik, who thought he would be smashed to bits!

I stayed and drew for two hours and am going to begin the statuettes on Sunday. The negotiations for the £50 studio have fallen through. I must look for another. On Wednesday evening I went to see the Bagnold because of the plaster cast. She is staying with Dollie and another girl whom I don't know. There was a boy there called Lunn; we spoke of Murry but I don't want to see him again : I don't dislike a person easily, but when at last I do, it's for good. We arranged with the Bagnold that she should take the plaster for £3— with what is left over I will bake one or two little statues and buy a decent book for Christmas. The Bagnold still has the same peculiarity. In the middle of a conversation she rushed away to the Embankment without saying a word. Affected, of course—but in spite of that she is the most interesting of girls—she at least tries to understand and to get into touch with things.

I learn through the *Guerre Sociale* that Kropotkin, the great Anarchist, lives in London. I have heard the Wilshires speak of him and must ask them for his address—I should be the happiest devil if I could do his portrait. I enclose an article about him, although you haven't been interested in politics for the last two weeks.

I'm half asleep, dear love, and I don't remember what I meant to say. It will come into next Sunday's letter, and you shall have a long one next week. I am in a state of creative effervescence. I'm looking after myself well, I sleep well (for the last 7 or 8 days I haven't got up until 8 o'clock). The boss doesn't come to work until 11 a.m., and to-morrow he leaves for Norway.

I kiss you with all my heart, press you and hug you, dear love. I pray the Sun for you, your health and your work. I'm very happy about the hysteria and all that you tell me. I kiss you a thousand times.

Your Pik.

P.S.—Tommy, when referring to you, speaks in a general way of nerve maladies, which shows clearly that you must seem very nervy, for I have never said that you were ill in any kind of way. Tommy and Chuquie have put quite a pace on to find me a studio. They still want me to take the £50 one, and they say that the other ones further out are no good at all—that one needs a big one in a good position. As they insist so and as they are morally responsible I have left them to it. Tommy, with his knowing air, has given me to understand that if I take the studio he wants me to take he will get me some orders for illustrations—if not he will do nothing. That is the 'hoped-for change' he speaks of in his letter to you. 'La Chuquie' is already bucked at

the idea of helping me to move and of putting things in order, while Tommy will arrange terms, etc.

Oh, Sisik, do for goodness' sake calm yourself—I suppose not before our bread is assured from some other source.

Good-bye, 10,000 . . . kisses.

Zosik, dear, I kiss you, I kiss you.

<div style="text-align: right">Pik Brzeska.</div>

[*Postcard*] 10 *a.m. 7th December* 1912

Sappho, I understand that the important thing for you is intellectual intransigence, but for me the important thing is sculptural intransigence. Till you can understand this there will be no possibility of our discussing things with any accuracy and consequent possibility of agreeing. As usual, your pride detaches itself in its omnipotence, and you don't take the trouble to think of what you are writing. Your wailings on what I wrote to you are ill-placed—those on the Bagnold erroneous, those on the studio, etc., unreasonable. I will write all about it in a letter—Sisik sees the dark side of everything too much—herself included, and I repeat that if I were to carry on as she does, I should never do a statue in my life. Get into your head once for all that I'm a workman, and it is nothing to me to be *hoflieferant* so long as I produce. Tender kisses.

<div style="text-align: right">Pik.</div>

[*Postcard*] 4 *p.m. 7th December* 1912

Sappho—Wulfs has left and I have just made a contract with him for a year at £10 per month. I can't leave him before the end of next year, nor can he send me away before then. It is better than two years—one is a little freer, although I am such a queer, bad Pik, who makes Zosik unhappy. But, Zosik, it is never intentional, and you are a little too pessimistic, for you often scold unreasonably when you get on your high horse. As to the studio, there were some concessions I didn't want to make, so I am looking for another, more modest, at £25 to £30, in Chiswick. I don't want to upset the Hares and so alienate them. Lousada telephoned to ask if I had any statues, and I said No. I had better wait a little. I will get him to come in January. Much love.

<div style="text-align: right">Pikusik.</div>

[*Postcard*] 9*th December* 1912

I have refused the studio because it is damp and I should have to pay £50 plus rates and taxes. I have another to look at, as big as Epstein's—gas and water all included at £36 a year, but no bedroom. I suppose I could make one inside. Next door there is a smaller studio

which is, even so, at least twice as big as Fraser's used to be, at £26 a year, and probably I ought to take that and hire a room at 3s. a week, but I am awfully attracted by the big one, which has a furnace to do plaster moulds. I went to the Wilshires' again yesterday and met two charming people there, an actor and his wife—very sound ideas about art. They have been in England for 9 years and now that they have the chance they are clearing out, they detest it so much. They are Scotch, and they are going to America, where they say the people are just as stupid, but there is more freedom. I am writing you a long letter, kisses,

<div align="right">Pik.</div>

STUDIO LIFE

At Christmas Henri went to Dodford again, but he and Sophie did not recapture the joy they had found the time before. Sophie was feeling ill during these few days, and Pik caught a dreadful cold. It rained all the time, and they sat together in a room without talking. The landlady, it seems, hurried all the farm-hands to bed so that Pik and Zosik might be left undisturbed, and Zosik said she believed the landlady suspected they were not brother and sister, and if not, it was a typical example of English purity—ready even to encourage incest so long as it did not become obvious.

Pik stayed with her for four days, irritable and contrary all the time, and then, just before he left, told her that he was fonder of her than he had ever been before : he implored her to come and live with him in London. He said platonic love could not last for ever—that she had made excuses from month to month, from year to year, and with all this waiting his passion had died down—and then he hurried away to catch his train. Zosik was left very much disturbed, and Pik's letters only added to her worries. He complained much of feeling ill, he bled a great deal at the nose, didn't take regular meals, and suffered from the cold.

With the help of the Hares, he at last found a studio, and he wrote to Sophie :

The studio is a marvellous place, and I feel as if I had been lifted from Hell into Heaven, I am filled with inspiration, and burn with the holy and sacred fire of creation. What infinite peace after the hellish din of Redburn Street !

Ideas keep rushing to my head in torrents—my mind is filled with a thousand plans for different statues, I'm in the midst of three, and have just finished one of them, a wrestler, which I think is very good. I'm also doing sketches for a dozen others. God, it's good to have a studio ! It's disgusting that so fine a hole should remain empty while I am at this filthy 'business'. Zosik could be quiet here, and would write better than while stowed away in the country. . . .

A little later he wrote to Dr. Uhlemayr :

On the advice of some friends and patrons, English *mécènes* without generosity, I have taken this studio in the hope that it will bring me more work. Anyhow, I can work better here than in ordinary rooms —though what I really want to do is to sculpt a large statue in hard stone, and for that I must first get a commission. All this year I have been reduced to doing little statues in plaster and bronze, and portraits, which haven't in the least satisfied my desires or my ability.

The struggle for life is hard here, worse than elsewhere, because all these wretched people are without sensibility, without heart, attracted only by what is eccentric and odiously pretty. To get anywhere one must either wait for ages or prostitute one's art. The only advantage is that art fetches a higher price here than elsewhere, but against that food and lodgings are very dear. I would willingly go elsewhere, but where? I can't go back to France, for last October I deserted their Army, slaughterers of the Arabs, and if I return it is I whom they will slaughter. In Belgium there is nothing doing. Germany swarms with artists, and I'm not sure that the stupid law would leave me alone. It's better to persevere here, for in another three years I shall be a British subject and definitely free; after that we will see, perhaps I could go to Munich, Berlin or Vienna, it's my greatest desire, and when I have reached my full vigour, at 40 or so, I shall set up in France. Philosophically, if I forget my surroundings, I enjoy life and I feel that I am gaining an enormous experience, and in matters of art a very delicate sensibility. Life normally is so lovely, although filled with grave doubts; an artist always suffers, mostly because of the enslaved people who surround him, bleating like a lot of sheep. I still work uncongenially during the daytime at tapestries and calicoes, silks and carpets, but there it is—we must have bread, and in good times to come these will only be happy memories. . . .

One day at a friend's he met a girl with a demon-like expression, who, when he was alone with her in the studio, looked at him with wicked eyes, and complained that the old days of Bacchanalian debauch were over. Pik was again suffering from pains in his head, and in telling Sophie of this incident, he said that he had asked the girl to bring some of her friends to his studio, where they would indulge in some of the 'exercise' she seemed to want—it would do him good, 'and the old Sisik, who has so often recommended this to her Pik, will surely not mind.'

To Sophie's surprise, although she had formerly persuaded herself to the contrary, she found that now she did mind—she was terrified of Pik's getting into the hands of some girl who would tarnish his

innocent nature. She gave greater consideration to all that Pik had said to her, and for the first time she began to feel, mingled with her fondness for him, the magnetism of a physical affection. Pik said that his studio would make a charming home, that it had a small kitchen, and everything of the utmost convenience. Sophie decided to join him, and in February 1913 arrived in London.

The first blow which met Miss Brzeska on her arrival was Pik's telling her they could only sleep in the studio for a day or two, since the solicitors had said it was only to be used as a studio and not as a domicile. They would have to find a room somewhere for Zosik, and Pik could sleep in the studio on a camp bed which he would turn into a chair by day. Pik had promised, before she came, to clean the place, so as to receive her regally; but there had been other things to do, and when she arrived the studio was in the utmost dilapidation. There was a pool of water on the floor.

'Oh,' said Pik, 'that's nothing, the roof fell in two days ago and the rain came in, but they have repaired it now—don't let us worry about such things, let's have supper. I'll run and get a bottle of wine—eh! Sisik, darling, and then we will have a little love and then to bed.'

Sophie describes the situation : 'I had to wash all the plates and forks before we could start supper, everything was covered with indescribable filth—the Underground trains which passed just outside the window made a row enough to split my head in two, the draughts on all sides were as if we were on a lighthouse in the open sea, soot from the stove suffocated my nose and throat, and the general untidiness threw me into a nervous exhaustion.'

All night long in this strange room the light from a street lamp shone through its high window, and an old torn blind flapped and gesticulated in the gusts of wind which entered through a broken pane.

For the next fortnight Sophie lay ill with influenza. When she was better, she looked for a room and found what, at night, seemed to be a dream of quietness. She took it, only to find next day that she was surrounded with noises and, what was more, the landlord proved to be a milkman who, at 4 a.m. each day, was up and rattling his pails just outside her room.

She tried again to get a post as a governess, but she was always turned down, which is no wonder, since the demands were for a 'strong, young, cheerful, domesticated woman'.

Miss Brzeska had gold fillings in her teeth, and when she went to see friends or people she wished to impress with her importance, she would smile in order to show the gold; but when speaking to prospective landladies, she took great care to keep her mouth closed as much as possible, so that they should not suspect a millionairess, and raise their prices.

Henri Gaudier was very happy during these months, never daunted in his enthusiasm, always expecting a regular flood of orders which would be sure to burst upon them from one day to another. He calculated only in hundreds. They would take a magnificent flat and have a house in the country, spend the summer in Switzerland and the winter in Florence, London, etc.

These air-blown castles were perhaps due to the influence of Frank Harris, who had returned from America and was seeing a good deal of Gaudier. He must have found Gaudier's aliveness a great help, as also his sure judgement on quality. Gaudier, on his side, gained impetus from the financially larger life of Frank Harris. Harris came several times to sit, and at one of the sittings, Zosik met him. They seem to have got on rather well at this first meeting, and she and Pik were invited to dinner on the following Tuesday. Zosik had many misgivings—she hadn't unpacked her clothes, she had nothing suitable to wear, and for three nights she had hardly slept. Then Pik came home to get ready, and somehow before they could stop it they found themselves angrily bickering. In the end, Pik said :

'Zosik, don't be angry—see, we've again said dreadful things to each other, things we don't at all mean.'

She protested that she was now too tired to go out, but he persuaded her. She dressed in some strange, high-necked, tight-waisted red blouse with silver trimmings, and Pik was shocked, asking why she had got herself up like a landlady. There were then more words, which concluded by Pik's not minding what she wore, but Sophie said she wasn't going to sit opposite him and feel his critical eye upon her all the evening, to avoid which she dragged out of the bottom of her box a collar of old lace which had belonged to some Polish ancestress.

They arrived at the Harrises' punctual to the minute, but Frank Harris was busy, and they waited an hour. They occupied themselves by studying the things in the drawing-room. There was a statue of two lovers by Rodin which Mrs. Harris, according to Pik, was always hiding behind vases. Pik pulled it out into the middle of the mantelpiece, and Zosik said that if Mrs. Harris moved it back she would tell her what she thought about it. At last came what Zosik calls the 'Triumphal Entry', Mrs. Harris on her husband's arm. The opening of dinner is amusing as Miss Brzeska described it.

'What do you drink at dinner?' asked Mrs. Harris, who spoke to me with the utmost sweetness, never separating herself from her smile all the evening.

'"Well, really, I shouldn't drink at all, because of the state of my nerves."

'"Just make an exception for this evening," threw in Pik, who was also smiling. The smile of a lovely and gracious lady is contagious, so

we were all smiling as if some beatitude had fallen upon us from on high.'

They had champagne, it seems, and a very nice dinner, and everyone was in excellent form. Afterwards, they had great discussions about books, and Zosik said that she couldn't abide Balzac; that five times she had tried to read him but could never get to the end; that he was overdone and long-winded. Harris rose in his defence, and so the hours passed, until finally he suggested to his wife that it was time she went to bed. Pik on these occasions would never go, and it always ended by their being shown the door and, what is more, having to walk home, since the last 'bus had gone.

At the end of a long revolutionary political letter to Dr. Uhlemayr, Gaudier refers to the people he is meeting :

12th March 1913

I've lately met people who have a little more influence than those I've known before, and I'm to be introduced into the best circles of English *mécènes* (you can imagine their mugs), the Lord —— (who protects Ibsen because he is dead, and Rodin because he no longer needs it), Lord ——, Lord ——, etc., who wishes to buy things cheaply, keep them for a few years and probably sell at a large price —anyhow, I have no illusions—Illusion is a winged girl, but the English fog is so heavy that she can scarcely shake her feathers. I am in the midst of a portrait of a writer called Frank Harris, and he promises that in a few months everything will be going well with me. It's about time, for I am a little discouraged. I have suffered frightfully from all manner of miseries since I left Germany, doing all kinds of jobs, but if in the end I can give myself up entirely to my art I shall be the happiest man in London. . . .

Then Frank Harris went away, and things seemed to stand still— Pik dropped out of London life, and no one came near the studio. About August he was much disappointed at hearing that Harris would only have his bust done in plaster, but revived with the idea that he was an Artist, and Harris just a middle-class nonentity who would be too greatly honoured if Gaudier-Brzeska were to worry over his stupidities.

At this period the Brzeskas' friendship with Brodzky made an amusing interlude in their lives. Brodzky was a greater relief to them, for he did not mind their joking at his expense, yet he irritated as well as amused them. He gave them a sense of solidity, for he seemed a person so much less rooted than they were that they could offer him their protection; and they were able entirely to follow their own bent, since he was too indolent to interfere.

Gaudier started a portrait of Brodzky for the Albert Hall Exhibition, and he suggested to Sisik that she should come to the studio to

meet him. 'He is a Pole, born in Australia and brought up in America, not very clever, but a pleasant enough, amusing fellow,' Pik explained.

'I suppose, since he's a Jew, he's very materialistic,' said Zosik.

'Yes, frightfully, I tell you that the first time he came to see me, I was in the midst of arranging my drawings, and there were quantities spread all over the floor; he had hardly crossed the doorstep before he cried out, without even stopping to wish me good day: "Aou! What are you doing? Walking on your drawings? There are mines of gold in them. How wasteful you are!"'

Sophie found Brodzky lying at full length in the basket chair; he seemed half asleep, and could not bring himself to get up to welcome her. She was reminded of a big serpent warming itself in the sun. Pik, in his presence, seemed to be thrown into a vivid energy. He kept darting about, and every now and then would rush at Brodzky, leap on him, wrestle with him, or thump him about. Brodzky would defend himself as best he could, calling him 'Savage' and 'Redskin'. It pleased Pik to be thought an elemental, and Brodzky and Zosik would call him 'Savage Messiah', a name deliciously apropos.

Once when Pik came back to the studio, Brodzky leapt up, seized his hat and hung it on a peg to save it from the spirit of destruction which consumed the master of the house. He might easily treat it as he had treated his own, new a month before and now a crumpled piece of felt. Pik always looked like a scavenger who had spent the

night on the floor of a pub—he thought that a man could not be clean and at the same time an artist.

Ezra Pound says that Gaudier once burst out about Epstein: 'Work! Work? I know he does not work. His hands are clean!'

It was arranged that Brodzky should paint a portrait of Sophie, for which Pik bought a canvas. It went on for weeks, and got worse at every sitting, until Pik was horrified, and called it a regular 'academy' piece. Pik's friendship for Brodzky was often strained, and Brodzky's attitude towards this portrait was more than usually trying to him. Although they were very friendly, when they met there was always a slight antagonism on Gaudier's side. On one occasion, before a dinner party to which they had invited Cournos, Pik said:

'I hope that this time you haven't asked Brodzky.'

Zosik had, and Pik swore that he would go to the Museum and stay there until eleven o'clock in the evening. Zosik had thought that Pik was fond of Brodzky, but Pik said:

'Because I fool about with him, it does not mean that I love him. He is stupid and materialistic, and has no talent at all.'

Pik stayed all the same, for his outbursts did not mean much, and Sophie prepared a nice meal of hors-d'œuvres, meat, vegetables, fruit, and biscuits, with a good French wine to go with it. But all was spoilt, for Pik was insufferable: gobbled his food and behaved like a bear, chipped in whenever Zosik wanted to speak, and contradicted her from beginning to end; to have any say at all, she had to raise her voice to a scream, which frightened Cournos. Brotzky, according to Miss Brzeska, spoke little at dinner, since he was too much occupied with eating, though, from time to time, he encouraged Pik in his savage explosions. At eleven he left, and Cournos soon after, evidently with the fear that Pik and Zosik might come to blows in front of him.

Gaudier admired Brodzky's drawings, but used to tell him that he would never know anything about painting, and that he had really better give it up.

There was great excitement over Brodzky's expected millions from America,* and Zosik and Pik were delighted that he took the prospect of riches so calmly. They had a big 'beano' in Pik's studio to celebrate Brodzky's good fortune, and they became very merry: Sophie had not laughed so much for many a year.

Frank Harris now returned from America and though Pik had not heard from him while he was away, he at once expected great things from his return. They did not see much of each other, but when they met, Frank Harris was full of promises, and said he would buy the marble dog for five pounds, or the high relief in red and yellow. One of Harris's projects was that Henri should go with him to China. He was extremely friendly and full of ideas, on the strength of which

* A newspaper report that Brodzky had inherited millions.

Gaudier gave up his work in the City. This was, of course, a daring move, and for the first two months no one bought anything from him. Mrs. Hare tells me that in order to earn a little ready money, Henri obtained work as a porter at Covent Garden, getting up in the small hours and carrying baskets of fruit and flowers; he was not very strong, and found this work a great strain, but it brought in a little money, and gave him his day in which to work at his sculpture.

Zosik's nerves were giving her much trouble, and she told Pik never to accept any invitations for her, but always say that she had a cold.

'Shut up,' said Pik, 'I am a sculptor, not a bloody diplomatist,' and when Zosik called him an egotist, he said : 'I love myself better than anyone else—everyone loves himself best.'

One evening he called on the Harrises after dinner, and Mrs. Harris took him to the dining-room to give him a meal, but although he was hungry, he said he had already eaten. They all thought he was looking very ill, thin, like a ghost, and the Simpsons, who were there, tried to persuade him to go to the seaside. Harris said that as soon as he had his paper he would give him the job of caricaturist, and that he expected this would be in a fortnight; but so many fortnights had gone by, with the same project in view, that Pik had begun to lose heart.

In September, Gaudier had had his studio for nine months, but hadn't managed to earn the forty pounds which would pay the rent.

One day they had arranged to go to Richmond with Brodzky for a picnic, when Henri received a telegram from Mr. Harris : 'Good news for you will be with you soon after three.' Zosik and Brodzky had to go alone to Richmond, leaving Pik to join them later, for so exciting a telegram must mean at least a fortune which it would never do to miss. When Pik came he whispered into Zosik's ear that it was the French Ambassador, which threw Zosik into a tremendous flutter of excitement. She thought that France had at last realized what a splendid artist they had in Gaudier; the Ambassador himself had come to congratulate Henri, and tell him that he would be able to go back to Paris without fear of military service.

After half an hour Pik said : 'It wasn't exactly the Ambassador, but his secretary. He says that he will get the Ambassador to sit for me.'

The secretary was Paul Morand; he had been very enthusiastic over Pik's work, and thought that he might help Gaudier to place some of his drawings in France. He suggested that through his father, who was then Director of the Arts Décoratifs in Paris, he would show some of Henri's drawings to Rodin, or perhaps to Maillol. After this first visit he did not come back for so long that Pik and Zosik, had given him up, until one day, on going into the studio, Zosik found a young man of about twenty-four, who looked a little

like a Japanese, but whom, to her surprise, Pik introduced as Monsieur Morand. He was intending to bring the Ranee of Sarawak to see Pik, and told Miss Brzeska that she was an English lady brought up in India, to which Zosik replied that she was then probably far more intelligent than people brought up in this country. M. Morand passed over this undiplomatic remark in silence, and Zosik, understanding her *faux pas*, bit her tongue for shame.

When M. Morand took the Ranee of Sarawak to Pik's studio, she admired his sculpture, thinking it simple and alive, though she did not buy any. She chose a dozen of his most recent drawings, and when she asked the price, Pik, according to formula, said that he would be delighted if she would accept them as a present. She took them away, and later on sent ten pounds to Gaudier through M. Morand. He tried also to sell for Gaudier 'La Chanteuse Triste', now in the Tate Gallery, London,* but wrote to say that the lady to whom he had hoped to sell it had jumped out of her skin with horror at the sight of such a manifestation of modern art.

Wolmark also encouraged Gaudier a good deal at this time, and they did each other's portraits. Wolmark did two portraits of Henri, one a small one, now in America, representing him naked to the waist, with a statue and a big sculptor's knife; the other large, and conspicuous at the International Exhibition of 1913, where it was first shown as 'The Man with the Green Face'.

Henri at this time was wearing a scarlet Russian tunic and a heavy black cloak and sombrero, and Wolmark shows him thus in the portrait.

One day he arrived at Wolmark's with his face terribly swollen, unable to speak or to eat. After some hours he began painfully to jerk out his story. As he had passed through Soho, a carter had flung some insult at him, and Gaudier had naturally answered back. The carter got down from his cart and went for Gaudier, thinking him only a puny youngster, but Henri, throwing back his cloak, gave him such a blow that he fell unconscious in the street. At this moment some man came out of a public-house behind, and hit Henri on the jaw, dislocating it. Henri had the presence of mind to force his jaw back into its place, and then ran away before he was surrounded by a crowd. 'But before I left, I dug my foot into the carter's chest as a parting gift, and I heard his bones scrunch.' Wolmark says that he will never forget Gaudier, scarcely able to speak, describing in a whisper this last ferocious thrust.

Wolmark introduced Gaudier to several people, and among others to Mr. Kohnstamm, who very much liked the Maternity statue, now in the collection of Mr. Eumorfopoulos. His interest seemed to flag when Pik said he wanted forty pounds for the group. Gaudier's

* Presented by Mr. C. Frank Stoop.

erratic pride often prevented his making a little money at a time when he badly needed it. At times he would give a statue away for a song, and at others he would ask what was then a quite exorbitant price.

Mr. Edward Marsh says that when he went to Henri's studio, he never saw any drawings, that at that time he did not even know that Gaudier did drawings, save for two or three slight ones which Gaudier had once sent him in a letter. All that was on view was a series of rather large pieces of sculpture, each costing about fifty pounds, quite a formidable sum in pre-war money.

A HOLIDAY

Towards the end of September 1913, ill-health and the Ranee of Sarawak's unexpected ten pounds decided Pik and Zosik to take a holiday at Littlehampton, and Pik was in a heaven of joy at the prospect, since he hadn't seen the sea for over a year. They made each other endless promises : Zosik not to get excited, and Pik not to force Zosik to run about, since it was better for her to keep quiet. They decided to take only one room, and to use the money saved for some excursion. Pik said he would sleep quietly on one side all night, and never jump about.

Their holiday started badly, for Zosik had indigestion and could eat nothing; she was tired out with packing and anticipation, while Pik, on the other hand, had got it into his head that they would be late for the train; so they rushed like madmen through the streets, to find themselves at the station with two hours to spare. Pik was like that. When he got an idea into his head, were it catching a train or cutting a piece of marble, he could think of nothing else, even though he might feel dead with fatigue. On their arrival at Littlehampton, Pik was so excited that he forgot all his promises and was for rushing Zosik down to the sea without either rest or refreshment.

It was a curious life that these two spent, strangely wrapped up in each other, and yet, because of the hardness of their lives, constantly angry with each other. Their arrival at Littlehampton was typical. They had been up since early morning, and it was mid-afternoon, they had had nothing to eat, and were naturally tired.

Zosik : 'Don't be so rough—you're just a hooligan, without any sense of decency.'

Pik : 'And as for you, you're nothing but a stupid old woman, full of imaginary illnesses—you think of nothing but your nerves and your stomach and the devil knows what.'

Zosik : 'Oh ! You disgusting egoist—you know quite well that it is now three o'clock and that I've not been able to eat anything since yesterday, and you won't even take me somewhere to have a little hot milk.'

Pik : 'Hot milk ! What crass stupidity ! Let's get down on the beach and see the sea.'

Zosik : 'That's all very fine for you, since you're hungry, and have a basketful of provisions that I can't touch.'

Then they went and had some milk, and ten minutes later were

sitting side by side in the sunshine as happy with each other as two children who are the best of friends.

They left looking for a room until the sun had set, and they then had to drag from place to place, finding everything so expensive that in the end they were forced to accept a dingy room with a bed which was a regular implement of torture and fit to kill a saint. Pik had insisted on paying a week's rent in advance in case they lost their money; which meant that they could not leave, but had to endure the torture of their bed. According to Miss Brzeska, Pik bounded about as if he had St. Vitus's Dance, and each morning they both ached from head to foot with the pain of sleeping on the iron bars of the bed. Each evening as they went to bed it was : 'Three more nights of torture.' 'Only two more nights', etc.

It was hard work to keep Henri interested on this holiday, for almost at once he wished to rush back to town and start cutting stone again. At first he bought a fishing-rod, but after a fishless day and a half he found it a boring occupation. Then Zosik set him to doing embroidery in coloured cottons for a blouse she was making. This was an excellent idea, and Pik was enchanted; he sat at it from early morning until late at night and could scarcely be dragged away. Next day, he was up with the lark and already at his sewing. He kept comparing it with Zosik's : his was the more brilliant; had the better design; he would do lots and lots; it would be a delightful occupation for the evenings when he got back to London. For several days they sat together on the beach working at this blouse, then Pik became restless and life was again a turmoil.

One day they decided to go for the day to Arundel Park. As usual, the excitement of the project upset Sophie, and she could not concentrate on getting ready; she dawdled about and fussed with one thing and another, while Pik waited, impatient to be gone. At last he could stand it no longer and started off alone. Zosik followed him, feeling hurt and angry that he had not waited for her. When she caught him up, Pik told her that she would never make an artist, since she was so much concerned with all her little affairs—so much on her high horse over absurd futilities; and for the hundredth time they found themselves saying the most dreadful things to each other. Pik, in a moment of fury, flung down the provisions he was carrying, and apples and sandwiches were spread in the dust, while he strode on ahead. He looked back, to see Zosik on her knees, picking everything up, but he didn't stop, and she toiled after him with the bags of food. One of the bags broke, the apples fell into a ditch and Zosik had great difficulty in getting at them. Henri saw her in this predicament and rushed to help her.

'Zosik, darling, don't let us quarrel; we're only tired and hungry; let's be happy. We're a couple of queer fish—but it's quite natural—

142

artists can't have the same nature as common bourgeois folk. We are capricious and proud and it makes things harder—don't you think so, Sisik?'

Very soon they were sitting in the park, transported by the beauty of it all; the lake and the hills with woods spread over their slopes. They took off their shoes and stockings so that the sun might warm them better, and they ate their lunch among a flock of peacocks, which took food out of their hands. Later they found a crystal stream and refreshed themselves with its bright cold water. It was one of the happiest days they had ever had, and in the evening, as they left the park, they watched the deer on the hillside.

One big stag was calling deeply and beating the branches of trees and the long grass with his antlers. Zosik was frightened, but Pik told her that it was the setting sun that gave him this longing. They followed him at a distance, and he looked magnificent with his great antlers sweeping the air and his rich colour outlined against the green of the hillside. He went over to a group of does who were feeding with some young stags nearby, and the young stags fled before so regal an approach, while the does allowed themselves to be driven, like sheep before a sheepdog, into a small, wooded enclosure, where the royal stag would make love to them through the night.

Many of Gaudier's best drawings and the two pieces of sculpture by which he is usually known are the result of this vision of deer, and it was with joy in his heart at so pleasant an experience that he returned to London next day, leaving Zosik to stay on for a week or two more.

His first letter came to her a few days later :

Sweet little Sosisiko,
I don't know where to begin, there are so many things to tell you.
First of all, the Jew from Cracow is at Wolmark's—he is really in-
telligent; he knows all the artists from Cracow, and has very good
taste. He is fed up with the English. He thought he was going to
find people full of energy, etc., etc. He has never done saying how
stupid they are. I went to the Wagner concert with them—the Craco-
vic and Wolmark. They played all the best parts of *Lohengrin, Tann-
häuser, Tristan* and *Parsifal* and *Gotterdammerung,* and it's an insult
to God, the stupidity of this rotten composition is unsurpassed—
there is no kind of unity—no agreement, no depth. The melodies are
dull, slow and sentimental, with inevitable claps of thunder. I con-
vinced Wolmark that Wagner is neither great, nor even an artist. The
other argues that Wagner is good, and as he speaks well, he may be
forgiven. Afterwards they took me to a '*café à putains*'. We cleared
out at once and ran into Epstein. He praised Strindberg's *Cabaret.*
Yesterday I had been with one Jew to see the other Jew, Epstein; he's
doing most extraordinary statues, absolute copies of Polynesian work
with Brancusi-like noses. We stayed there all the afternoon and then
'Crac' came round here and wanted to buy my little alabaster Venus
for £3. I let him have it because it will go to Cracow—otherwise he
certainly wouldn't have got it so cheap. He then took me to Wol-
mark's, where we had dinner, and from there we went to the Café
Royal because we had invited Epstein. On the way we met Brodzky.
We sat with Epstein, his wife, a French engraver called Norbel, and
Augustus John, who looked as if he would burst. While we were drink-
ing someone called me and I looked round, to find Marsh, with Mark
Gertler—I talked to him and he invited me to dinner next week. Al-
though Sisik won't like it, I accepted. On Monday morning I ar-
ranged my garret in Bishop's Road, and yesterday I went with Fab-
rucci to Putney, so it is only to-day that I have been able to see Harris
and —— about the money due to me. Tippets has written for the
rent, which I can't pay him, so that I *must* pick up something from
somewhere. To-morrow is the International, and the day after I have
an interview with a big dealer—Duveen—to make some garden orna-
ments. Wolmark has got me this and has one or two other ideas on
foot, so these two days have been very much occupied and I've been
able to do very little work.
 Epstein told me that Brancusi is a Rumanian and not an Italian—
to-morrow I'll send you more gossip.

<div align="right">Your devoted Pik.</div>

Thanks awfully for your sweetness—as usual your love becomes clouded over once there's a question of money. Well, if there's any reason for blowing me up for going to that Café it's because I lost hours of sleep, but never did I spend a penny. Wolmark saddled me with the Jew, asked me to look after him, and as he is intelligent I said I would, and he's sufficiently sensitive to see that I found it awkward, so he insisted on paying. As for ——, I've asked him several times before yesterday—but what can I do, he is almost bankrupt. His place no longer exists, for the bailiffs have sold his books—not all, but some of them. I went in last night, as he was going to give me a statement, but as he only wished to part with £1 I said 'No', for I needed at least £3, for which I would come again on Saturday. But what can I do? He hasn't got a farthing. Harris says he has owed him . . .

As for Brodzky, he's been ill and has spent the little money he had; it's hardly my fault he can't pay me what he owes.

You are angry with me about the little statue, but in this I thought I should be giving you pleasure, since it would go to Poland. It's at this moment that I need money if I've ever needed it, and what will really put you in a fury is that I shan't even be paid for the statue until the end of the month. Rant and scream as much as you like—it makes no impression on me so long as your worry is to do with material things. If you want to stay at Littlehampton I don't want to beg you to—come to me—no fear! Your little ways are far too gentle—particularly at this moment! Naturally I haven't paid Tippets, because I need first to 'get myself good food', according to your instructions. I'm just fed up and don't care what happens—if I break my neck so much the better. Since you tell me to go to the devil I return so charming a compliment with interest.

<div align="right">Henri Gaudier-Brzeska.</div>

Does it interest you to know that Wolmarca had a boy yesterday morning?

PEOPLE AND EXHIBITIONS

While Sophie was left alone at Littlehampton she became very much worried about Pik's inability to look after money, and the way he allowed several people to be his debtors, and did not call upon them for payment. She realized that her own savings were nearly at an end, and Pik had earned practically nothing for so long that it was small wonder she got into a panic over their finances. She had decided not to go back to London, but when she wrote to tell Pik of this, his calm way of taking it made her feel that she was, perhaps, losing her power over him, besides, it seemed to her stupid to be spending twelve shillings for a room in Littlehampton while Pik was paying for rooms and a studio in London. This, taken with the fact that Pik would spend less if she were there than if he were alone, made her decide at a moment's notice to come up to town. She had not time to warn Pik, and he had gone out. His rooms and his studio were locked, and she had no money left in her purse. She ran from one place to the other, hoping to meet him, and finally had to wait up in the landlady's kitchen until Henri's return at 2 a.m., a none too good beginning for their renewed life together.

When Zosik was pessimistic and complained of the hardness of life, Pik would say : 'I cannot complain, if I am earning nothing at the moment, that doesn't matter at all; it is sure to come. I despise people who complain. I have always had good luck because I know how to defend myself. I never have any debts, and am never despondent. Everyone is his own master, and the weak naturally perish because they haven't the strength to fight.'

Just before Miss Brzeska's return from Littlehampton, Gaudier had noticed a girl standing in front of his 'Wrestler'. He spoke to her, and found her intelligent, not prudish nor hypocritical, and she agreed to sit for him. The story of this first sitting is striking. After she had sat for some time, and Henri had done a dozen drawings or so, he said suddenly : 'Now it is your turn', and quick as a flash, he had taken off all his clothes, seized a large piece of marble, struck an attitude, and told her to start drawing. Pik was delighted to have a model, and they were soon great friends. One of the first things she told Pik was that she had no pretensions to being a pure woman, and that she had felt very much annoyed with some man who had lectured her on the beauty of virginity.

Sophia said that she was trying to seduce Pik, but this was not the

case for their friendship was a Platonic one. Pik answered Sophie's comments with : 'Well, of course, I intend to make love to her, since my Zosik is no use, and keeps me waiting so long.' Zosik gave him her blessing, and said that she must be allowed to be behind a screen, and when Pik asked her if this wouldn't make her jealous, she replied that since she was unable to satisfy his wishes, she would not be so mean as to hinder his pleasures with others. 'Good Sisik,' said Pik, 'you will always be the favourite, and she will be the concubine.'

Pik was always very anxious to please his new friend when she came to his studio, and kept asking Zosik for shillings to buy cakes for *ma —— qui est pauvre*. Miss Brzeska acidly suggested that Miss —— would not be so poor if she did not smoke so much. After several weeks Pik brought her to see Sophie. Miss Brzeska was feeling particularly irritated by the noise around her, had stopped up her ears with cotton-wool, and was sitting right up against the wall, with her back to the room, so as not to see its bare misery, and was singing at the top of her voice. Pik had to call her two or three times before she turned round.

A little after this, —— went to Paris for a few weeks, and came back with sensational tales of how she had danced naked, greatly to the delight of the artists there; how Isadora Duncan had wanted to meet her, and how several theatres had offered to engage her. Also Modigliani had wanted to sleep with her, but she had refused because he drank and had no money. She was going back to Paris in a few days. Pik was charmed, he thought her dashing and brilliant, and admired her unconventionality.

Gaudier and Sophie had many discussions over Rodin, who had at one time been such a god in Pik's life. He considered that his head of Smythies was as good as any Rodin, and that those of Brodzky and Wolmark were probably better, and quite original.

'I am an artist,' he said, 'and nothing but art has any interest for me. So long as I do good sculpture, I don't care how I arrive at it.'

This last remark annoyed Sophie, who said that it did not accord with what he used to think, to which he replied that what he had said yesterday was no precedent for what he might say to-day—that he was only twenty-two, and that she must realize that he was developing. He brought her some of his drawings, men with Brancusi-like heads, but he denied that they were derived from Brancusi, and said that they were a direct evolution from his old work, and that his sculpture had by now become quite abstract. This made Zosik fear that he would sell nothing; but Pik's reply was that he wasn't a dealer, but an artist. To Major Smythies, who protested against Gaudier's abstract work, he wrote :

'We are of different opinion about naturalism, I treat it as a hol-

low accomplishment : the artificial is full of metaphysical meaning, which is all-important.'

Nina Hamnett, who was one of Gaudier's friends at this time, obtained for him some sculpture lessons in Hampstead at two and sixpence an hour, and she also introduced him to Roger Fry. Fry had said that he would like to meet him, and that he could, perhaps, give him some work at the Omega Shop.

'What is this Fry?' asked Miss Brzeska.

'A very advanced painter, who has started the Omega workshop for modern art in decoration, furniture, and other things : a fine man, who has put his capital into giving work to artists, into making their existence easier. He is entirely disinterested, and when I see him to-morrow, I shall show him my most advanced works, which, to tell the truth, are only old-fashioned neo-impressionist work.'

Fry, it seems, was much pleased with the poster for *Macbeth* and with the alabaster 'Boy', and said that he could sell this latter for twenty pounds. He ordered a special poster, and also a tray, for which Pik might expect a few pounds, though he did not know how much, for, as he put it to Sophie, 'one can't bargain with a splendid fellow like Fry'.

At the Alpine Club Exhibition, organized by Fry, Gaudier exhibited five works; his red stone 'Dancer'* he likened to Ezra Pound's poems, and when Zosik asked for an explanation of this, he said :

'Well, if you can't understand it, I can't explain it to you. I just feel it, and there's an end of it.'

He felt that his work was not simple enough, and his search for greater simplicity often resulted in an added complexity of form. He exhibited also the Torso, now in the Victoria and Albert Museum : 'a marble statue', he wrote to Major Smythies, 'of a girl in the natural way, in order to show my accomplishment as a sculptor'.

He thought that Duncan Grant, with his big picture of Adam and Eve, shown at the Alpine Exhibition, was the Phœnix of English painting, and Miss Brzeska suggested that Fry's pictures were thoroughly academic and chocolate-coloured, 'a family trait, since he is a nephew or son of Chocolate Fry'.

Pik sold his 'Fawn', which gave him tremendous pleasure, and later Cournos told him that someone wished to buy two statues of his for fifteen pounds. Pik agreed, but when he heard that this 'someone' was Ezra Pound, 'the abstract poet', his joy knew no bounds.

There was some talk of Mr. Kohnstamm buying 'La Chanteuse Triste', but this must have fallen through, for he purchased an alabaster relief instead. Mr. Sydney Schiff went to visit Gaudier at his studio in Putney, and bought the 'Dancer', which he presented later through Miss Brzeska to the Victoria and Albert Museum.

* National Gallery, Millbank.

Mr. Schiff had two bronzes made of this statue, and Gaudier wrote to him :

'I am naturally glad that Mme. Schiff likes the statuette. It is a sincere expression of a certain disposition of my mind, but you must know that it is by no means the simplest nor the last. The consistency in me lies in the design, and the quality of surface—whereas the treatment of the planes tends to overshadow it.'

Mr. Stanley Casson, in his book, *Some Modern Sculptors*, writes :

'In this [Gaudier's] interpretation of movement he really achieves a new style in modern sculpture. The Dancer is a figure in which movement is detected rather than seen, and detected at a moment when it is neither static nor in motion : when it is potential, and yet not stopped. No sculptor, to my knowledge, has ever depicted a figure thus *descending* out of one movement into another. Rodin's defini-tion of movement as "transition" is here carried out more clearly than he could ever have wished, and more effectively than he could ever have achieved. There is no representation of motion here, only its full and direct expression.'

Gaudier had a profound belief in himself; he would often say : 'It was an honour for So-and-so to be in my company.' He said also : 'You will never make me believe that a man who is strong and healthy-minded cannot accomplish his ends. I have always done everything that I wanted to do. So long as I have tools and stone to cut, nothing can worry me, nothing can make me miserable. I have never felt happier than at this moment; you must take happiness where you can find it, it's no good waiting until it comes and offers itself to you.'

This was near the beginning of 1914, and apart from his studio expenses, Pik was only supplying twenty-six shillings a week for their rooms, their food, their clothes; and Zosik had to use her own savings, which by now had dwindled again to about sixty pounds.

Their rooms were very cold : they had only a tiny oil-stove, and Pik suffered from this discomfort. Zosik was able to do less and less of her literary work : she was entirely occupied with mending and cook-ing and cleaning and being ill, until she came to wonder if she was only destined to be mentioned in the annals of great twentieth-cen-tury men as someone who had had an influence on one of their lives.

Gaudier was now great friends with Ezra Pound, and this friend-ship lasted until Gaudier's death. It was the strongest attachment that he made in England. Mr. Pound describes their first meeting in his book on Gaudier. Henri was enchanted that Pound should have bought two of his works, and in addition to these he was to make him a marble box for five pounds. He was also at work on a large bust of Ezra Pound which he hoped would one day find a place in the Metropolitan Museum, New York.

Miss Brzeska described an evening she and Henri spent with Ezra Pound. As usual, she was very nervous and excited before starting, while Pik added to her worries by pressing her to hurry, and by objecting to all she put on. He did not want her to wear goloshes, and hated her to take an umbrella. *Quoi! Tu penses à emporter ce sale meuble? Affreuse vieille bonne femme—pourquoi ne pas emporter tes fourchettes ou ta commode?*

He refused to carry her umbrella, saying that he was not a lackey. When the wind blew hard, he took the umbrella from her and closed it angrily, so that she arrived at Pound's tired, wet, and bedraggled.

Pik had these swift ferocities : it was due to their difference of age, their poverty, and their sexual estrangement. Afterwards he would be so sorry, and she too would make resolutions to be much more patient; and then, as she said, 'my nerves got the better of me, and all resolutions went to the winds'.

At the Café Royal, Zosik's excitement led her into talking very loudly, and it is small wonder that Mr. Pound wished to escape from her company. He had been extremely attentive to her all the evening, and on the way home Pik actually offered to carry her umbrella, having seen Pound do so, but this time Sophie kept it to herself.

Gaudier hoped now that Pound would buy the 'Stags', which were to be exhibited at the London Group, and a friend of Pound's ordered two marble charms at ten pounds each. Again Pik felt that life would be full of ease, and he arranged for Zosik to go away for a splendid holiday in France. She badly needed this holiday, for she was very run down, and, among other things, had a sudden feeling that she was mad, which was a great shock to her. But she had to wait until they received the money and, as usual, the idea proved but a castle in the air.

At the London Group Exhibition, held at the Goupil Gallery, Gaudier was exhibiting, among other things, the 'Stags', the 'Dancer', and the 'Maternity Group', which last Konody at the time called 'affectation in stone'. Pik was very much excited about going to this Exhibition, and Miss Brzeska says that when they asked him at the door who he was, his voice trembled as he replied : 'I am Gaudier-Brzeska, who is exhibiting here.'

The London Group closed in March 1914, and Gaudier had sold nothing. There is a detailed account of his financial position at this moment. From October until the end of March, he had earned forty-seven pounds nineteen shillings, and out of that he had spent twenty-four pounds twelve shillings for materials, tools, studio, and exhibitions, leaving less than four pounds a month for their life together, washing, clothes, food, and rooms. Again Henri found Sophie useful to him, for her slender savings made life possible. The months of May and June were very peaceful, and they often went together to Rich-

mond Park, where they enjoyed the flowers. One day Pik was so much entranced with the beauty of nature, that he said that he would probably return to a naturalistic style in his work.

Henri went home much more often in the evenings, talked and read to Zosik, and did not get angry because the washing was hung out to dry in the room. He praised Zosik's careful economy, which enabled them to continue as independent beings.

THE WAR

When summer came, their hard-won domestic peace was over, for with the heat their rooms became infested by bugs. It was too much, and Zosik broke down entirely, for though each morning they exterminated every bug, by the evening new ones had come. They took other rooms, and Miss Brzeska went again to Littlehampton, where she found a charming landlady, a Spaniard, who was a great comfort to her.

Pik, who now found himself entirely without money, went round to his various friends to ask them to pay their debts, but for one reason or another he could get none of them to pay. He wrote to Sophie : 'Send me ten shillings, —— promised to pay me to-day, but has disappointed me. I have asked him so often. He seems always to have enough for his girls, and for the Café Royal, but as far as I am concerned, I can died of hunger. Since you left, I have only had three pounds, and most of that I have had to spend on things for my work, so for the last four days my cat and I have lived on milk and eggs given me on credit, and it isn't enough; my stomach is already dreadfully upset, and I haven't a halfpenny.'

Zosik sent him some money, and at the same time his friends seem to have paid their debts. Paul Morand came again to see him and suggested that Gaudier should call on the Ranee, whom he had brought before. But Gaudier, however hard up, could never ask people to buy things from him, nor would he visit people in the hope that they would buy.

Then Zosik came back to London with a plan. They had a friend, a French girl, whose sister was coming to London. She suggested that they should take larger rooms in a quieter place, buying the necessary furniture with her last pounds, and take in these two girls as boarders. The three of them would do the house-work in turn, thereby giving each of them a fortnight's freedom for work. Pik was enthusiastic, rooms were found, the money was spent and all nicely arranged, when, a week later, war was declared, and the girls rushed back to France, leaving Miss Brzeska with her rooms and her surplus furniture. This is a typical example of the ill luck which had beset her all through her life, and it is small wonder that she believed that the Furies were against her.

The outbreak of war was a great shock to them both, and Pik at once wanted to go to the Consul for his passport. For a little while

Zosik dissuaded him, saying that the war would soon be over, that it was a full moon,* which would surely bring bad luck, that he owed nothing to France, and so on. They had both, at different periods, long before, dreamt that Pik would be killed in a war, and this added greatly to their fears; but after a couple of weeks Pik could stand it no longer, and said : 'One has to die some time; if it is in bed or in the war, what does it matter?' So he got his passport and left for France.

Zosik was in despair—she felt for the first time that she had always been very hard on Pik, that her recriminations had been small-minded, and that every time it had been Pik who had taken the first steps to make up any quarrel. She longed beyond endurance to have him back that she might be really charming to him.

Next day, when she was going to sit in the Park, who should she meet but Pik. She thought it was a spirit and ran away, but he called after her : 'Zosik, Zosik, I have come back'. He then told her what had happened.

'When I arrived in France I was told that I was a deserter and that I should get twelve years' imprisonment. They didn't want my kind at the Front. So they whisked me off to a prison, and told me that I should be shot by the sentry outside if I attempted to escape. There was a tiny window in my cell, with a bar across the middle, and as I had one of my chisels with me, I managed after many hours to get the bar loose. I looked out, and saw no sentry; so being small, I succeeded in squeezing out, scaled a wall and ran across many fields. I ran for several hours until I got back to Calais, where I lay concealed until it was dark. I then slipped into the harbour, having persuaded the man at the gate that I had come with baggage that morning. I even made him believe that he remembered my lighting his cigarette for him. I told him that I had been in the town for a bit and that I must get back to England by the night boat—and here I am.'

It all seemed fantastic and miraculous, and they were so happy to be together again that for some time there were no disagreements. Pik thought that he would not try again to go to the Front, and Zosik remembered how desolate she had felt without him. Pik tried to persuade her to be his lover in a fuller sense, but she said that she was ill and tired, that she would give him her intellectual and spiritual love, and that he must be satisfied with that.

After a while, some dispute arose—Pik found her clothes old-fashioned, her shoes worn out; she was particularly ill at the moment, and forgot her resolutions to be patient. Pik went to live in his studio,† while she stayed in her room.

* Miss Brzeska had a half-moon in her family crest, and felt that it was this which had brought her ill luck throughout her life.
† During this period Gaudier was great friends with T. E. Hulme, who also was killed in the war.

Early one morning in September, he came and knocked at her door; he had come to say good-bye, for he was off to the Front again, having obtained a new and more satisfactory passport. Sophie thought it a trick to get into her room, and would not open it to him; after half an hour he went away. She then rushed to her window and called him back as he was half-way down the street. They had a very happy last two days; she did not try again to shake his determination to go, and though all his friends said that it was stupid to go a second time, he said : 'I'm going, I absolutely must; there's no more to be said about it, and nothing else to do.'

Unfortunately, none of his letters to Miss Brzeska from the Front have been preserved; but Mr. Pound, in his book, quotes several written to friends, which throw a very interesting light on his reactions to the war. Four letters, hitherto unpublished, one to Mr. Edward Marsh and three to his home, take him to the end of 1914.

[*Copy of letter to Mr. E. Marsh.*] 1*st October* 1914

My dear Eddie,*

Here I am face to the foe. I have been at the Front for the last fortnight and have seen both latent and active fighting. By latent I mean staying days in trenches under heavy artillery fire, keeping ready for any eventuality [such] as a raid or an unforeseen forward movement from the enemy—by active, a nice little night attack that we made last Saturday night upon an entrenched position. We crept through a wood as dark as pitch, fixed bayonets and pushed some 500 yards amid fields until we came to a wood—There we opened fire and in a bound we were along the bank of the road where the Prussians stood. We shot at each other some quarter of an hour at a distance of 12-15 yards and the work was deadly. I brought down two great giants who stood against a burning heap of straw—my corporal accounted for four more, and so on all along the line. They had as much luck, unhappily, for out of 12 of my squad that went we found ourselves five after the engagement, and on the whole company the toll was heavy. . . .

Confident in ultimate success, I remain,

Yours ever, Henri Gaudier.
Au front: par Le Hâvre (*French army at the front*)

Dear Parents,

I've been in the trenches for 15 days, and in spite of a most bloody night attack and four days' exposure to a regular hail of shells I've managed to reach the age of 23 to-day.

I am now resting with my battalion in a little fortress of which the only rottenness is having to sleep in the cellars. This sleeping out all

* The original of this letter is in English.

over the place and in any weather has given us all diarrhœa, and the drugs which they give us aren't much use. Apart from this everything is all right—naturally life is very monotonous and animal, one hasn't the energy nor the desire to think, and one is too disturbed to concentrate anyhow. I kiss you all tenderly and hope to see you soon.

Henri.

Dear Father. *9th November* 1914

Thank you for your card—I have already told you that I am in front of the town sacred to the Kings, that should explain and I cannot say more. The Cathedral burnt in front of my eyes, now you will understand. I had a good laugh last night. My Lieutenant sent me to repair some barbed wire between our trenches and the enemy's. I went through the mist with two chaps. I was lying on my back under the obstacle when pop, out came the moon, then the Boches saw me and well! pan pan pan! Then they broke the entanglement over my head, which fell on me and trapped me. I took my butcher's knife and hacked at it a dozen times. My companions had got back to the trench and said I was dead, so the Lieutenant, in order to avenge me, ordered a volley of fire, the Boches did the same and the artillery joined in, with me bang in the middle. I got back to my trench, crawling on my stomach, with my roll of barbed wire and my rifle. The Lieutenant was dumbfounded and I shall never forget his face. When things had quieted down I went out again, did my job and got back at 5 a.m.

Henri Gaudier Soldat
Ie Section 7e Cie 129e de Ligne
3e corps au front par L Hâvre.

12th November 1914

Dear Father,

Thank you for your letter of the 6th. The day before yesterday I wrote you a card telling you of my adventure in a barbed wire entanglement. At the time I hadn't noticed it, but I find that I have two wounds, one tear on the right leg made by the wire, and a bullet wound in the right heel. I put some iodine in it when I was in the trench, and yesterday I had it bathed, but it doesn't prevent me from walking as well as before.

Everything was all right in your parcel, nothing was pillaged. You must not send me any more clothes—every week I get some from London and I'm expecting another parcel at this moment. The only thing I want is tobacco at 50 centimes.

I'm not at all bored in the trenches. I am doing some little pieces of sculpture. A few days ago I did a small Maternity statue out of the butt-end of a German rifle, it's magnificent walnut wood and I managed to cut it quite successfully with an ordinary knife. The Cap-

155

tain had asked me to do it to give as a present to someone.* I can't tell you the names of the officers, etc.—anyhow, there's no need, you will know later on, and they are most sporting fellows.

Love to you all and thank you for your good wishes.

Henri.

By the New Year Gaudier had been made a corporal, and a few weeks later, a sergeant. A letter which he wrote to Mr. Schiff shows that his energy was as much alive as ever.

26th February 1915

I learnt of Currie's death while in the trenches near Rheims some time in November, I believe, and of course I was not surprised; he had tried once when I was at his place. He was a great painter, and a magnificent fellow; in ordinary times, I should naturally have been more afflicted, but as you may imagine, death is here a daily happening, and one is expecting it every minute. . . .

These last twelve days I have succeeded in making the enemy angry—we were only 50 yards off, and I got a bugle to blow false alarms, then I insulted them, and went out of the trench with a French newspaper. A German came out to meet me, and gave me the *Hannover Zeitung* and *Kieler Nachrichten* in exchange; it was very amusing, but I profited by the excursion to discover an outpost, on which I directed our artillery. At 3 p.m. four big shells fell on it, and the twenty chaps in it went up to heaven. I also brought one down with my rifle the next day. . . .

In April Mr. Shiff sent him some money, and he replied : 'I can only thank you for the note, and consider it as an advance on account of work you want me to do for you.'

This is, I believe, the only instance of his having accepted any money by way of a gift, and even here, in the emotional climax of war, there is no question of not repaying its full value. He sent ten shillings to Zosik, and told her that life at the Front was curing him of many faults. His last letter to Mrs. Bevan arranges for news of his death, should it occur, to be given to Sophie. 'As I may fall, I should be grateful if you would ask for news of me from Capitaine Ménager, Commandant, 7e Compagnie, 129e Infant., 3e Corps, to convey it to my sister, but only if I have been at least six weeks without sending any news.'

* Monsieur Ménager (Gaudier's Captain) tells me that Gaudier did three or four bits of sculpture in the trenches, either from the butts of rifles or in soft stone, using only his penknife. These works were preserved for a little while and then thrown away to make room for clothing.

Monsieur Ménager writes of Gaudier in a letter dated 9th March 1929:

Nous admirions tous Gaudier, non seulement pour sa bravoure, qui était légendaire, mais aussi et surtout pour sa vive intelligence et la haute idée qu'il avait de ses devoirs. . . . A ma compagne il était aimé de tous, et je le tenais en particulière estime car à cette époque de guerre de tranchées j'étais certain que—grâce à l'example qu'il donnerait à ses camarades—là où était Gaudier les Boches ne passeraient pas.

In the meantime, Miss Brzeska went away to teach at a girl's school. The food was miserable, and the noise, to her, appalling, so that after a few months she had to leave. She found a small attic in the neighbourhood for very litle money, and six times a week she went to teach French to the children of Lady G. at a house five miles away. For this she received six shillings a week; it was a two hours' walk each way, and she had to leave at eight o'clock in the morning and walk all through the mud of the country lanes. Lady G., she said, was very kind to her, and spoke to her sympathetically on her arrival.

Miss Brzeska was back in London when she heard of Henri's death in June 1915.* He had written to her saying that he longed to come back, and that when he did, he wanted her to be his wife. In the meantime, she had been feeling terribly desolate, and had sent him a letter, which crossed his, blaming him for her life in England, and demanding that he should come back and take her away. After hearing from him she spent some time thinking of his proposition, and finally replied most sympathetically, but did not post it at once, adding here and there new thoughts and new hopes for their future happiness together.

Before she was ready to post this letter, she received the information that Henri had been killed. She felt that her first complaining letter had perhaps driven him into danger, and the torture resulting from this thought is a constantly recurring theme in the closely-written diary which she kept for the next seven years.

Many people will remember Miss Brzeska in the streets of London, a strange, gaunt woman with short hair, no hat, and shoes cut into the form of sandals. She felt that the world was against her, and never for an instant did she forget the tragic loss of her 'little son'. He became for her the whole of her life, but a life consumed by remorse, in that she had not been to him a companion more complete, more lively, and more sympathetic.

Henri Gaudier, on the other hand, had regretted nothing, always using his energy to the full and feeling sure of ultimate success.

* Henri Gaudier was killed at about one o'clock in the afternoon of June 5th, 1915, during the attack on Neuville St. Vaast.

THE ASSASSINATION OF TROTSKY
by Nicholas Mosley

Brilliant investigation of the most notorious political murder of the century. Now filmed by Joseph Losey with Richard Burton as Leon Trotsky.

50p *Illustrated*

THE CONQUEST OF THE INCAS
by John Hemming

'Much the best book on the Incas since Prescott's, which it is entitled to supersede . . .'

£1.25 *Illustrated* Philip Magnus, *Sunday Times*

AKHENATEN: PHARAOH OF EGYPT
by Cyril Aldred

'Enthralling . . . Akhenaten, husband of Nefertiti and predecessor of Tutankhamen, remains one of the most fascinating figures in world history.'

75p *Illustrated* *Daily Telegraph*

WORLDS IN COLLISION
by Immanuel Velikovsky

A startling re-interpretation of the historical past based on the the comparative study of ancient civilizations and literary traditions.

'A literary earthquake.'

60p *New York Times*

All Sphere Books are available at your bookshop or
newsagent, or can be ordered from the following address:

Sphere Books, Cash Sales Department,
P.O. Box 11, Falmouth, Cornwall.

Please send cheque or postal order (no currency), and allow
7p per book to cover the cost of postage and packing
in U.K., 7p per copy overseas.